Louise Bourgeois

Marie-Laure Bernadac

Louise Bourgeois

Flammarion

Paris - New York

I would like to thank most especially Louise Bourgeois for the close attention and valuable help that she kindly contributed throughout the preparation of this book. Jerry Gorovoy also deserves to be singled out for his judicious comments and generous assistance. Furthermore, I would like to thank Robert Miller, John Cheim and the entire gallery staff, notably Diane Bulman, for their indispensable and efficient collaboration in this task. Others who deserve acknowledgment for having helped in various ways are: first of all Karsten Greve in Cologne Nathalie Brunet, Laure de Buzon-Vallet, Bernard Marcadé, Marie-Odile Peynet, Anne Sefrioui, Françoise Thibault, and Makhi Xenakis. Finally, special thanks goes to Anne Morien for allowing me to use transcripts of the interviews carried out for the film by Camille Guichard.

Designed by Pascale Ogée
Translated from the French by Deke Dusinberre
Edited by Philippa Brinkworth-Glover

Typesetting by PFC, Dole
Photoengraving by Euresys, Baisieux, France
Printed and bound by Mame Imprimeurs, Tours

Flammarion
26 rue Racine, 75006 Paris

200 Park Avenue South, Suite 1406
New York, NY 10003, USA

ISBN : 2-08013-600-3
Numéro d'édition : 1087
Dépôt légal : March 1996
Printed in France

CONTENTS

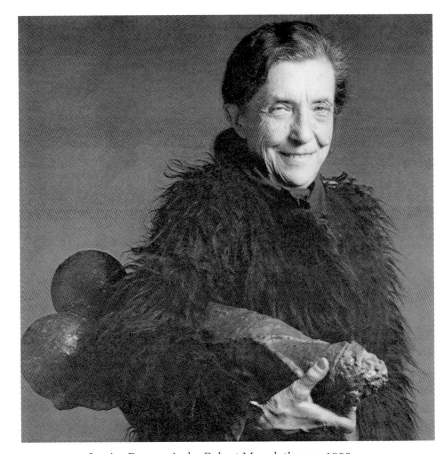

Louise Bourgeois, by Robert Mapplethorpe, 1982.

INTRODUCTION

SCULPTING EMOTION

It is not an image I am seeking. It's not an idea. It's an emotion you want to recreate, an emotion of wanting, of giving, and of destroying.[1] L.B.

Louise Bourgeois has become a major phenomenon in the space of just a few years, almost in spite of herself. Her place in art history is now so special that the legend surrounding her occasionally tends to eclipse the aesthetic import of her œuvre. This fate is typical of strong and charismatic personalities whose lives are tightly intertwined with the evolution of their work.

How could an artist who remained almost completely overlooked for thirty years (despite several noteworthy shows) suddenly enjoy national and international recognition as one of the greatest artists of the century? Current infatuation with her work is probably exaggerated—not in terms of artistic quality, but in terms of media hype—and seems inversely proportional to the neglect she suffered. It appears as though the enthusiastic discovery of her art in the early 1980s, following a retrospective exhibition at the Museum of Modern Art in New York, came as a revelation, that is to say a long-awaited, inevitable yet startling event.

It is clearly no coincidence that this all transpired in the 1980s. Recognition of Louise Bourgeois's work could only come with the emergence of a new sensibility typical of the "post-modern generation" that advocated a return to subjectivity, to a form of expressionism, to an eclecticism perceived as liberating in the face of strict formalist norms. This new focus on the self—observed in recent decades following a loss of values and the collapse of ideologies—mainly stresses the body, organic forms, and sexuality, all realms in which Bourgeois was a pioneer. Today, numerous artists cultivate an approach that formerly seemed too figurative, overly personal and excessively sensual.

Bourgeois's special status also stems from her feminist stance. Once again, it no coincidence that she is viewed as a model or figurehead by many women artists and by artists interested in the attributes of femininity. The fact that a female artist, wife and mother of three children, could attain such fame reinforces her singularity.

Paradoxically, it is probably this long period of neglect that enabled Bourgeois to accomplish her artistic task. Liberated from the constraints of fashion, success and market pressures, Bourgeois, as she herself acknowledges, could work entirely for herself, out of personal necessity, in complete freedom. The final string to her bow is her age: that a woman over 80 possesses such creative energy and visual inventiveness, constantly anticipating the concerns of younger generations, reinforces her position as precursor and visionary, confirming once again the theory that certain great artists experience a cyclical return to youthfulness in old age.

These personal traits should nevertheless not mask the fact that Bourgeois clearly belongs to the post-war period of twentieth-century art. Even if the infinite diversity of her œuvre subverts all notion of style, she is nonetheless

subject to certain influences and shared ideas. As a French-born American artist, she studied art in the 1930s in Paris, where she inherited a taste for art deco from teachers such as Paul Colin and Cassandre, and where she came in contact with Giacometti and the surrealists. On arriving in the United States, she felt close to the abstract expressionists, and by the 1960s Bourgeois symbolized "eccentric abstraction," a term invented by Lucy Lippard to describe an organic, biomorphic abstraction hinging on sensuality. The climate of the 1970s, meanwhile, favored environments and performances, reinforcing her political concerns; starting in the 1980s, Bourgeois returned to a figurative idiom. Finally, the recent and particularly prolific period has been devoted to the production of magic rooms in which Bourgeois fashions her "fetishistic" objects into a synthetic whole. Yet her sculpture nevertheless remains unclassifiable. She is barely mentioned, moreover, in dictionaries of twentieth-century sculpture.[2] And when mentioned in essays on modern sculpture, she is usually linked to Isamu Noguchi, Louise Nevelson or totemic sculpture.[3] On the other hand, it is clear that she has directly or indirectly influenced a good deal of contemporary American and European art (even when her work was little seen). Neither surrealist nor expressionist, neither minimalist nor baroque, Bourgeois resembles no one else. Fiercely independent, she obstinately asserts her originality, remaining wary of the work of others. The only artist with whom she claims to identify is Giacometti. Often more interested in emotional content than formal features, she is more sensitive to the drama conveyed by an artist than to his or her style. "People misunderstand my work. I am not a surrealist, I am an existentialist."[4] She has often been incorrectly linked to the surrealist movement on the grounds that she met André Breton both in Paris and New York, and that as a Frenchwoman living in America she inevitably encountered members of the group during its wartime exile. But the connection stops there. Not only is Bourgeois much younger than the surrealists but, above all, her exploration of the unconscious has nothing to do with surrealist methods: "I never

dream. I think, though I'm not sure, that my connection with the unconscious comes not through the dream but through real life. Except I complain about the terrific tension by having all this access. It's the suppression of immediate reality."[5] Her images spring neither from dreams nor from an "automatic" process, but from a physically experienced exploration of her own past, which thereby grounds her imagery in reality.

Every time Bourgeois feels the need to express something, she does it in the way that seems most appropriate, independently of form and materials which, for her, are merely tools. Paradoxically, however, Bourgeois also states that her goal is "formal perfection." Despite her artistic sophistication on both theoretical and practical levels, it is tempting to classify her (regardless of her objections) in terms of *art brut*, an *art brut* which is deliberately rather than falsely naïve. Hers is a "primal" art in the sense that inspiration springs directly from emotions triggered by her past. It is fetishistic rather than literary or cerebral, functioning as an exorcism with curative and magical effects.[6] This might explain its freshness, seductiveness, and resistance to traditional classification. It is an art that is closer to life than to art. Bourgeois's esthetic credo might be stated as follows: "Art is a guaranty of sanity."[7] Its power to exorcise lends it therapeutic value. "Art," says Bourgeois, "is the experiencing—or rather the re-experiencing—of a trauma."[8] She became a sculptor to get rid of her past, re-creating it in order to survive. "As a child, she felt manipulated, so as an adult she wanted to manipulate. Sculpture was her weapon of revenge."[9] This explains the essentially biographical and psychological interpretation of her work, why memory and the past serve as wellsprings for her creativity, why her sculpture is so profoundly erotic.

Indeed, her entire œuvre is elaborated around childhood references. "Confessions, self-portraits, memories, fantasies of a troubled being who seeks from sculpture the peace and order lacking in her childhood—such is the work of Louise Bourgeois."[10] The basic trauma—the rift from which creative energy surges, the never healed wound—stems, according to Bourgeois, from her father's

"betrayal" when he incorporated his mistress Sadie, a young English governess, into the family unit. The ménage à trois lasted for ten years under the wounded gazes of the children, with their mother's tacit consent. This unhealthy atmosphere of deceit, hypocrisy, jealousy and double betrayal (since Louise felt betrayed not only by her father but also by Sadie), generated a profound psychic disturbance within the artist. Sadie created an imbalance that negated traditional family values and threatened the reassuring, structuring unit, or cell, of the father–mother–child trio. It was only in 1982 that Louise officially mentioned this incident and related it to her work, her fears, and her need to repair things via sculpture.[11] Previously, she stated, she did not dare admit it, was not able to confront the past, which for her meant reliving it. This may indeed have been one of the reasons for her long silence. Yet it is hard not to feel also that Bourgeois could only speak out when such language could finally be heard, when artistic activity was becoming increasingly linked to autobiography and when criticism once again began taking private life into account in the analysis of an œuvre.

An "anti-biographical" position cannot be maintained for long in the case of Louise Bourgeois, because the weight of interpretation linked to childhood memories simply cannot be ignored. Not just because the artist herself asserts it, and because her comments on her work are part of her œuvre, but also because she thereby brilliantly revives the concept of art as autobiography, previously advocated by Picasso and subsequently developed in various modes by artists like Boltanski. From her own life, Bourgeois mainly stresses the years spent in France. Exile, for her, was a second deep, emotional shock that was crucial to her artistic development insofar as it paradoxically gave her the necessary energy to struggle, in vain, to overcome the sense of absence. However crucial and beneficial, separation from relatives and country (coming after the "break" with her father), nevertheless provoked irremediable suffering within her. Like Marcel Duchamp and Gaston Lachaise, other American artists of French origin, Bourgeois could fulfill her artistic calling only in America. Despite aesthetic and formal differences, it is hard not to note that the work of all three artists was entirely devoted to sexuality and femaleness, as if they used the puritanical American context as a foil, as an antidote to psychic repression, and as a way of escaping France's libertine tradition.

"Great images have a history and a prehistory. They always exist simultaneously as record and legend."[12] Far from confining herself to personal "incidents" or anecdotes, Bourgeois has unconsciously tapped into the great primordial myths, thereby endowing her personal history with universal scope. By delving deep into her own unconscious, she has relived and brought back to life the buried images of a collective unconscious. "One could follow a path through the childhood neurosis into the unconscious and out the other side into the world of ancient religious archetypes."[13]

Many artists allude to an Edenic childhood, when sensations were the most pure, drives the most intense, when everything was spawned and forever etched in the memory. "The artist does not go through the rites of passage. He remains a child that is not innocent and yet cannot pass or shake the bonds. He is not able to liberate himself from the unconscious. It's a tragic fate."[14] The regular reactivation of this happy or unhappy past then acts like a hallucinogenic drug. "I am an addictive type of person and the only way to stop the addiction is to become addicted to something else, something less harmful."[15] (It was art that filled this role for Bourgeois.) The sight of a photo, sound of a word, or trace of an odor can suddenly thrust you into the past even as you remain in the present. This tension between two real worlds, the gulf between what was and what is no longer, is often the driving force behind artistic creativity. Art is a way of bridging the gaps, soldering the cracks. Bourgeois's own "break" (schize) is particularly "active." Both her personality and her work were born under the sign of duality and ambivalence, which she sees as the product of her mother's rationality and her father's intuitiveness (or, more accurately, "her father's heartsickness"). It is no coincidence that Bourgeois is particularly interested in

certain mental illnesses, especially what she calls Tourette's syndrome—that is, saying one thing while thinking another, being constantly torn between two opposing yet apparently equivalent propositions. This permanent double bind partly explains the wealth of toing and froing within her œuvre, as well as the apparent contradictions in her personality.

Bourgeois is aware that being an artist is a "privilege." She considers it a gift or grace that has to be merited every day in order to avoid feeling guilty. But art also means sacrifice—the cost of sublimation can be steep. "Art is a sacrifice of life itself. The artist sacrifices life to art not because he wants to, but because he cannot do anything else."[16]

The energy required to shift from the unconscious to the conscious by reliving the past down to the tiniest detail, complete with the physiological sensations which that experience entails (beating heart, confusion, excitement, depression), is of a sensual and even erotic nature. "It's like the sexual act: it's exhausting, yet at the end you are at peace, and completely tired."[17] The erotic dimension to Bourgeois's art manifests itself at this level. She admits that she is not passionate about sex in the usual sense of the term, but at the same time she sees sex as an experiential confirmation of reality, the only thing that truly matters. "I am interested in the real thing, that is to say, the sexual attraction. The rest doesn't count."[18] Seduction—the power to eroticize life, a hypersensitivity to both objects and feelings (including the most ambiguous of human relations)—enables her to give form to her emotions, to concretize the most inexpressible feelings, especially pain. For Bourgeois recognizes the masochistic aspect of the artist as eternal sufferer. "The subject of pain is the business I am in. To give meaning and shape to frustration and suffering. What happens to my body has to be given a formal aspect. So you might say, pain is the ransom of formalism."[19] Because her emotional resources are inexhaustible, Bourgeois's work displays great diversity.

Thus everything is closely linked and intertwined: childhood and memory, art and life, healing and eroticism.

Once the fundamental features of her personality are known, it is tempting to ignore them and strip the œuvre naked, analyzing its own organic development in terms of various phases, harbingers, regressions, returns. "I want to hide and have the object define itself. I don't want my objects to depend on my presence. The sculptures have to last long after me. They have to have a value outside of people, outside of history. They have to have an intrinsic value, otherwise they are not successful."[20] Since she claims that her sculpture represents her body, it is possible to attempt a precise description of the principal parts and typical features of the sculptural corpus. Bourgeois is wary of the excessive interpretation that her work often inspires, and which tends to lead to a process of identification; she prefers simple analytic descriptions that render the pieces present and alive.[21] On the other hand, the very inspiration behind her œuvre would seem to authorize psychoanalytic comparisons, even though her attitude toward psychoanalysis is ambivalent, wavering between wariness and parody: wariness, because she thinks that psychoanalysis is incapable of healing the ills of artists,[22] and parody because her ever-ironic art, despite its tragic dimensions, incarnates (or mimes) the theory of the Oedipus complex to such an extent that it might be wondered whether, despite herself, her work represents a precocious "anti-Oedipal" transgression of Freudian "phallogocentrism."[23] As she progressively expresses her lifelong anxieties and fears in the language of matter and form rather than words, Bourgeois delves ever deeper into her unconscious, thus moving from homesickness to organic refuge, from the destruction of the father to a release from guilt and a confrontation with the "primal scene." This long trajectory has been traced in wood, plaster and marble, in figurative as well as abstract sculptures and environments. But whatever the subject handled, in whatever form, the emotional intensity that attends the birth of these works is such that it is immediately communicated to the spectator. Bourgeois relinquishes a little of herself with every work; the more she relinquishes, the easier it is for her to overcome obstacles. Similarly, she draws strength from her

fragility. The artist's permanent battle to monitor herself, know herself, express and convey her own experience to others is conducted with courage and tenacity, but not without violence and risk. "In my art, I am the murderer," she says. "The life of the artist is the denial of sex. Art comes from the inability to seduce. I am unable to make myself be loved. The equation is really sex and murder, sex and death. . . . The fear of sex and death is the same."[24]

This fear of sex and its association with death is the very definition of eroticism.[25] The resulting œuvre possesses real powers of enchantment and attraction, operating in a disturbing fashion on all who let themselves be seduced by it.

NOTES

1. Quoted in Christiane Meyer-Thoss, *Louise Bourgeois: Designing for Free Fall* (Zurich: Ammann Verlag, 1992), p. 194.
2. A. M. Hammacher, *The Evolution of Modern Sculpture, Tradition and Innovation*, (New York: Abrams, 1969), p. 322; Herbert Read, *Modern Sculpture*, (London: Thames and Hudson), 1989, p. 203.
3. Rosalind Krauss, *Passages in Modern Sculpture,* (London: Thames and Hudson, 1977), p. 148.
4. Quoted in Terrie Sultan, "Redefining the Terms of Engagement," in *Louise Bourgeois, the Locus of Memory, Works 1982–1993* , exhibition catalogue, (New York: Brooklyn Museum, 1994), p. 28.
5. Meyer-Thoss, p. 122.
6. In this respect, it is impossible to overlook affinities with her husband, Robert Goldwater, who was a historian of primitivism, although direct influence is not necessarily involved.
7. Phrase etched on the hoop ringing *Precious Liquids* , 1991–2.
8. Interviews with Bernard Marcadé and Jerry Gorovoy for Camille Guichard's film, *Louise Bourgeois*, co-produced by Terra Luna Films and the Centre Georges Pompidou, Paris, 1993. (Not all of this interview material, made available to the author by Anne Morien, was included in the final cut of the film.)
9. Jean Frémon, *Louise Bourgeois* , exhibition catalogue, (Paris: Maeght, 1985).
10. *Ibid.*
11. Louise Bourgeois, "A Project by Louise Bourgeois: Child Abuse," *Artforum*, December 1982.
12. Quoting the philosopher Gaston Bachelard when discussing Bourgeois has become a veritable commonplace. Indeed, it is tempting to relate the theme of the house (in its various forms) and the nature of materials with the various spatio-temporal symbols employed by Bachelard in works like *The Poetics of Space* and *The Poetics of Reverie*. Bourgeois, however, rejects this comparison. She admits having read Bachelard late in life, but claims that she found his "deductive" philosophy disappointing.
13. Thomas Mac Evilley, "History and Prehistory," *Louise Bourgeois*, exhibition catalogue, (Barcelona: Tapiès Foundation, 1990), p. 239.
14. Meyer-Thoss, p. 199.
15. *Ibid.*, p. 189.
16. *Ibid.*, p. 197.
17. *Ibid.*, p. 132.
18. *Ibid.*, p. 138.
19. *Ibid.*, p. 189.
20. *Ibid.*, p. 199.
21. Interview with Pat Steir, *Artforum*, no. 10, summer 1993.
22. Louise Bourgeois, "Freud's Toys," *Artforum*, no. 5, January 1990.
23. As demonstrated by Rosalind Krauss in *Louise Bourgeois*, exhibition catalogue, (Barcelona: Tapiès Foundation, 1989).
24. Meyer-Thoss, pp. 195 and 196.
25. Despite her wariness of literary allusions, Bourgeois willingly quotes Georges Bataille and praises Denis Hollier for having been such a good interpreter of Bataille and for having introduced his work to the United States.

PRIMAL SCENES
(Drawing, Painting, Engraving)

For me, drawing is a form of diary. I could not help but make them as a means to exorcise or deconstruct daily fears; they (the themes) are recurrent, precise, accurate, self-incriminating and immediately regretted. Still you let them be, because the truth is better than nothing.[1] L.B.

Until the late 1940s, Louise Bourgeois worked essentially on paintings, drawings and engravings, even though her mentor, Fernand Léger, on seeing one of her drawings, informed her very early of her calling as a sculptor.[2]

Thus she first approached the visual arts through drawing. The graphic and imaginative potential of drawing provided the driving inspiration behind all her work, and was the basis from which her sculpture would spring.

In fact, Bourgeois's early images constitute the matrix, or womb, of her later work. Primal scenes allude both to her childhood and her motherhood in a cyclic system of mutual cross-reference that would culminate in 1994 with the *Red Rooms*, those bloody parental and infantile bedrooms where the mystery of creation takes place in a highly charged atmosphere of taboo, desire, and disturbing eroticism that characterizes all of her work.

Threading through a skein of drawings

The emergence of drawing in the œuvre of Louise Bourgeois initially hung by a thread—namely the thin, fragile thread of the worn and hole-riddled tapestries that her parents restored in a workshop in Choisy-le-Roi near Paris. From age eleven, in fact, given her talent (and the absence of Monsieur Gounod, the professional draftsman at the Gobelins Tapestry Manufactory who usually came on Saturdays), the young Louise drew missing patterns on tapestries, often the feet of people or horses. That was how she learned that art was "useful."[3]

Her drawing then took another direction, that of geometry, when she studied mathematics at the Sorbonne. These twin sources—figurative and abstract, detailed and theoretical—are behind the duality detected in her forms. Finally, Bourgeois studied traditional drawing in the various art schools and studios she attended during the 1930s, although there is no trace of this academic drawing in her œuvre.

Bourgeois calls her drawings *pensée-plumes* ["quill pensives"], that is to say, thoughts plucked from the air. "Drawing is indispensable because all these ideas buzzing around have to be caught like flies as they go by. And then what do you do with the flies or butterflies: you save them and use them—blue ideas, pink ideas, passing ideas. Then a drawing leads to painting, and a painting leads to sculpture, because sculpture is the only thing that liberates me. It's a tangible reality. What might be better than sculpture, would be real people."[4] The regular activity of drawing, parallel to yet independent of sculpting, serves as a sort of private diary for noting feelings and visual ideas that may

Page 12:
Untitled, 1947–48.
Oil on canvas, 81 x 246 cm.
Kröller-Müller Rijksmuseum,
Otterlo.

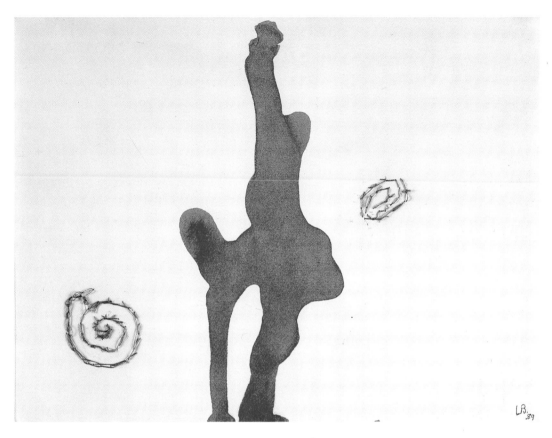

Untitled, 1989.
Red ink and blue thread,
22.8 x 29.8 cm.
Musée national d'art moderne,
Centre Georges Pompidou, Paris.

or may not give birth to sculptures. Bourgeois draws in a repetitive, almost obsessive
fashion, with a great deal of pleasure. It is an exercise in revelation rather than exorcism,
which enables her pen to disentangle the complex skein of memories and multiple
images provoked by intense emotions. The impulsive and spontaneous nature of her
drawing, similar to the expressive truth of children's drawings, provides direct access
to primal images, to buried memories and the unconscious; it is a form of transcription
even more automatic than writing, since the emerging form and meaning develop pro-
gressively as the line is etched. "What you've written becomes visible, but I want more
than that, I want the visible to become tangible."[5] Such works have a unique status, dif-
ferent from a sculptor's traditional sketches. Her drawings were long kept secret, in fact,
usually hung in series in her studio or stuffed into drawers. Bourgeois exhibited them

only rarely, keeping them as intimate documents for personal use. "I myself am a woman with no secrets, but I would never have shown these drawings. That for thirty years they stayed in boxes, in storage, proves it."[6]

Several types of drawings can be distinguished within the total œuvre ranging from 1940 to the present, for which accurate dates and chronology are hard to establish: those with flowing, linear draftsmanship; those with wiry, simplified lines close to caricature; the skein-drawings composed of bundles of parallel lines; abstract drawings with flat and geometric shapes (highly colored and often linked to sculptures); "action" drawings (burns, cuts, stitches, etc.); writing-drawings; and, more rarely, collages. All of these categories overlap one another, just as one motif can give birth to another motif in a constant process of metamorphosis that testifies to the almost organic vitality of the work of Louise Bourgeois.

In yielding to the pressing need to draw, Bourgeois accepts every invitation from the medium—each virgin surface is likely to receive a mark (recto and verso), an inscription, a rough sketch—whether envelope, graph paper, colored paper, cardboard, emery cloth, tracing paper, musical score, or whatever. She sometimes uses fine white paper for certain large, "finished" drawings. The others, more like "drafts," are done hurriedly. Her choice of technique varies as a function of formal requirements, but Bourgeois nevertheless displays a penchant for charcoal and black or colored ink. Her favorite colors are blood red (which she feels symbolizes emotional intensity), blue (which she says represents dreaminess, unreality, escapism, peace) and white (a cancellation, a way of "getting back to square one").

Primeval Images

The first images to appear in the 1940s were linked to birth, childhood and motherhood. They alluded in various ways to the cycle of life and death, generation and fecundation— a way, perhaps, of suggesting a correlation between creation and procreation. Although generally uninterested in her own face, Bourgeois executed several self-portraits during the war years, when she found herself stranded in America. It was as though displacement prompted her to seek her own identity. The image that she gave of herself could be incredibly accurate; thanks to the thin lines and ambiguous facial shading that looks like a beard, it is almost possible to perceive an "eternal," ageless Louise with a serious yet childlike expression and a keen, searching gaze (p. 17). The unique nature of this self-portrait, more of a caricature than a likeness, stems from the simple technique and intense expression that endow it with a strange presence and clarity. In another drawing (p. 18), Bourgeois shows herself giving birth—the infant emerging from the womb,

Page 17:
Self-Portrait, 1942.
Ink on paper, 28 x 21.5 cm.
Musée national d'art moderne,
Centre Georges Pompidou, Paris.

Page 18:
Untitled, 1941.
Ink on paper, 28 x 21 cm.
Kunstmuseum, Berne.

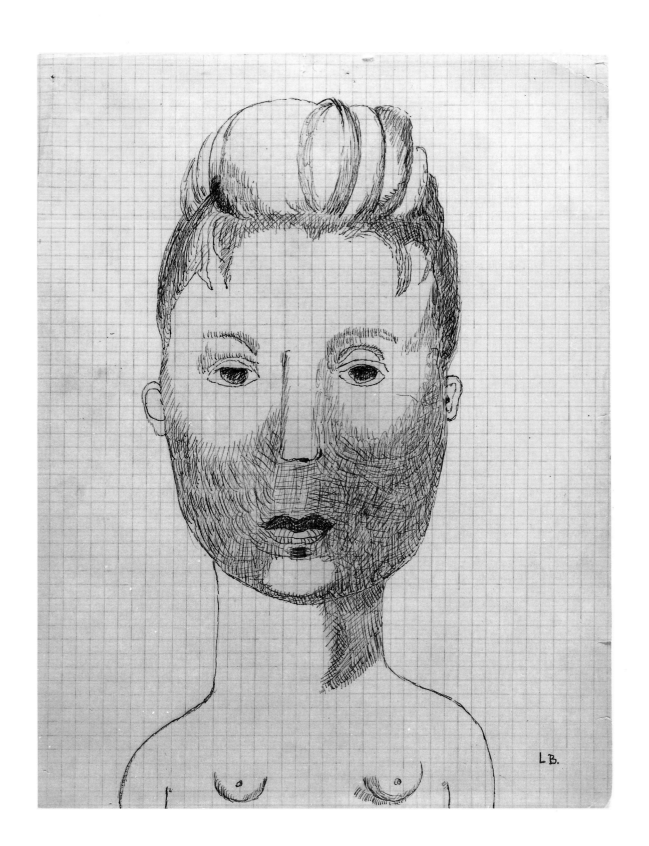

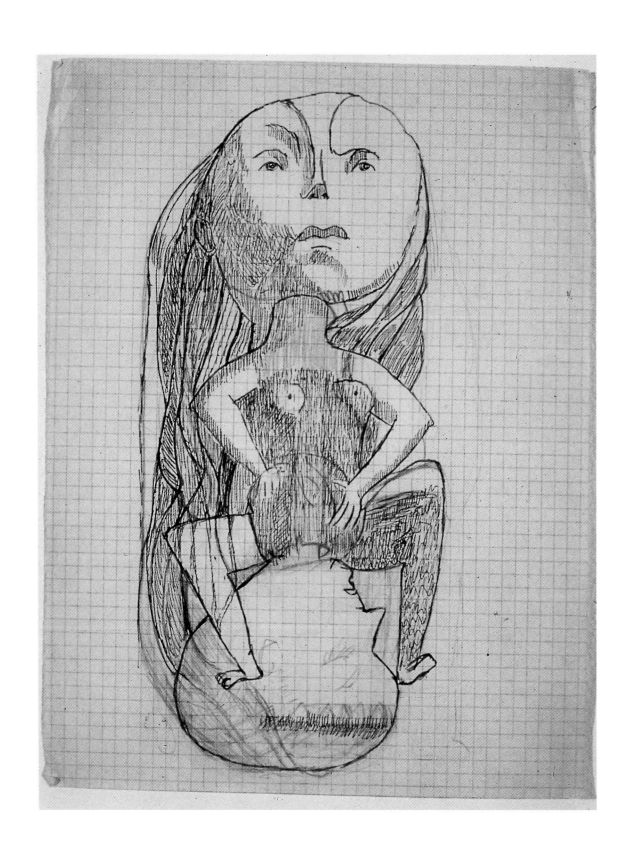

as large as the mother, is an inverted double of herself. The birth seems like a blossoming forth because the figure is surrounded by long twisting strands of hair that form an organic matrix sheathing the scene like the bud of a plant. This physical depiction of birth is countered by a more symbolic one in the form of a small, sexless child in a bowl-like vase, at the intersection of two profiles, maternal and paternal, expressing the fact that the infant results from the coupling of its parents. The idea of having a "child in mind" is developed in a more dramatic fashion in the drawing showing the bald head of a mother eating her offspring (p. 19). As usual, Bourgeois's imagery is open to multiple interpretations, including highly contradictory ones; each viewer may project his or her fantasies and personal history on to it. Bourgeois herself sees this drawing as an act of cannibalism, an unconscious desire to do away with the child when it becomes too burdensome. She eats her offspring like a vengeful Medea or Kronos, but this symbolic, ogre-like act can also be perceived as the ingestion of male power, the child emerging from the mouth like a tongue or substitute phallus. The "wicked" mother in this drawing is countered by a "good," protective mother who wraps her children in her cloak (p. 20). Bourgeois adopted an even sketchier style here, etching the face with broad, imprecise lines, energetically scoring the outlines to give the character a grotesque appearance.

The same handling recurs in *Girl Falling* [p. 20], a small figure with empty head, her belly swollen with a cluster of balloon-like seeds—the very image of blessed pregnancy. This vision of a pregnant woman occurs in several sculptures where the woman is headless and armless (therefore defenseless), as though she were henceforth identified solely by the bulge of her all-encompassing belly. "My early portraits are armless because they are helpless. No arms means you cannot defend yourself. In this state you know your limits."[7] The good mother with abundant nipples prefigures later sculptures featuring a profusion of round protuberances.

Other autobiographical depictions of joy or distress were expressed via a small round child-like figure with long hair, coiled or erect. The figure either flies through the air, free and happy, or weeps (tears in the form of children) and drowns (an allusion to Ophelia, Narcissus, or even Louise throwing herself into the Bièvre River near Paris). This type of highly simplified drawing is particularly moving, for with several awkward but spontaneous strokes Bourgeois manages to accurately condense the gist and veracity of her feelings.

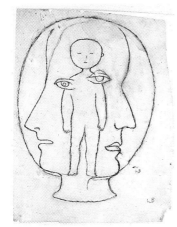

Untitled, 1940.
Pencil on paper,
28 x 22.2 cm.
Private collection.

Untitled, 1943.
Pencil and ink on paper,
12.5 x 7 cm.
Galerie Lelong, Zurich.

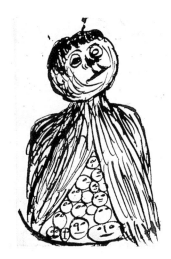

Untitled, 1943.
Ink on paper,
10.8 x 7.6 cm.
Robert Miller Gallery,
New York.

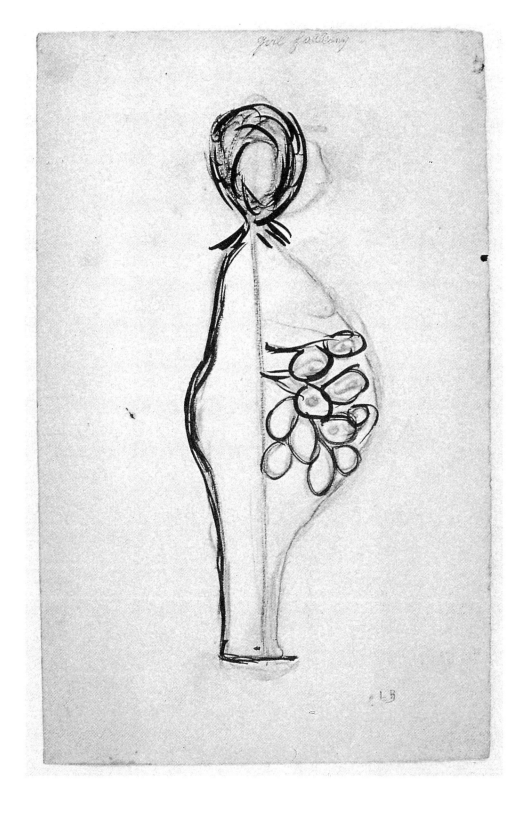

Girl Falling, 1947.
Pencil and ink on paper,
28.5 x 17.8 cm.
Private collection.

Untitled, 1950.
Ink and charcoal on paper,
25.5 x 28 cm.
Private collection, New York.

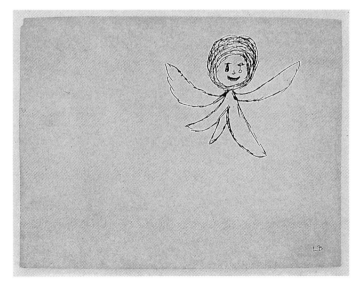

Untitled, 1945.
Ink on paper,
22.8 x 30.4 cm.
M. Palladino Collection.

Early Paintings

Bourgeois's first known painting is entitled *Réparation*, and it dates from 1938 to 1940, that is to say when she first arrived in the United States. It shows a little girl (Louise) bringing a flower to a temple-style grave (that of her grandparents in Clamart), with a ghostly pink shape in the center and a funerary urn below. In the background are ornately pruned boxwood bushes from her grandmother's garden in Montchauvet. The title, like the scene, alludes to Louise's feeling of gratitude toward her forebears. (She had left deceased ancestors like her grandparents behind in France.) All her work would henceforth represent a wish to make reparations, an appeal for love and forgiveness. "My mother would sit out in the sun and repair a tapestry or petit point. She really loved it. This sense of reparation is very deep within me."[8]

Another theme that appears in the paintings is the "woman on the roof." In *La Chanson du toit* ("Roof Song," 1947), she can be seen free and happy, hair blowing in the wind, next to a chimney producing cloudlike smoke. (Bourgeois executed her first sculptures on the roof of her house, which explains the numerous images of a woman entering or leaving a chimney, and the depiction of a band saw in one of them.) It would seem that Bourgeois identified with the house to such an extent that she associated its roof with her own head, that is to say, the classic realm of imagination, creativity, and freedom.

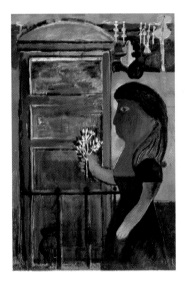

Réparation, 1938–40
Oil on canvas,
76.2 x 50.8 cm.
Private collection.

Untitled, *c*. 1946–7.
Oil on canvas,
66 x 112 cm.
Ginny Williams Family
Foundation, Denver.

Femmes-Maisons

The *Femmes-maisons* ("House–Women") are perhaps emblematic of Louise Bourgeois's entire œuvre. The combination of geometric and organic forms, of rigidity and malleability, of architecture and viscera, serves as a metaphor for her own psychic makeup. By visually and graphically uniting the two heterogeneous dimensions of woman and house, Bourgeois managed to overcome the dichotomy of mind and body, reason and emotion, analytic spirit and sensuality. "The house," according to Bachelard, "is body and soul. It is the human being's first world," the first universe. It is therefore a symbol of maternal refuge, of the protective warmth of childhood, of memory. "A house," continued Bachelard, "is imagined as a vertical being. It rises upward. Verticality is ensured by the polarity of cellar and attic."[9] The irrationality of the cellar could be juxtaposed to the rationality of the roof, darkness juxtaposed to light, dampness to air. An early house of 1942 shows a cage on rollers inside a tall booth (an allusion to the rolling racks of clothes that she saw in New York's garment district); significantly, the flowering head (of a person, despite its mechanical appearance) seems to want to leave by a hole in the ceiling. A sketch from 1947, meanwhile, combines several key motifs from her œuvre on a single sheet—spider, hanging legs, femme-maison in gestation. Bourgeois even drew a kneeling house–woman–animal with tree-shaped muzzle and tail (p. 24). This type of compartmentalized notation illustrates how she visually juxtaposed forms and motifs until she established a theme that could subsequently be developed. The overlap of architectural and vegetal elements sometimes took the form of transparent homes like greenhouses full of potted trees. Putting an accumulation of objects on display was a tactic that reappeared in later sculpture when she stacked glasses and bottles on shelves (*Le Défi*, "The challenge", 1991). The house also represented a box or container for Bourgeois. Another drawing sets a narrow house with spiral staircase opposite a post-like figure bedecked with triangular points, crowned by a round head which is ringed with bristles. The confrontation of these two elements (male and female, aggressive and defensive, exterior and interior) prefigures the entire development of her future œuvre; the duality between two figures already recurs in one of the engravings for *He Disappeared into Complete Silence* (1947).

The large femmes-maisons of 1946 to 1947, both painted and drawn, are most eloquent from this standpoint. In one, the entire bust is represented by a brick house, while legs and lower belly are depicted according to "naturalistic" criteria (p. 27). A central staircase leads to the vertical slit that serves as door. Above, three arms rise toward the sky in a cry for help: "It's a tragic house, because it's not light, you don't know what's happening, the door is very dark. And then, this woman, look at her legs, this woman is unaware of herself. She's obviously somebody very erotic, who doesn't know she's

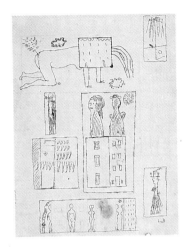

Untitled, 1947.
Charcoal and ink on paper,
28 x 24 cm.
Kröller-Müller Rijksmuseum,
Otterlo.

erotic. She's having a hard time. She says, 'Come get me, save me from eroticism.' That's my interpretation of it."[10] Although this interpretation is recent, it corresponds well to the pose and gestures of the femme-maison, and proves that eroticism is indeed the hidden key to the entire œuvre, even if Bourgeois sometimes offers different analyses. Another woman, nude and depicted frontally from the knees up, has a flower-like pubis and a house with columns for a head (p. 26). "It is a southern house, a court house, that is to say a place where people have disputes." Wings or hair rise from the roof. "These wings say, 'Try to come to our aid, try to bring peace to the court house.'"[11] This is yet another autobiographical interpretation, a childhood memory of the house where her parents were in dispute. The head of a third woman is a white wooden house with burning roof; she converses with a flower-woman recognizable only by her legs. "The woman is unaware of herself, since she is completely nude and doesn't know it."[12] The idea of guilt is ever present, even in apparently innocent images. The final femme-maison, a drawing, shows the house in the Paris suburb of Antony, with the Bièvre River running through the cellar. "The little hand in the air seems to be saying, 'Come to my aid. Something is hurting me, I'm suffering from this situation. Don't forget me, come get me, because I'm sick, I'm homesick.' She left for a country where she needs to reconstitute, to collect, to clutch an empty house she once knew."[13] Here the corporal and architectural elements are intertwined to such an extent that the semicircles of the breasts function as openings in the façade, the rib cage being marked by the steps of the staircase and four doors. One arm rises from the attic on the left, while the other hangs from the cellar on the right. The basement and foundations of the house overhang the void, suggesting a feeling of imbalance, instability and dissymmetry also present in many works, betraying the profound fragility of the character. It all looks as though everything might—must—collapse. Line drawing facilitates this fusion of genres, this shift from one register to another with no break or separation. Another *Femme-maison* (p. 25), drawn in a more schematic way, is composed of four stacked cubes, with two legs and an arm. The most lively and organic element is the vast, enveloping head of hair. All the possibilities of drawing are present here, enabling Bourgeois to go from the mechanical to the vegetal, from solid geometric volumes to flowing, curving lines.

These paintings and drawings of femmes-maisons in fact spring from autobiographical memories (the four houses were real: Choisy-le-Roi, New York's narrow residence, the southern house, and Connecticut). They are organic and architectural incarnations of emotions experienced by Bourgeois. Some people have interpreted these images as an allusion to the demands of domestic and family life made on an artist who found herself with three children to raise. But despite the real burden that family life meant for Bourgeois, it was more a question of concretizing a psychic state, an inner model rather than a feminist metaphor. This theme, so present in her work, goes back to the source of all her recollections—the family house of her childhood. As Bachelard

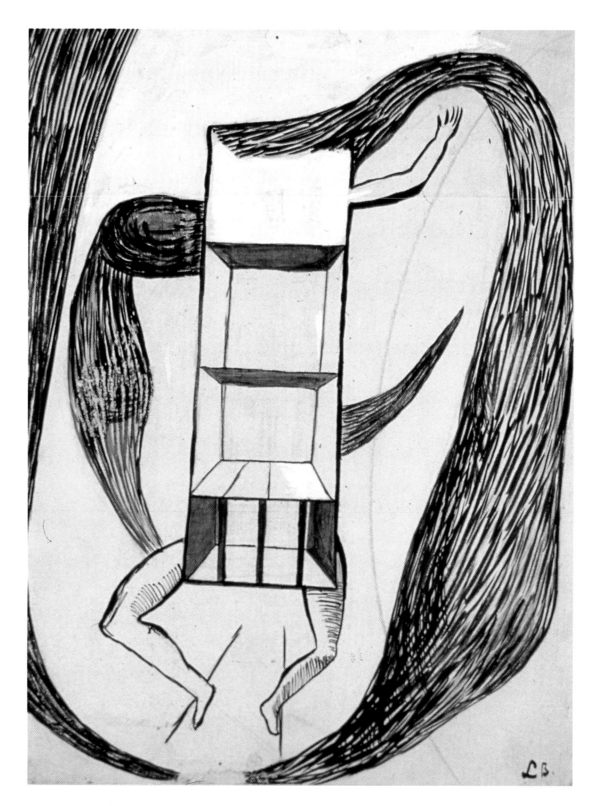

Femme-maison, 1947.
Ink and gouache on paper,
31.2 x 23.5 cm.
Fischer Collection, New York.

Page 26, left:
Femme-maison, 1946–7.
Oil and ink on canvas,
91.4 x 35.5 cm.
Private collection.

Page 26, right:
Femme-maison, 1946–7.
Oil and ink on canvas,
91.4 x 35.5 cm.
Private collection.

Page 27, left:
Femme-maison, 1946–7.
Oil and ink on canvas,
91.4 x 35.5 cm.
Private collection.

Page 27, right:
Femme-maison, 1946–7.
Ink on paper,
23.2 x 9.2 cm.
The Solomon R. Guggenheim
Museum, New York.

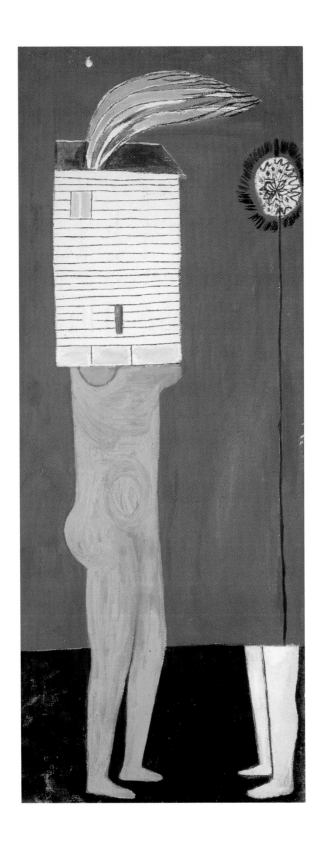

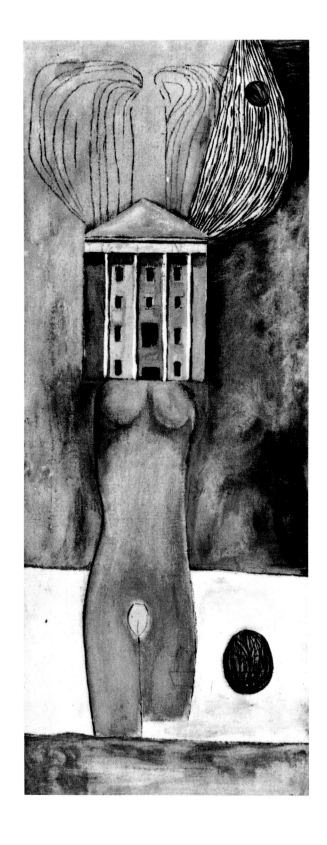

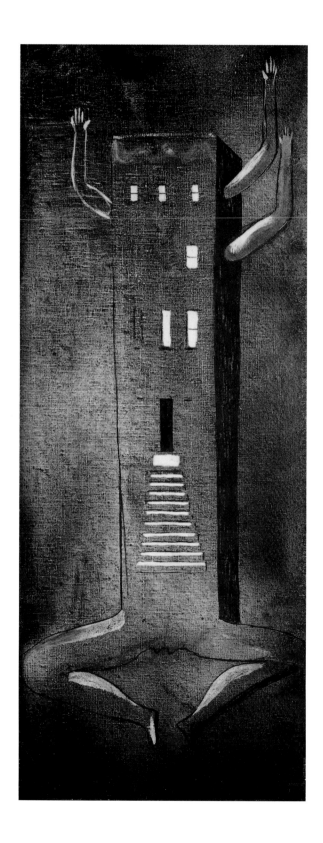

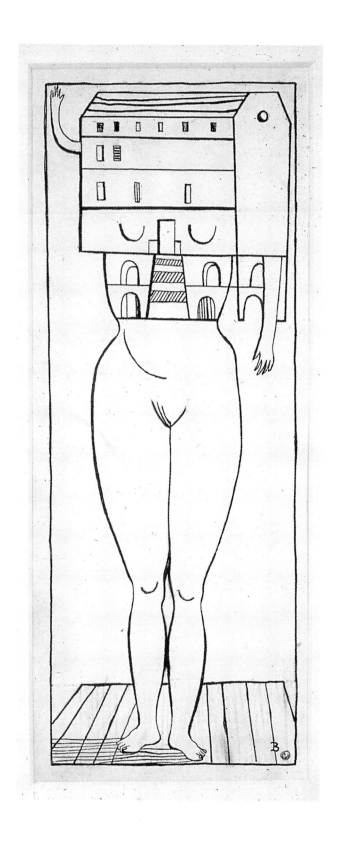

observed: "Over and beyond our memories, the house we were born in is physically inscribed in us . . . [it] has engraved within us the hierarchy of the various functions of inhabiting. . . . all the other houses are but variations on a fundamental theme."[14] Bourgeois would produce variations on this theme, in diverse forms, throughout her œuvre, ranging from the skyscrapers of 1947 to the round forms in the *Cells* of 1990 via the *Lairs* of the 1960s.

The Plant Kingdom

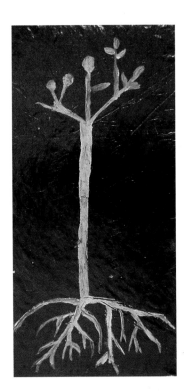

For a long time, one of Bourgeois's favorite activities was topiary work, the art of pruning and shaping trees. But instead of clipping or cutting off the tops, she would twist the fine tips and roll them into loops.[15] This highly personal method of gardening, of looking after plants, reveals her great interest in the plant kingdom, and in trees in particular. Trees were present in her paintings very early on. Subsequently, Bourgeois became interested in everything that might symbolize trees with tall branches reaching skyward and roots sinking downward. A body full of sap symbolizes vital force and *élan*, feet firmly planted on the ground yet hairy head in the clouds. Furthermore, the contrast between the hardness of the trunk and the softness of leaves is similar in nature to the opposition established in the femmes-maisons between stone and flesh, hard and soft, masculine and feminine. When a branch breaks, sap no longer flows; it is the being that is broken, separated from life-giving sustenance—the flowers with broken stems seen in the engravings that Bourgeois did for Arthur Miller's book, *Homely Life, A Girl* (1992) are a clear reference to the domestic tragedy of her childhood.

But her allusions to plant life usually stress the germinating, bulbous, budding nature of plants and flowers, that is to say everything entailing proliferation and sprouting. In the drawings that she entitled either *Eccentric Growth* or *Concentric Growth* (p. 29), Bourgeois produced dense patterns of small circles like alveoli moving inward to the center or outward to the edge, suggesting the patient, meticulous task of a bee building its hive.

Untitled, 1944.
Oil on paper, 25 x 14.5 cm.
Private collection,
New York.

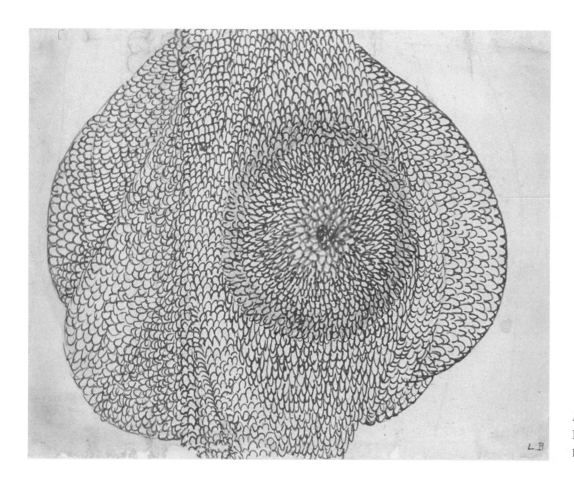

Eccentric Growth, c. 1965.
Ink on paper, 24 x 33 cm.
Private collection.

Skein Drawings

Taking the thread simile literally, Bourgeois developed a special line-drawing technique that is highly personal and easily recognizable yet allows for all sorts of formal and iconographic variations. The drawings evolve from a dense series of parallel lines that proliferate in a semi-automatic way. This repetitive, compulsive technique defines surfaces and volumes through systematic hatching. The suppleness of this approach, as pliable as plaster or latex, favors an infinite range of formal combinations—loops, knots, spirals, hangings. Fibrous structures may suggest the mineral, vegetable or animal kingdoms (hair and muscles).

The metaphors for hair find their most explicit expression in a drawing where long manes of hair and women intertwine, masking one another. Bourgeois herself had very long, beautiful hair, a sign of sensuality and magic power: "Hair is a symbol of

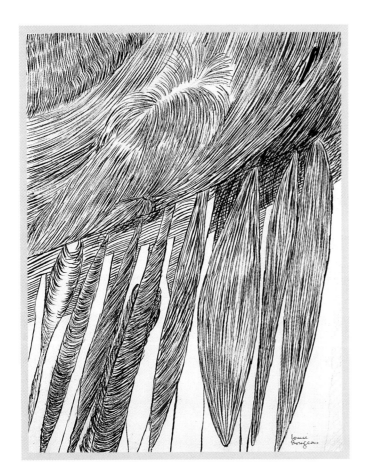

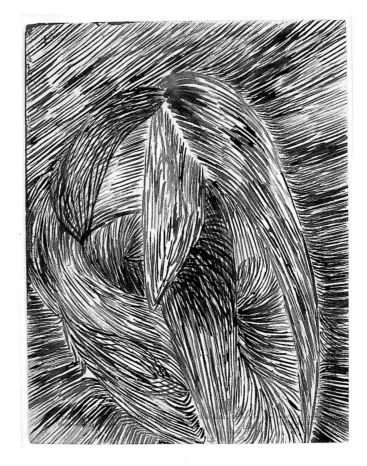

Untitled, 1949.
Ink on paper, 35.5 x 28 cm.
Catani Collection, New York.

Untitled, 1950.
Ink on paper, 35.5 x 30 cm.
John Eric Cheim Collection, New York.

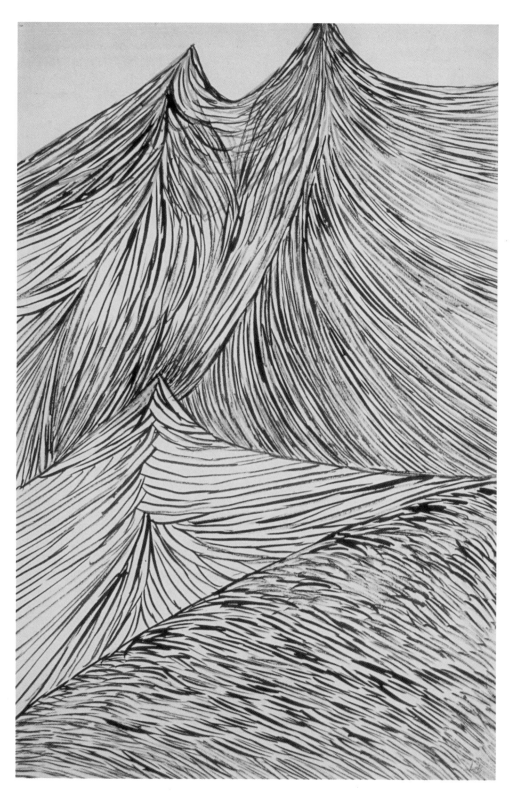

Untitled, 1950
Ink on paper,
50.8 x 33 cm.
Michael Williams,
courtesy of the
Ginny Williams
Collection.

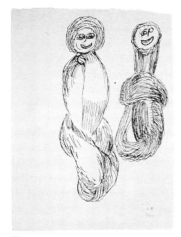

Top:
Skeins, 1943.
Ink on paper,
30.5 x 22.9 cm.
Private collection.

Right:
Untitled, c. 1953.
Ink on paper, 33 x 50.1 cm.
Private collection.

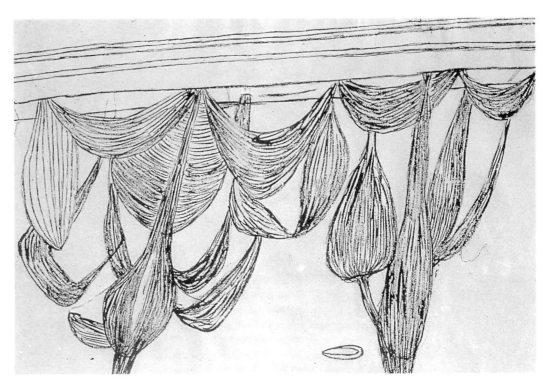

Above:
Untitled, 1949.
Ink and charcoal on paper,
28 x 21.5 cm.
Private collection.

power. It represents beauty. It's a gift you're born with."[16] The origin of the thread motif relates not only to her childhood memories (skeins of wool for tapestries, braided stalks of onions hanging in the attic, spinning thread), but also to the fundamentally organic nature of her work. The fact that they refer to both plant and animal kingdoms (e.g. trees and spiders' webs), permit these skein drawings to elaborate patterns on the model of yarn coming off the distaff. Half Penelope, half Sleeping Beauty, Louise the spinner is both witch and fairy, weaving her figures the way her mother once wove tapestries. The act of weaving (which Freud described as a specifically feminine invention[17]) provided Bourgeois with a special expressive idiom. "The skeins of wool are a friendly refuge, like a web or cocoon."[18] Bourgeois is able to follow up every "thread," weaving mountains, landscapes, rain, plants, spindles and distaffs out of ovoid, airy, aquatic forms. Such metamorphoses enable the artist to shift easily from one register to another, effacing differences and thereby uniting the diversity of the cosmos into an elastic, floating space free from the constraints of matter.

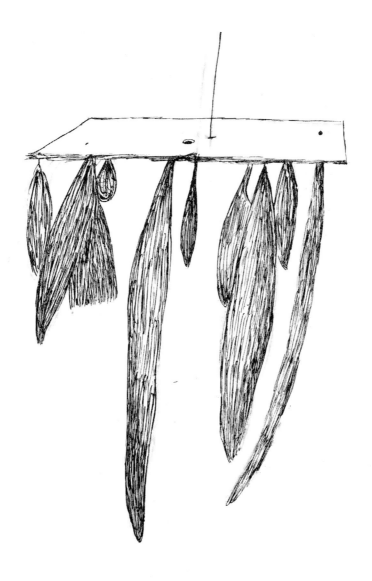

Untitled, 1947.
Ink on paper,
28.2 x 19 cm.
Private collection.

The Body

Louise Bourgeois's primordial interest in biomorphic, living shapes of every type explains why her sculpture and drawing favor the human body, especially in fragmented form—eyes, feet, hands, legs, pelvis, thorax, spine. She claims that this penchant for dismembering goes all the way back to the sight of washerwomen visually cut in half when they bent over to do their laundry in the Bièvre River. The image of a woman cut in half recurs in a 1990 engraving entitled *Dismemberment Anatomy*. In its crazy quest for unity, dismembering expresses nostalgia for a lost Wholeness; moreover, the extremities are the parts of the body of which people are most easily aware.

In the 1940s, Bourgeois drew bodies that were mechanical and geometrical almost to the point of abstraction. Yet despite formal simplicity and machine-like appearance, a bodily element could always be discerned, whether base, trunk or head. The figures thus generated seemed to entertain relationships among themselves, just as the later wooden totems would do. After the femmes-maisons, "whole" bodies were depicted only in a suffering, eroticized state, for example *Sainte Sébastienne* or the man with his back arched in hysteria (it is worth noting Bourgeois's deliberate inversion of roles, the saint being female and the hysteric, male). In 1987, she once again drew the martyred female saint (handled in a geometric fashion in 1947), producing a more ambiguous image of suffering combined with orgasmic bliss, insofar as the arrows planted in the curvaceous flesh do not seem to pierce it. The double face of cat and woman underscores the complicity between attacker and attacked, avenger and victim; such complicity is the hallmark of this disturbing character, depicted once again in a series of engravings in 1990.

The 1993 sculpture of a man with his back arched in hysteria echoes a 1991 series of drawings of "woman with child" (pp. 138–9). The ambivalence between masculine and feminine finds its most literal and most significant expression here. Once again, each drawing triggers several interpretations. The child arched between its mother's legs may, as the artist herself suggests, be an angry child throwing itself backward in defiance, yet it may also be a phallus, since it is known that a child is sometimes considered as a phallic substitute. An engraving from the same period shows a child with twisting, arched back, in front of a simultaneously masculine and feminine figure. A few small drawings in red ink clearly show the development of the tense arch of hysteria, a body ultimately hanging by a thread in a position suggesting both elevation and collapse.

Bourgeois's ever-present interest in the gaze is apparent in several drawings of eyes on latex, which should be related to the many sculptures of eyes in marble (*Eye*, 1981) and latex (*Le Regard*, "Gaze", 1966). The eye may be phallic or vaginal, convex or concave, like the orbital cavity itself. Eyes do not lie, according to Bourgeois; furthermore, they are the artist's main tool.

Sainte Sébastienne, 1987.
Ink, watercolor and pencil on paper, 63.2 x 48.3 cm.
Jerry Gorovoy Collection,
New York.

Sainte Sébastienne, 1947.
Watercolor and pencil
on paper, 28 x 18.5 cm.
Wendy Williams Collection,
New York.

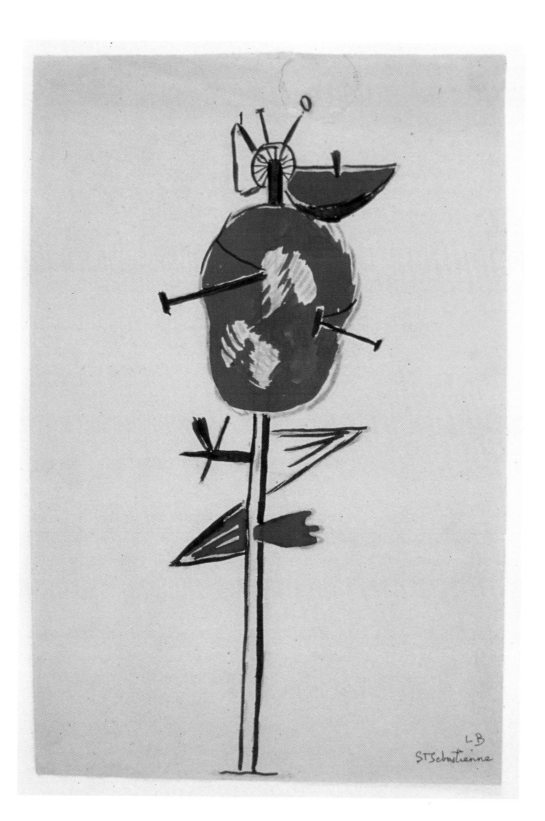

St Sebastienne

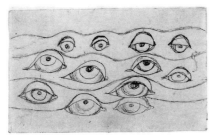

Eyes, 1974
Ballpoint on paper,
7.6 x 12.7 cm.
Galerie Lelong, Zurich.

Untitled, 1947.
Ink on paper,
29.3 x 18.4 cm.
Robert Miller Gallery, New York.

Facing page:
Untitled, 1986.
Pencil and watercolor
on paper, 60.6 x 48.2 cm.
Robert Miller Gallery, New York.

The drawing of little legs dangling from a line like green beans illustrates Bourgeois's ongoing interest in cutting the body into pieces than can be assembled and disassembled at will, like a shop dummy.

Her rare drawings of skeletons and bones are devoted either to the pelvic region or the spinal column, that is to say to the "foundations," to structural elements of the human body. In females the pelvis, as the site of childbearing, generally evokes the concept of life and death. But Bourgeois depicts a male pelvis, narrower and leggier. From a mechanical standpoint, the hips are the "base" of the body when walking, the platform between legs and torso. Bourgeois claims that a man can be recognized by his gait, which is dictated by the design of his pelvic region. Meanwhile, the thorax, for Bourgeois, is the site of breath, of life. She depicted it in a sculpture that is in fact a self-portrait (*Torso Self-Portrait*, 1963–4). In a later engraving (*Anatomie*, 1989), she added windows and doors to the spine, turning it into a house.

For the drawings produced in the 1980s, Bourgeois used all sorts of techniques with great freedom and an apparent indifference to the means of expression; every medium was mobilized to the benefit of meaning—red ink spreading like a blood stain (p. 15), latex, plastic materials, string, pastel, gouache. During the same period, she also undertook a series of drawings devoted to studio tools (echoing the sharp objects that she drew in the 1940s, such as Swiss army knives, spikes, blades, screwdrivers, and so forth). Pliers, scissors, and tongs were assembled on plates into industrial-like drawings, or sometimes they might encircle a small pair of scissors in a threatening way. Another drawing shows little scissors dangling between the legs of a larger pair: "It's me and my mother," explains Bourgeois, in this way recognizing her mother's crucial and symbolic power of castration.

But her mother also evokes needle and thread. Thread spun into cobwebs. Bourgeois's most recent drawings, all devoted to web-like activities, thereby represent a veritable ode to her mother.

Abstract Drawings

Any overview of Bourgeois's drawings must include a discussion of the other side of her art, the abstract side. Although most of her drawings are figurative, there are nevertheless certain large drawings composed of flat washes of color and geometric shapes—circles, semicircles, ovals, and triangles—which the artist seems to arrange in every possible combination. These drawings are generally related to sculptures, like *Partial Recall* (1979) or *Cumul* (1969), allegories of waves or hilltops, or profusions of protuberances, whether phallic or cloud-like (pp. 84 and 101). Bourgeois says she prefers her abstract

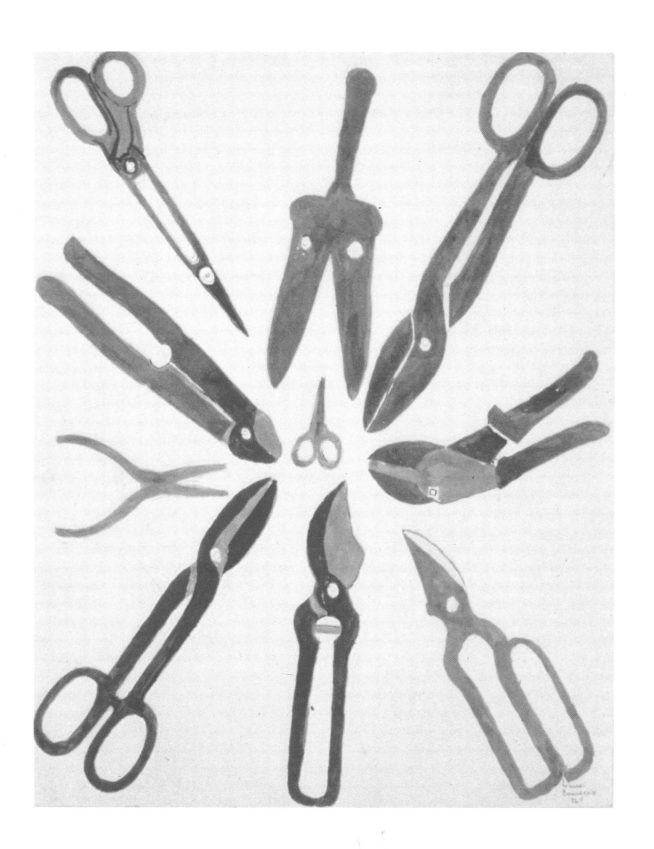

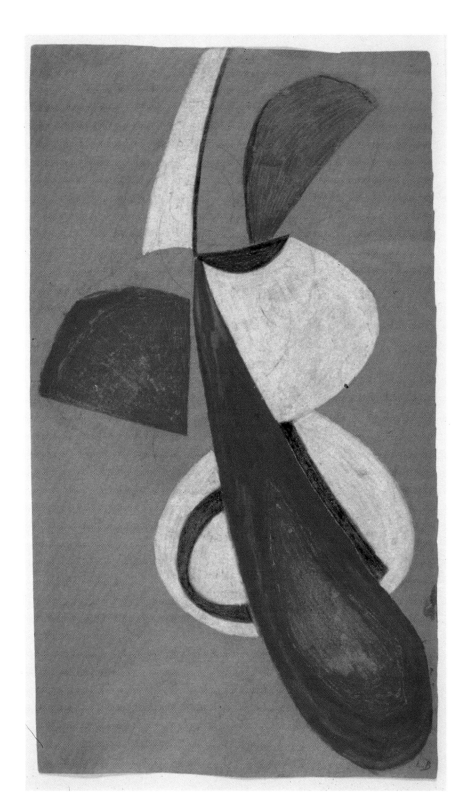

Untitled, c. 1965.
Watercolor, crayon and
pencil on paper,
38.7 x 22.2 cm.
Dittmer Collection,
Lake Forest.

drawings, probably because "geometry is a safe thing that can never go wrong, a guarantee. It offers a reliable world, a reliable system, and an unchanging frame of reference that will not betray you."[19] Her reliance on the rationality of geometry is a way of putting some order into the chaos of her emotions and the instability of human relationships. Yet however removed from representation, these drawings are always animated with a life of their own, thanks to composition, color, or certain incongruous details. They find themselves unwitting bearers of meanings that are not merely formal. It is almost as though, despite the tranquil pleasure that she takes in producing these drawings, Bourgeois could not prevent herself from breathing some of her own life into them.

Finally, certain works on paper could be included in the category "drawing" even though they apparently move beyond the category in two opposing directions, namely writing and action. Both writing and action are fundamental aspects of Bourgeois's creativity, poetry and exorcism; she automatically considers the written page a drawing insofar as it combines ideas and form.

There are two types of "writing–drawing": either entirely composed of words (like the hundred lines of *Je t'aime*, entitled *Le Désir*, that alludes to grade school punishment), or simple annotations that maintain an ambiguous relationship to an image (Bourgeois sometimes draws on paper previously used for writing, playing in certain instances on the transparency of the paper to let the writing show through). The overlap between writing and drawing, words and images, is crucial. Bourgeois occasionally draws in her diary, thereby shifting from one register to another. Because she is bilingual, and above all thanks to her sense of humor, she particularly enjoys puns and *double entendres*. She also feels the need to note down her thoughts and ideas in writing in order to make them more "real." Most of the writing–drawings are terms and declarations of love, sometimes in the form of a question—*Do you love me, yes or no?*—generally addressed to someone specific. Feelings are repeatedly, compulsively expressed, as they are in little notes written by adolescents. "The child, obsessed by obviously erotic dreams, begins to write them down, and it is the only thing she can write. It is someone who loves but is not loved, otherwise it wouldn't become an obsession. 'I love you' means tragedy and punishment. . . . It's the calamity of masochism."[20]

The "action–drawings" testify to violence perpetrated on the medium, such as cigarette burns that Bourgeois let spread, integrating the blackened edges of holes into the drawing; slashes done with a razor blade to draw white stripes in the "flesh" of cardboard or wood; paper inlays stitched with colored thread, or spirals embroidered directly on to the medium. All these actions function as types of exorcism, and in that respect relate more closely to her sculpture. Clearly, Bourgeois is a violent woman whose anger can lead to an outburst of throwing and breaking, as though breaking an object (usually

Untitled (Le Désir), 1987. Pencil and watercolor on paper, 29.8 x 41 cm. Robert Miller Gallery, New York.

Je t'aime Je t'aime Je t'aime Je t'aime Je t'aime Je t'aime Je t'aime Je t'aime Je t'aime Je t'aime
Je t'aime Je t'aime Je t'aime Je t'aime Je t'aime Je t'aime Je t'aime Je t'aime Je t'aime Je t'aime
Je t'aime Je t'aime Je t'aime Je t'aime Je t'aime Je t'aime Je t'aime Je t'aime Je t'aime Je t'aime
Je t'aime Je t'aime Je t'aime Je t'aime Je t'aime Je t'aime Je t'aime Je t'aime Je t'aime Je t'aime
Je t'aime Je t'aime Je t'aime Je t'aime Je t'aime Je t'aime Je t'aime Je t'aime Je t'aime Je t'aime
Je t'aime Je t'aime Je t'aime Je t'aime Je t'aime Je t'aime Je t'aime Je t'aime Je t'aime Je t'aime
Je t'aime Je t'aime Je t'aime Je t'aime Je t'aime Je t'aime Je t'aime Je t'aime Je t'aime Je t'aime
Je t'aime Je t'aime Je t'aime Je t'aime Je t'aime Je t'aime Je t'aime Je t'aime Je t'aime Je t'aime
Je t'aime Je t'aime Je t'aime Je t'aime Je t'aime Je t'aime Je t'aime Je t'aime Je t'aime Je t'aime
Je t'aime Je t'aime Je t'aime Je t'aime Je t'aime Je t'aime Je t'aime Je t'aime Je t'aime Je t'aime
Je t'aime Je t'aime Je t'aime Je t'aime Je t'aime Je t'aime Je t'aime Je t'aime Je t'aime Je t'aime
Je t'aime Je t'aime Je t'aime Je t'aime Je t'aime Je t'aime Je t'aime Je t'aime Je t'aime Je t'aime
Je t'aime Je t'aime Je t'aime Je t'aime Je t'aime Je t'aime Je t'aime Je t'aime Je t'aime Je t'aime
Je t'aime Je t'aime Je t'aime Je t'aime Je t'aime Je t'aime Je t'aime Je t'aime Je t'aime Je t'aime
Je t'aime Je t'aime Je t'aime Je t'aime Je t'aime Je t'aime Je t'aime Je t'aime Je t'aime Je t'aime
Je t'aime Je t'aime Je t'aime Je t'aime Je t'aime Je t'aime Je t'aime Je t'aime Je t'aime Je t'aime
Je t'aime Je t'aime Je t'aime Je t'aime Je t'aime Je t'aime Je t'aime Je t'aime Je t'aime Je t'aime
Je t'aime Je t'aime Je t'aime Je t'aime Je t'aime Je t'aime Je t'aime Je t'aime Je t'aime Je t'aime
Je t'aime Je t'aime Je t'aime Je t'aime Je t'aime Je t'aime Je t'aime Je t'aime Je t'aime Je t'aime
Je t'aime Je t'aime Je t'aime Je t'aime Je t'aime Je t'aime Je t'aime Je t'aime Je t'aime Je t'aime

3/19/77

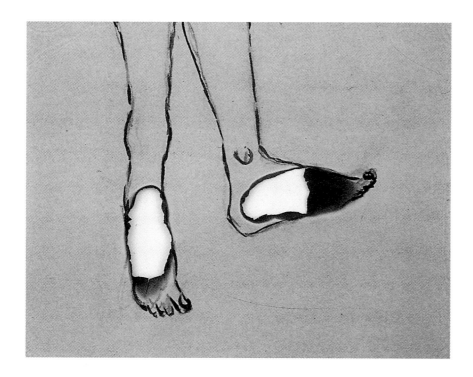

Untitled, 1991.
Ink and charcoal on burned
blue paper, 21.5 x 27.9 cm.
The Solomon R. Guggenheim
Museum, New York.

of glass!) were the only way to calm "broken" nerves. These drawings are not necessarily produced with aggressive intent, but they contain an emotional and physical charge resulting from the alterations they have undergone.

In her recent drawings of 1994 Bourgeois tends to incorporate the third dimension, whether through cut-outs that allow a colored background to appear, or puzzles applied to a thicker base. Pure and rational geometry is still present in a series of drawings of triangles set in a circle, on a round base of Japan paper. She calls these drawings "fixed points," alluding to the two points of a circle from which a multitude of triangles can be projected. The difference between the straightforward simplicity of the basic proposition and the infinite complexity of the consequences is a constant source of amazement to her.

Following the thread of Bourgeois's drawings in fact leads to numerous aspects of her creative approach. The drawings provide a *linking thread* to her personality that can be read between these very lines. "Events have to be knitted together like a sweater," she stated when referring to her memories.[21] Drawing's almost organic generation allows for all sorts of metamorphoses and transitions from one theme to another. Everything is interconnected, and develops as creative images emerge: "The tree in one painting becomes the figure in another. The hair of the figure becomes the line of the landscape. Rolling hills and trees become breasts and phalluses. Landscapes and breasts become

Facing page:
*Le Désir : vous me ferez
100 lignes - non 200 lignes*,
1977.
Felt-tip on graph paper,
21 x 32.5 cm.
Private collection.

spirals; the spirals become eyes. The objects change in materials and styles: objects become environments, environments become performances."[22]

Drawings are done with a sense of urgency, at any time of day or night, to exorcise her fears. As Robert Storr has noted, they thus combine "the physical aspect of the found object with the discursive surprises of automatism."[23] They maintain a close

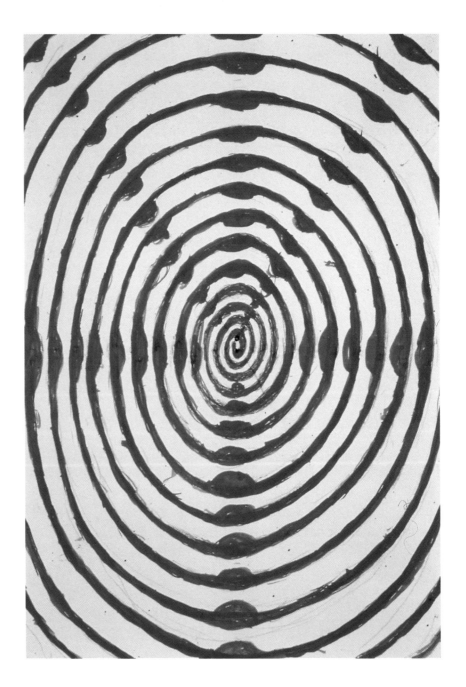

Spiral, 1994.
Watercolor, ink and colored
pencil on paper,
33.6 x 24.1 cm.
Robert Miller Gallery,
New York.

dialogue with her sculpture and especially her engravings. The imagery generated through these drawn and painted images provides the matrix for her œuvre, the site where ideas for sculpture germinate and gestate. Yet at the same time, drawing remains a specific activity. Whereas sculpture mobilizes space, drawing is linked to notions of time. In Bourgeois's words, sculpture represents her "own body," while drawings incarnate her memories and imaginative faculty.

Engravings

Bourgeois did a lot of engraving in the late 1940s and early 1950s. She has increasingly returned to it in recent years, spurred by market pressures linked to her success as much as by necessity or pleasure. Like drawings, engravings constitute a convenient means of expression, easy to produce at home (she owns a small press), lighter and quicker than sculpture. Even more than drawing, engraving invokes narrativity, especially since it often accompanies texts. Bourgeois nevertheless employs a highly demanding technique, burin engraving, that requires a strong and confident hand. But the more resistance a material offers, the more she puts it to the test. The first book she executed in the studio of S.W. Hayter, *He Disappeared into Complete Silence* (1947), includes nine plates illustrating short, enigmatic texts that are ironic and cruel, alluding to autobiographical incidents. A tale of unrequited love is followed by a recollection of France, the destruction of a house, an evocation of maternal love, and a marital dispute that degenerates into cannibalism (these recurrent themes can be found in various forms in her later sculpture). Complex feelings such as the fear of being abandoned, frustration, or "destruction of the father" are all depicted via geometric houses, with explicit references to New York buildings. "My skyscrapers are not really about New York. Skyscrapers reflect a human condition. They do not touch."[24] Although no organic element lends a human feel to these figures, their structure and interrelatedness suggest that they are human characters. (The same principle of verticality and geometry would recur in the early wood totem-sculptures.)

Plate I shows a solitary figure composed of a column topped by a house–head with a circle for a face. In Plate II, two houses side by side evoke a couple, while the three characters in Plate III constitute an allegory of the family. Plate IV shows a transparent house with strange antenna. Plate V entails a headless structure, illustrating the tale of a head cut off by the roof. The idea of ascent and elevation recurs in Plate VIII with the surprising presence of floating ladders knocking against the ceiling. The feeling of being shut in—of having no escape—is one of the constants of Bourgeois's art (recurring much later in the 1988 sculpture entitled *No Exit*). Plate VI once again shows a family trio, with the middle figure leaning on an angled leg that prevents it from falling over. Facing that

He Disappeared into
Complete Silence, 1947.
The Museum of
Modern Art, New York.

Plate 1

Once there was a girl and she
loved a man.

They had a date next to the
eighth street station of the sixth
avenue subway.

She had put on her good clothes
and a new hat. Somehow he could
not come. So the purpose of this
picture is to show how beautiful
she was. I really mean that she
was beautiful.

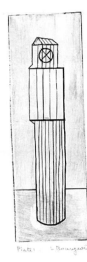

Plate 2

The solitary death of the Wool-
worth building.

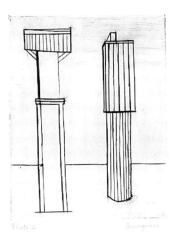

Plate 3

Once a man was telling a story,
it was a very good story too, and
it made him very happy, but he
told it so fast that nobody under-
stood it.

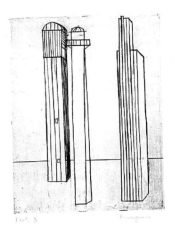

Plate 4

In the mountains of Central France forty years ago, sugar was a rare product.

Children got one piece of it at Christmas time.

A little girl that I knew when she was my mother used to be very fond and very jealous of it.

She made a hole in the ground and hid her sugar in, and she always forgot that the earth is damp.

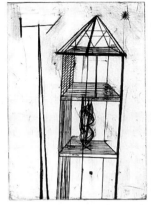

Plate 5

Once a man was waving to his friend from the elevator.

He was laughing so much that he stuck his head out and the ceiling cut it off.

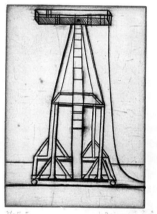

Plate 6

Leprosarium, Louisiana.

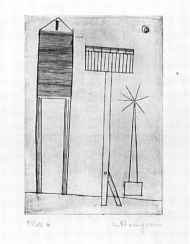

Plate 7

Once a man was angry at his wife, he cut her in small pieces, made a stew of her.

Then he telephoned to his friends and asked them for a cocktail-and-stew party.

Then all came and had a good time.

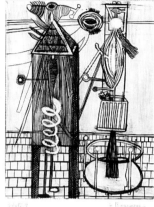

Plate 8

Once an American man who had been in the army for three years became sick in one ear.

His middle ear became almost hard.

Through the bone of the skull back of the said ear a passage was bored.

From then on he heard the voice of his friend twice, first in a high pitch and then in a low pitch.

Later on the middle ear grew completely hard and he became cut off from part of the world.

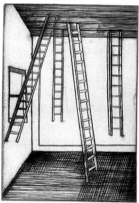

Plate 9

Once there was the mother of a son. She loved him with a complete devotion.

And she protected him because she knew how sad and wicked this world is.

He was of a quiet nature and rather intelligent but he was not interested in being loved or protected because he was interested in something else.

Consequently at an early age he slammed the door and never came back.

Later on she died but he did not know it.

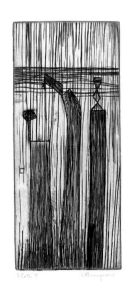

plate she wrote "Leprosarium, Louisana," referring to a lepers' sanatorium for afflicted people returning from Africa, near a house where she sometimes vacationed. But here leprosy is used by Bourgeois as a metaphor for solitude and blindness. Plate VII is the most organic and the most terrifying: the houses overflow with legs, guts, holes, hair and eyes. It is hard to identify man and woman because both figures have male and female attributes. Plate VIII accompanies a text about the deafness of a man cut off from the world. (The interest in hearing and ears surfaced again in *Cell IV* of 1991.) Plate IX employs the image of the family trio once again, but the houses seem to bend under the weight of their detached heads and of the rain blackening the scene, evoking mourning and separation. The flowing water alludes to flooding, to the three key rivers in her life: the Bièvre, the Creuse at Aubusson, and the Hudson. "It is the story of a very young person who hopes to find a soul mate," says Bourgeois. "The works from the 1940s represent a state of expectation and hope."[25]

"They are all tiny tragedies of human frustration," wrote Marius Bewley. "At the outset someone is happy in the anticipation of an event or in the possession of something pleasing. In the end, his own happiness is destroyed either when he seeks to communicate it, or, perversely, seeks to deny the necessity for communication. The protagonists are miserable because they can neither escape the isolation which has become a condition of their own identities, nor yet accept it as wholly natural."[26]

Isolation and difficulty in communicating are the source of Louise Bourgeois's work as sculptor.

NOTES

1. Quoted in Robert Storr, exhibition notes to "Louise Bourgeois, Works on Paper," (Amsterdam: Museum Overholland, 1988).

2. "'I don't know why you paint, Louise. Let me show you something.' So he took a shaving of wood and he hung it under his shelf and said: 'Look, the wood turns around like this. This is *sculpture* .' So I made some drawings of it. He said: 'Louise, you are not a painter, you are a sculptor. . . .' The passion for the third dimension and the idea of volume came from him. It was an idea which he was expressing himself in two dimensions. He was expressing the roundness." Douglas Maxwell, "Louise Bourgeois" in *Modern Painters,* vol. 6, no. 2, summer 1993, p. 41.

3. ". . . I was brought up with the idea that to be an artist is to be useful, because my parents worked very hard. They needed draughtsmen, beautiful draughtsmen, to repair the tapestry. But my father hated those pretentious people who want to be artists. He would say to me: 'Never talk to me about artists—they are parasites'. But when M. Gounod, the draughtsman, did not show up, they called on me. I would not say that I was as good as he was, but I wasn't bad. I was a useful person. I never asked to be paid." *Ibid.*, p. 41.

4. Interviews for the film *Louise Bourgeois* by Camille Guichard, (Paris, 1993).

5. *Ibid.*

6. Alain Kirili, "The Passion for Sculpture, a conversation with Louise Bourgeois," trans. Philip Barnard, *Arts Magazine,* vol. 63, no. 7, March 1989, p. 73.

7. Christiane Meyer-Thoss, *Louise Bourgeois, Designing for Free Fall*, (Zurich: Ammann Verlag, 1992), p. 177.

8. *Ibid.*, p. 187.

9. Gaston Bachelard, *The Poetics of Space,* trans. Maria Jolas, (Boston: Beacon Press, 1969), pp. 7 and 17.

10. Guichard, *Louise Bourgeois.*

11. *Ibid.*

12. *Ibid.*

13. *Ibid.*

14. Bachelard, pp. 14–15.

15. "These are little portraits of my friends. It is a very small place so the trees have to go up, otherwise the plants do not have enough sun and air. So everything is trimmed at the bottom, like in a forest. Instead of cutting the trees, I turn them into loops, and I make them into the figure '8', or I turn them into spirals." Paola Igliori, *Entrails, Head & Tails,* (New York: Rizzoli, 1992).

16. Meyer-Thoss, p. 178.

17. Sigmund Freud, "La Fémininité," in *Nouvelles Conférences sur la psychanalyse,* 1932.

18. Meyer-Thoss, p. 197.

19. *Ibid.*, p. 135.

20. Guichard, *Louise Bourgeois.*

21. Interview with the author.

22. Jerry Gorovoy, preface to exhibition catalogue, "The Iconography of Louise Bourgeois," (New York: Hutchinson Gallery, 1980).

23. Robert Storr, exhibition notes to "Louise Bourgeois, Works on Paper".

24. Meyer-Thoss, p. 178.

25. Guichard, *Louise Bourgeois.*

26. Marius Bewley, introduction to *He Disappeared into Complete Silence,* (New York, 1947).

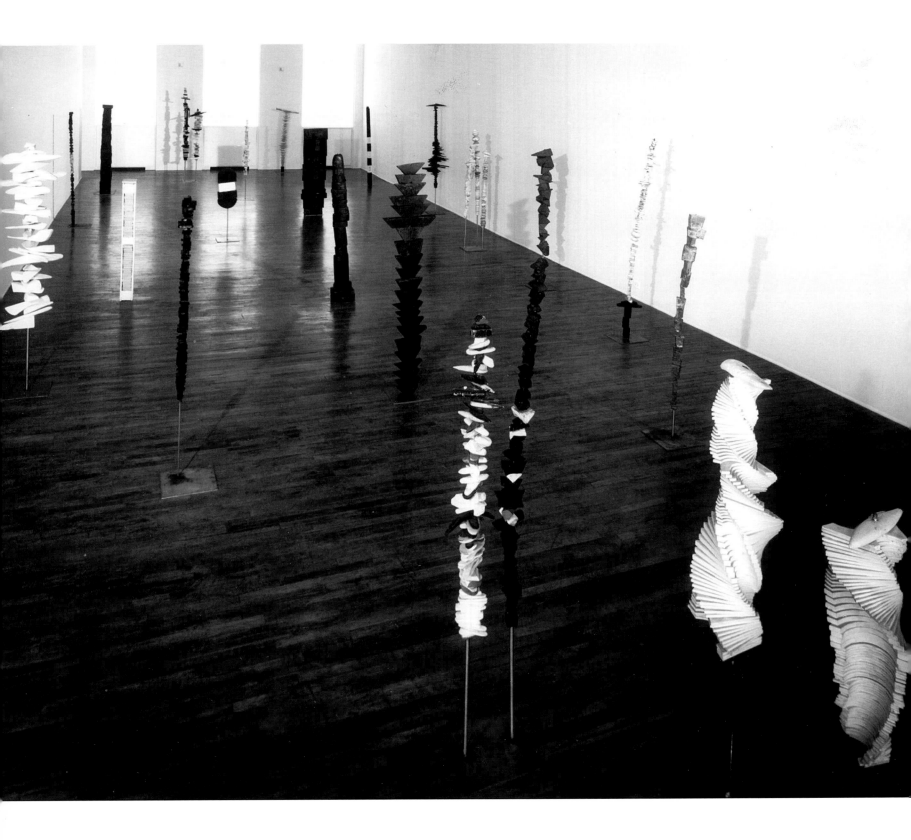

HOMESICKNESS

Despite youth and happiness, something was dead, which I had to resurrect. And what I wanted to resurrect was the right to be unhappy, the right to mourn France. It's not very complicated, but very intense. It's a phenomenally persistent but controlled chaos.[1] L.B.

Page 48:
Installation view Spoone-
Westwater Gallery, New York,
"Works from the Fifties",
18 April – 13 May 1989.
Robert Miller Gallery, New York.

What made Louise Bourgeois shift from painted, drawn and engraved images to sculpture, from two to three dimensions? The transition followed a *revelation* arising from everyday life. When, in the 1940s, she found herself alone at home "after breakfast," she would cut up milk cartons, fold them, and hang them together, as a way of warding off the solitude and distress she experienced at that time. Those first sculptures are still lovingly preserved in her studio. The form is basic—a prism that she later painted black—and the figures either stand alone or in clusters. "It is probably fetishism," she explained, "but all those triangles of that period, I just couldn't do without them."[2] The revelation concerning pure forms also had something to do with a form of control: "When the men had left, I experienced total chaos, by which I mean solitude, a terrible solitude. Then I realized that I could have some control over another form of expression, over another world. I could create these forms and then paint them black, expressing sadness. I could put them together, throw them on the ground, destroy them. This feeling of power enabled me to control my homesickness. Sculpture was revealed to me as means of expression thanks to a milk carton, thanks to the simple triangular shape of something useful and indispensable. Which meant that something could be expressed."[3]

Right from the start, then, sculpting meant exorcism. Bourgeois thereby managed to transfer a feeling of pain and impotence on to a material thing, giving shape to her *Angst* in order to control it, to shift it from her own body onto another body. For the first time, she was *sculpting* her *emotions* by shifting the pain on to an apparently neutral object. The choice of material was not irrelevant, for it incorporated all the possibilities of the sculptures to come, symbolizing the essence of her œuvre. Milk is obviously a nourishing substance, an organic liquid, the symbol of the maternal breast. The carton is something familiar, a domestic "found object" that can be easily worked and transformed. The triangular shape evokes the "trinitarian" nature of her work, suggesting the tension and conflict between three poles (father–mother–child, or couple–mistress, or three aspects of the same person). Triangles can be reformulated as a hexagon or even a circle ("the limit of the hexagon is the circumference of a circle"[4]). Bourgeois employed geometry's infinite and reliable variations as an instrument of power, a "guarantee" against the disorder and uncertainty of human feelings. Finally, the verticality of these clustered elements prefigure the work done in wood, her first publicly exhibited sculpture. The engravings of 1947, with their geometric and symbolic forms, similarly pointed toward the characters carved from wooden posts on the roof of her house.

Mortise, 1950.
Painted wood,
152.4 x 45.7 x 38.1 cm.
National Gallery of Art,
Washington.

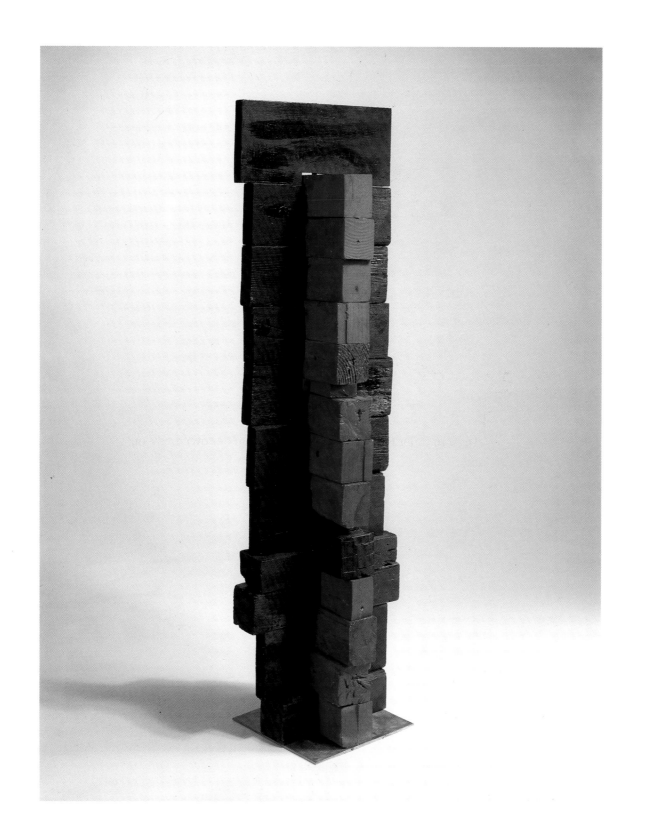

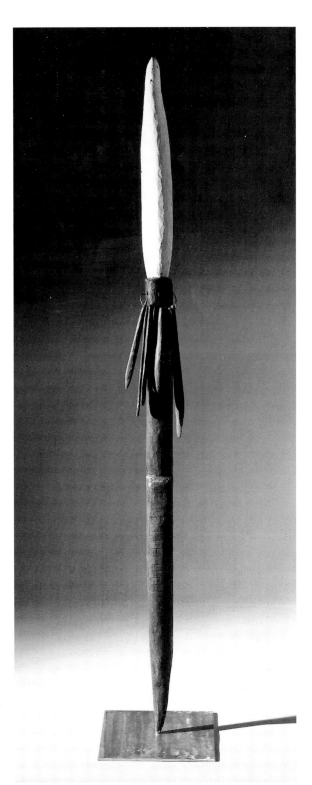

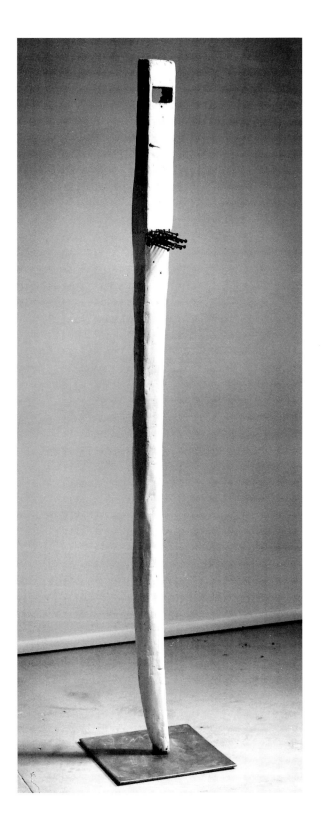

Right:
Persistent Antagonism,
1946–8.
Painted wood,
173 x 6.15 cm.
Private collection.

Far right:
Portrait of C.Y., 1947–9.
Painted wood
and nails, h. 169.5 cm.
Robert Miller Gallery,
New York.

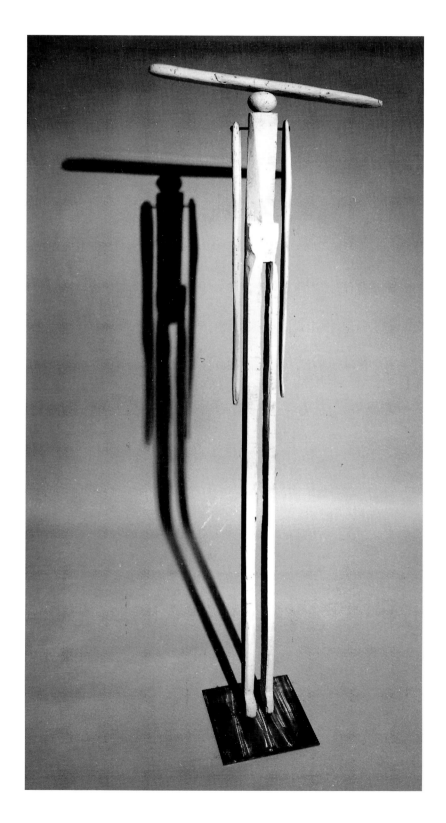

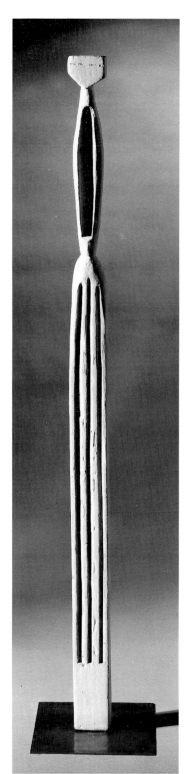

Far left:
Observer, 1947–9.
Painted wood, h. 195 cm.
Private collection.

Left:
Pillar, 1949–50.
Painted wood, h. 162.5 cm.
Private collection.

Characters

"As soon as I arrived in the United States," recalls Bourgeois, "I began to suffer from homesickness. But it was a subterranean, unconscious land that I longed for. So without knowing why, I began to re-create presences. I was on the roof of the Stanford White house near Gramercy Park, because no one went on to the roof since it was dangerous. So I adopted that outdoor site and I re-created all the people I had left behind in France. They were huddled one against the other, and they represented all the people that I couldn't admit I missed. I'd never have admitted it, but the fact is, I missed them desperately."[5]

The first exhibition of her sculpture was held in the Peridot Gallery in 1949, thanks to the help of Arthur Drexler (art connoisseur, architect and curator of architecture at the Museum of Modern Art), who convinced gallery director Louis Pollock to exhibit the strange sculptures which had also been seen by Matisse and Duchamp. "In 1949, I was eager to show that I could speak English," Bourgeois has commented jokingly, "so the titles are in English."[6] *Woman in the Shape of a Shuttle*: ". . . My mother's family were tapestry merchants, the shuttle was the tool of my grandfather's milieu." *Friendly Evidence*: "That means someone who will testify on your behalf, who is a friend." *New York City Pillars*: "The pillars refer to the pillars on the gate of the château de Sceaux." *Attentive Figures, Pillars, Rear Facade, The Tomb of a Young Person*: ". . . expresses fear, a kind of protective exorcism for the health of my children." *Persistent Antagonism*: "Antagonisms because I was isolated from my entire family, and suffered from it."*Woman Carrying Packages*: "A woman who carries packages is responsible for what she carries and they are very fragile. Yes, it is the fear of not being a good mother." *Portrait of C.Y.* (Catherine Yarrow, a socialite interested in artists): "That was a terrific fight I had with [an English lady]. Well, I had a lot of terrible fights, this was nothing new. But this one I exorcised, I got rid of by making a statue, putting a name on this statue." (The sculpture has nails stuck into the chest, like African fetish dolls.) *Captain's Walk on the Irving Place building*: "That's a reference to the house in which we were living on 18th Street." *Dagger Child* is composed of four flat, oblong shapes stuck together by a small knife—a mother and her three children. "[It's] the child who is in the position to hurt you. He has the power to hurt the mother. The knife is like a little toy." *Blind Vigils* "is like *The Blind Leading the Blind*. Blindness comes from the [shame] I experienced [when next to] the people around me. As I say, my father was promiscuous. I had to be blind to the mistress who lived with us. I had to be blind to the pain of my mother. I had to be blind to the fact I was a little bit sadistic with my brother. I was blind to the fact that my sister slept with the man across the street. I had an absolute revulsion of everybody—everything and everybody. Mostly for erotic reasons, sexual reasons."

The Blind Leading the Blind, 1947–9. Painted wood, 170 x 164.2 x 41.5 cm. Becon Collection Ltd.

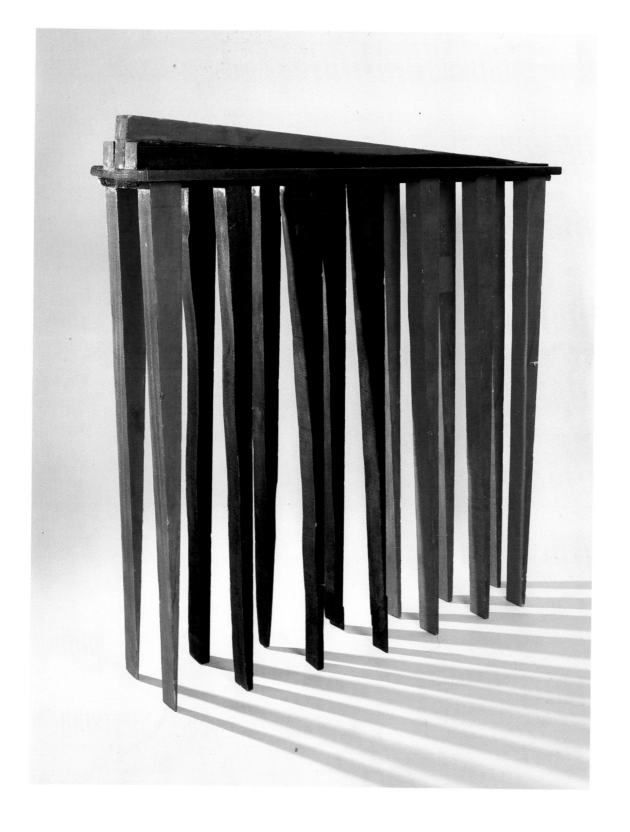

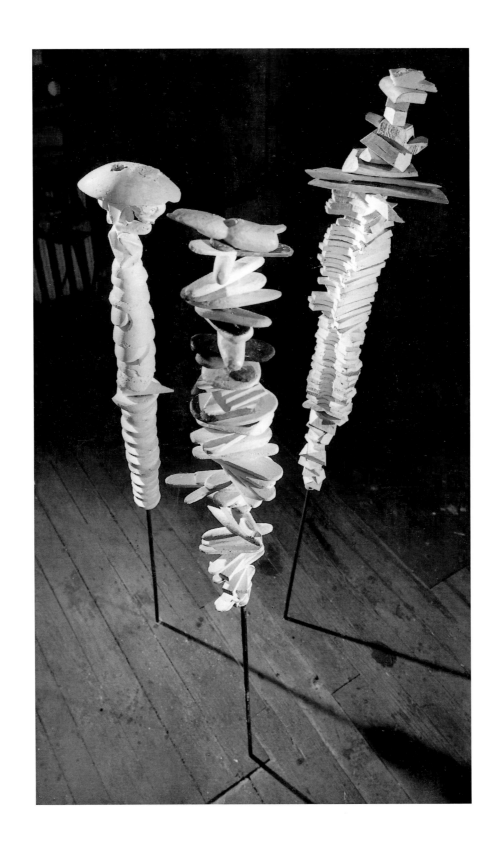

Bourgeois has thus made an explicit connection between blindness and forbidden desire, literally living out the Oedipus complex in her own way. The monumental sculpture from that period, *The Blind Leading the Blind*, is yet another allusion to sightlessness. "Since they can't see, they hang on to one another."[7] Bourgeois has related this work to a childhood photograph showing herself like a latter-day Antigone, leading her father who is leaning on his cane. Above all, however, this image harks back to the statue of Œdipus and Antigone that she used to see regularly at her high school, Lycée Fénelon. But Bourgeois sometimes offers another interpretation, linked to the fact that as a child she would hide under the dining-room table with her brother; from that vantage point they watched the ballet of their parents' legs, which suddenly made her feel excluded from the adult world, and totally helpless. Bernard Marcadé has compared this theme to Bruegel's painting of *The Blind Leading the Blind*, but Bourgeois's vision is more positive. Her sightless characters hold each other by the shoulder, mutually supporting one another. "In Bruegel's painting, it's a pessimistic version, since they fall. Instead of having confidence in their own awareness, they place their confidence in somebody else. Obviously, that's fatal."[8] Her construction, composed of two parallel bars held up by eight pairs of "legs," is apparently the most abstract in her entire œuvre, yet nevertheless harbors the densest and most obscure meanings. Three versions exist, corresponding to changes in her moods—black, black and red, or pink. The pink version is entitled *C.O.Y.O.T.E.* after an association of activist prostitutes ("Come Off Your Old Tired Ethics"), thus alluding once more to sex and sin.

In the Peridot Gallery, Bourgeois also set up her *Spiral Figures* composed of found pieces of wood skewered on to a rod like a shish-kabab. Others, entitled *Femmes Volages* ["Fickle Women"], suggested the form of a spiral staircase. The dynamic shape of the spiral recurs throughout her œuvre. The spiral is not only "the exteriorization of a desire to wrench"[9] but also suggests, for Bourgeois, the torsion of tapestry weaving produced by tension in two opposing directions. She sees the upward spiral as stemming from the opposition of contraries, symbolizing the circular (and therefore necessarily dialectical) oscillations of life's emotions. "They oscillate and return, obeying geometric curves. Emotions are not repetitive, but circular on one plane and dynamic on another plane. That's why the spiral always crops up."[10] The figure thus seems prey to conflicting movements—it literally loses its head, no longer knowing where it is, spinning like a top. That, obviously, leads to the title of "fickle women," prefiguring in that respect the hanging *Spiral Woman* of 1984.

All of these wood figures had pointed ends that were supposed to be stuck into the floor like totem poles. But the gallery director objected, and Louise was obliged to make a base for them. Certain figures had to be attached to the wall, however, since bases were unsuitable. That was the case with the *Portrait of Jean-Louis*, her son, which looks like a wooden knife with forked handle, and has a phallic upper part pierced with little

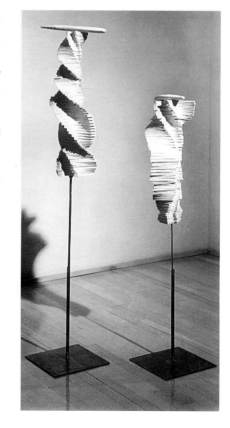

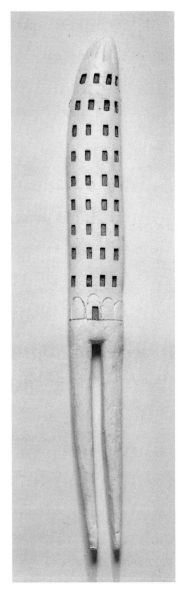

Portrait of Jean-Louis,
1947–9.
Painted wood, h. 90 cm.
Private collection.

windows that evoke a house. Photographs of the artist's studio, however, show it lying on the floor next to another figure. Bourgeois reportedly carried this fetishistic object with her everywhere, thus compensating for the absence of the child. She has said that the pointed base represents fragility, difficulty in standing, the unsteadiness that awaits us all. Thanks to these constraints, she began to weigh the problem of bases for her sculptures; henceforth she would make them herself, integrating them into the very sculpture, as Brancusi had done.

The great novelty of these works resided not only in their monolithic shape, but also—and perhaps above all—in their spatial elaboration. Strictly speaking, they represent Bourgeois's first installation, since it was the total ensemble that constituted—and made—the work. The space separating individual pieces played a primordial role by expressing their interrelationships, actively participating in the sculpture. Sometimes the pieces stood singly, sometimes they were placed in close pairs, and sometimes they were even propped up against one another. Visitors could walk among them. Almost all of the sculptures were painted white, stressing their unity and giving them a virginal appearance. Above all, these upright poles affirmed their verticality. They were armless and headless (or had just a small square or round head suggested by a hollowed out window). Carved with a razor blade, they are made of soft redwood, an exotic wood used in the cask-shaped water-towers so typical of New York roof-tops. She would use redwood again forty years later for *Precious Liquids* (1992).

A second show was held in the same gallery in 1950. This time the titles were in French and, given the inclusion of architectural elements and the frequent reference to houses, they constituted something of a manifesto regarding her work: *Figure qui apporte du pain, Figure regardant une maison, Figures qui supportent un linteau, Figure qui s'appuie contre une porte, Figure qui entre dans une pièce, Statue pour une maison vide, Deux figures qui portent un object, Une femme gravit les marches d'un jardin, Figures qui attendent, Figures qui se parlent sans se voir, Figure endormie, Figure pour une niche, Figure quittant sa maison, Figure de plein vent, Figure emportant sa maison*, and so on [Figure Bringing Bread, Figure Gazing at a House, Figures Holding Up a Beam, Figure Leaning Against a Door, Figure Entering a Room, Statue for an Empty House, Two Figures Carrying an Object, A Woman Climbs Garden Steps, Figures Waiting, Figures Talking without Seeing, Sleeping Figure, Figure for a Niche, Figure Leaving the House, Figure Exposed to the Wind, Figure Carrying a House].

These sculptures and titles referred to childhood memories, resurfacing like so many snapshots. "All those titles indicate exactly what I mean. There's no mystery at all; there's great intensity and great emotion that appears in the constant repetition of the word 'figure,' expressing the fact that I had left my entire family in Europe. Homesickness was mixed with a feeling of abandonment. I felt like I had abandoned them."[11] These figures were indeed physical presences for Bourgeois, replacement human beings,

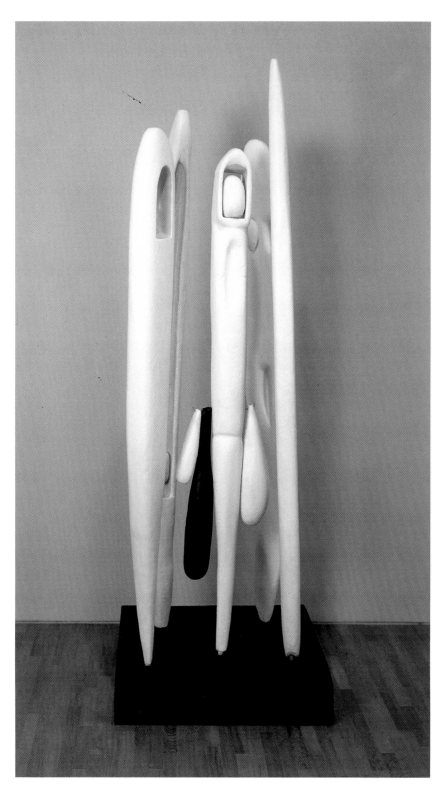

Quarantania, 1947–53.
Painted wood,
204.5 x 68.6 x 68.6 cm.
The Museum of Modern Art,
New York,
gift of Ruth Stephan Franklin, 1969.

Brother & Sister, 1945–6.
Wood, 175.3 x 36.2 x 27.8 cm.
Private collection.

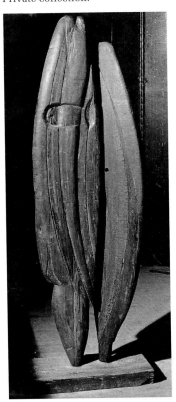

real characters. "Now, even though the shapes are abstract, they represent people. They are delicate as human relationships are delicate. They look at each other and they lean on each other."[12] Sculpture functioned as a tangible way of re-creating the past, that is to say controlling and manipulating it.

Those first two exhibitions met with success. Alfred Barr, director of the Museum of Modern Art, bought *Sleeping Figure* (1947) in 1951. The major difference between the first and second exhibition was marked not only by the change in language for the titles, but also by the shift from object to subject.

That period also yielded completely abstract sculptures like *Memling Dawn* (*c*. 1951), a square column of black wooden blocks stacked on one another, around a central axis. "Memling is a city on the river. It's the awakening to hope from the nightmare of drowning."[13] The triangular and cube-shaped pieces of wood comprising the composition were originally wedges used for water tanks on New York roof tops. In these sculptures, where assemblage is the basis of construction, Bourgeois tends to flaunt geometric imperfection. If there is the slightest error in calculation or clumsiness of execution, the balance fails and the construction no longer holds up.

This process of stacking, an intermediate stage between the monolithic rigidity of the *Figures* and the complexity of the *Femmes volages*, also prefigures the dialectic of whole versus parts, as developed in her work on the body in the 1960s. Bourgeois has also often contrasted pointed shapes with rounded shapes, as in the budding figure–totems with protruding belly and phallic heads, evoking fertility images: *Spring* (1949), *Breasted Woman* (1949–50), *Pregnant Woman* (1947–9). "There has been a similar gradual development from rigidity to pliability. When I was asked to give a fourth side to the flat back of a statue called *Spring*, which had been conceived as a stiff caryatid, I found it impossible to do: rigidity then seemed essential. Today it seems futile and has vanished."[14]

Brother & Sister (1945–6) and *Listening One* (1947–9) refer to couples; the characters share the same base or are even pressed up against each other. The same principle applies to *Quarantania* (1947–53), a sculpture elaborated around *Woman with Packages* by grouping other figures around it.

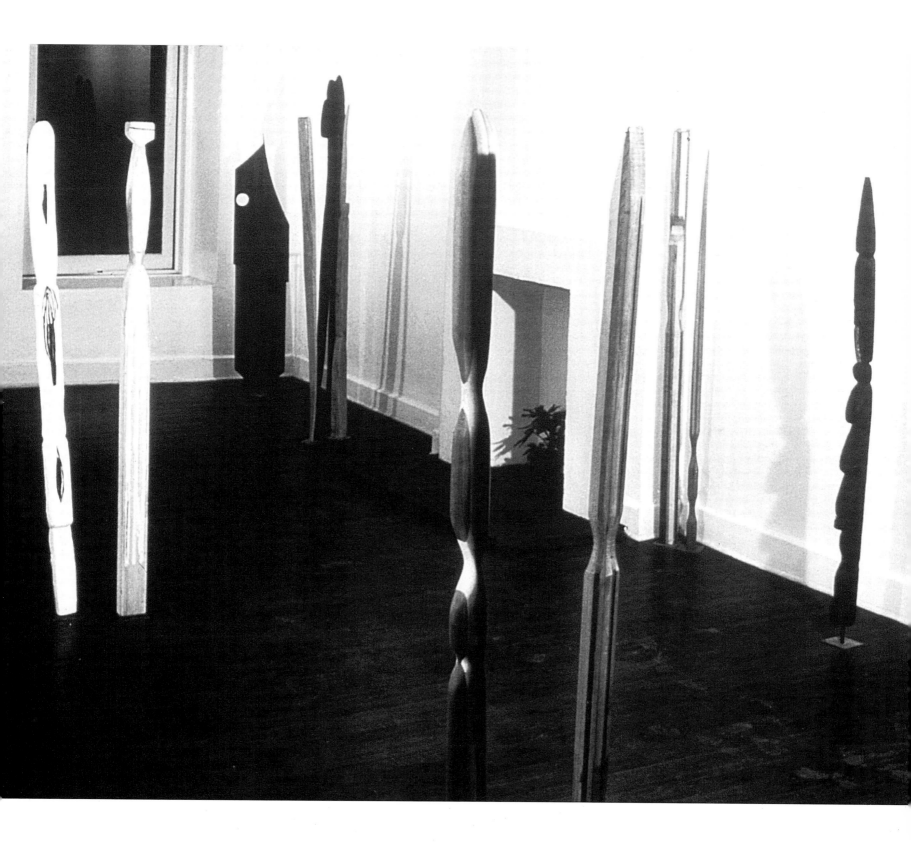

One and Others

The series came to a close with *One and Others* (1955), a sculpture that, despite being different from the others in size, color and composition, summed up that whole phase of work. The feeling of solitude was given a counterpoint here in the idea of group and gathering ("Being with friends to avoid being alone, friends mean a lot, and they are all different"[15]). "The relation of one person to his surroundings is a continuing preoccupation. It can be casual or close, simple or involved, subtle or blunt. It can be painful or pleasant. Most of all it can be real or imaginary. This is the soil from which all my work grows. The problems of realization—technical, and even formal and aesthetic—are secondary; they come afterwards and they can be solved."[16] In *One and Others,* the distance between figures has vanished. Their size is also reduced, for it is no longer a question of re-creating specific characters. The forms are all oblong (like distaffs), packed together, but painted in various colors to express variety within similarity. This sculpture marked a change in the way Bourgeois symbolized her solitude and neglect, that is to say the way she "mastered" them. Bourgeois no longer felt the need to refer to the real space of figures, she could henceforth operate in a more "abstract" space. "My work grows from the duel between the isolated individual and shared awareness of the group. At first I made single figures without any freedom at all. . . . Now I see my work as groups of objects relating to each other. But there is still the feeling with which I began—the drama of one among many."[17]

These characters represent a crucial contribution to the history of modern sculpture. Not only do the geometric buildings prefigure the minimalist sculpture of the 1960s, but Bourgeois also managed to reconcile the formal rigor and abstract simplification of Brancusi with the expressionism of Giacometti's strangely human figures. The influence of primitivism on many works from this period—of which she could hardly be unaware, since her husband, Robert Goldwater, was a specialist in the subject—does not operate on the formal level so much as on the level of the exorcizing function. These figures are truly *fetishes* because they represent other human beings.

Bourgeois has often stated that she is indifferent to materials, that she does not believe in their so-called truth, that for her they are merely tools, a simple means of expression and not an end in itself. "I avoid the grain and polish of the wood because their Romantic associations are disturbing."[18] The correlation between meaning, content and medium is nevertheless always significant in her case. The choice of wood as a light, fragile and rigid material that could be worked vertically was ideal for her inaugural series, but she soon tired of it. After having re-created all those characters, Bourgeois found herself comforted, reassured in her calling as a sculptor, and consequently less alone. Complaining of wood's excessive brittleness, she felt the need for a material both

stronger and more supple as well as more organic, to counteract the rigidity of wood. She chose plaster. "In the past, my work fought, sustained, and challenged; my new work, in which modeling and building up have replaced the hacking away, can roll and wear out, and settle down to a peaceful existence."[19]

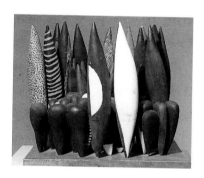

One and Others, 1955.
Painted wood,
46.1 x 20 x 16.8 cm.
Whitney Museum
of American Art, New York.

NOTES

1. Interview for the film *Louise Bourgeois* by Camille Guichard, (Paris, 1993).
2. *Ibid.*
3. *Ibid.*
4. *Ibid.*
5. *Ibid.*
6. The quotations in this paragraph are drawn from interviews for the Guichard film; Alain Kirili, "The Passion for Sculpture, a conversation with Louise Bourgeois," trans. Philip Barnard, *Arts Magazine,* vol. 63, no. 7, March 1989, p. 71; and Christiane Meyer-Thoss, *Louise Bourgeois, Designing for Free Fall,* (Zurich: Ammann Verlag, 1992), p. 180.
7. Guichard, *Louise Bourgeois.*
8. *Ibid.*
9. Jean Frémon, exhibition catalogue, *Louise Bourgeois,* (Paris: Maeght, 1985).
10. Guichard, *Louise Bourgeois.*
11. *Ibid.*
12. Meyer-Thoss, p. 179.
13. *Ibid.* p. 180.
14. *Ibid.* p. 181.
15. Guichard, *Louise Bourgeois.*
16. Meyer-Thoss, p. 179.
17. Deborah Wye, *Louise Bourgeois,* exhibition catalogue, (New York: Museum of Modern Art, 1982), p. 22.
18. Meyer-Thoss, p. 177.
19. *Ibid.*, p. 181.

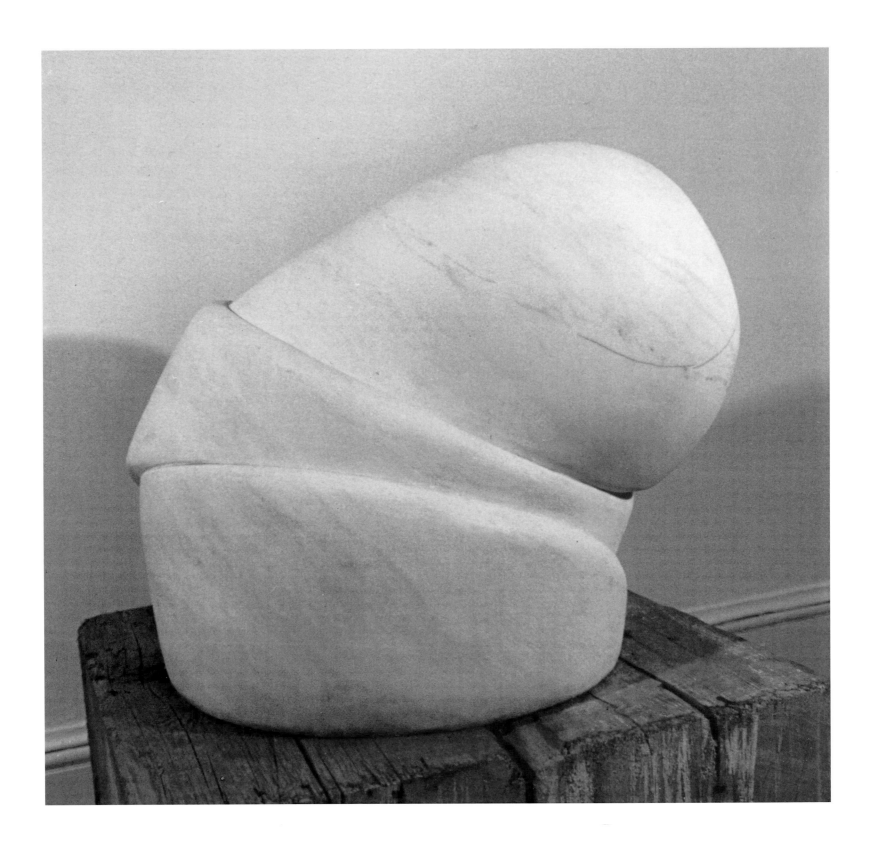

ORGANIC REFUGE

When you experience pain, you can withdraw and protect yourself. But the security of the lair can also be a trap.[1] L.B.

The Nest

A change that occurred in the early 1960s initially appeared radical. Louise Bourgeois adopted a new visual vocabulary diametrically opposed to the wooden figures of the 1950s, even though certain themes remained present. It would seem, in fact, that after having first tried to exorcise her homesickness by re-creating and transplanting characters from the past into her new environment, Bourgeois then felt the need to create a new home for herself, to take refuge in a nest, to build herself a shelter.

The shift from external space to internal space necessarily implied a change in materials and technique. Bourgeois abandoned wood (which she found too rigid and perishable, and which had to be carved or hollowed) for plaster and latex, liquid materials that were pliable, malleable and more suited to the organic content of her work. "I'm not interested in materials, they are just a means. Which doesn't mean I don't respect my materials—plaster, for instance, is a substance that gives a great deal to those who employ it. If you pour your plaster, the plaster will begin to play, settling down from liquid to solid; it has its own life, independent of the sculptor. Plaster and cement move, offer no resistance, allow for dialogue."[2] Hence her forms no longer emerged by subtraction, but rather by addition, starting from an inner core, moving from center to edge. The plaster sculptures of the early 1960s represented the opposite of the wood figures: suspension replaced erection, softness replaced hardness, liquid replaced solid, inner replaced outer. This return to fluid, organic forms served as counterpoint to the rigid, monolithic geometry of the vertical constructions. Bourgeois's art has always oscillated between two opposing poles, the emblematic figure of which is the femme-maison, that hybrid of architecture and flesh. But the central theme of the house would henceforth be conjugated in terms of nest or lair, that is to say a non-human dwelling appropriate to the primal or "wild" nature of her subsequent work.

The choice of nest was obviously not a random one. It was first of all a reference to the nests that, as a child, Louise found in her garden. But according to Bachelard, a nest also represents an "image of the simple house . . . the natural habitat of the function of inhabiting."[3] The shape of nest is dictated from the inside, since it is a house built by the body for the body. "'The instrument that prescribes a circular form for the nest is nothing else but the body of the bird. It is by constantly turning round and round and pressing back the walls on every side that it succeeds in forming the circle.' What an incredible inversion of images! Here we have the breast created by the embryo."[4] Everything is internal pressure, inner modeling. Furthermore, nests suggest not only safety but precariousness.

Page 64:
Sleep II, 1967.
Marble, 59.3 x 77 x 60.5 cm.
Robert Miller Gallery,
New York.

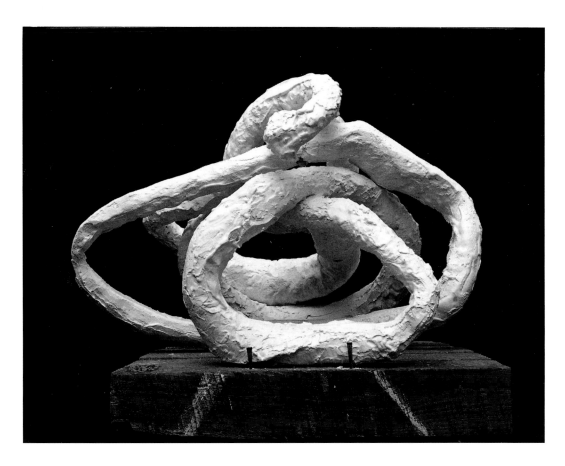

Spiral/Summer, 1960.
Plaster, approx. 35.5 x 53.3 cm.
Private collection.

The experimental nature of Bourgeois's early works in plaster—*Spiral/Summer* (1960), *Labyrinthine Tower* (*c*. 1962), *Lair* (1962)—prefigured the future direction of her sculpture. The spiral, a recurring theme throughout her œuvre, was here composed of coiled wire covered with plaster. "The spiral is an attempt at controlling the chaos. It has two directions. Where do you place yourself, at the periphery or at the vortex? Beginning at the outside is the fear of losing control; the winding-in is a tightening, a retreating, a compacting to the point of disappearance. Beginning at the center is affirmation, the move outward is a representation of giving, and giving up control; of trust, positive energy, of life itself."[5] The gut-like form of *Spiral/Summer* also suggests entrails, which recurred in other, more radical sculptures made of latex, yielding sausage-like shapes with highly scatological connotations (*Lair*, 1963). The wobbly *Tower* rises like a spiral staircase, prefiguring the phallic and implicitly sexual aspect of the works of the later 1960s. The 1962 *Lair*, one of the earliest, is a hollow, stepped pyramid, a sort of tower of Babel. Bourgeois's modeling technique, which involved direct contact with the hands, leaving the fleshy imprint of her body, led toward baroque pieces in which

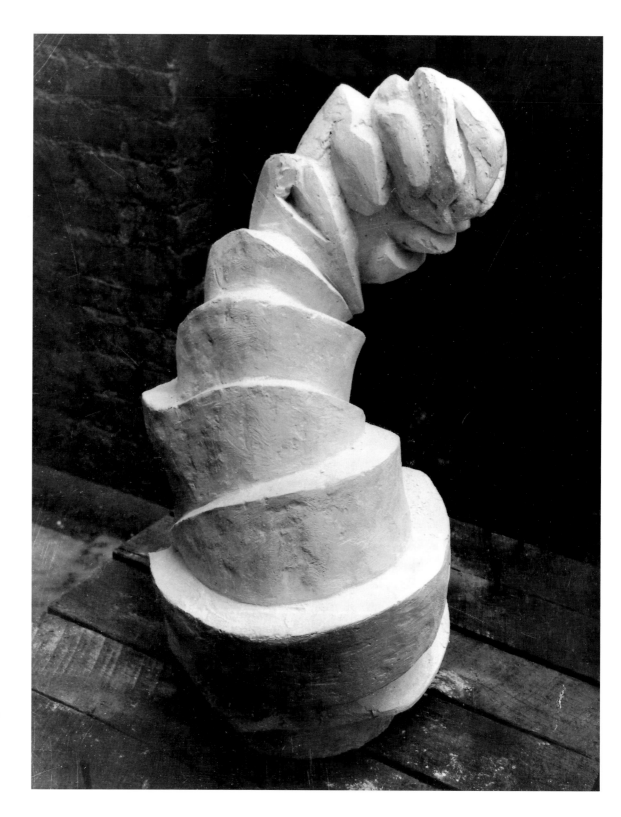

Labyrinthine Tower,
c. 1962.
Plaster, h. 45.7 cm.
Robert Miller Gallery,
New York.

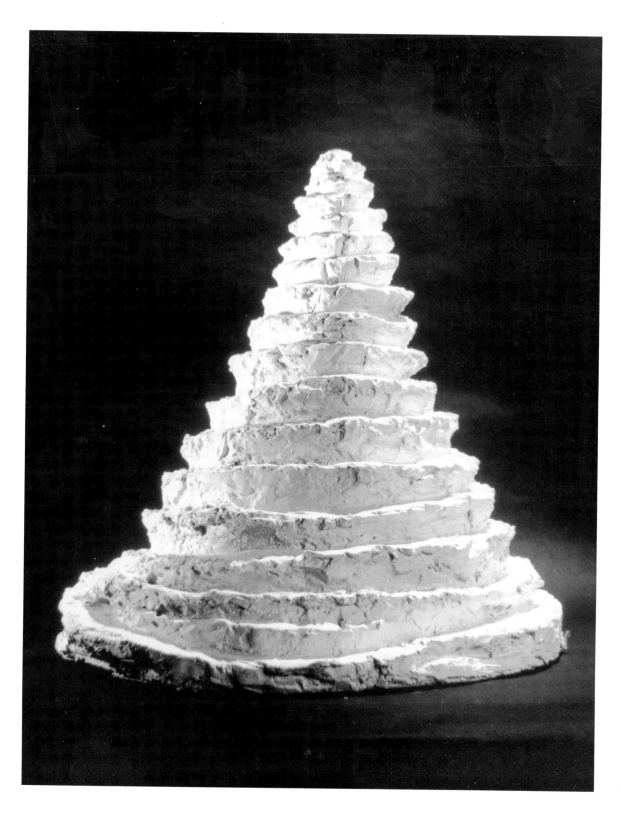

Lair, 1962.
Plaster, h. 55.9 cm.
Robert Miller Gallery,
New York.

Maison, 1961.
Plaster, 40.6 x 35.5 x 23.5 cm.
Robert Miller Gallery,
New York.

Page 71, left:
Fée couturière, c. 1963.
Plaster, 100.3 x 57.2 cm.
Robert Miller Gallery,
New York.

Page 71, right:
The Quartered One, c. 1964–5.
Plaster, 158 x 61 x 51 cm.
The Museum of Modern Art,
New York.

both the twisting, coiling, spiraling upward movement and the trace of her fingers are particularly apparent. Their titles are highly evocative: *Clutching* (1962), *Rondeau for L.* (1963), *Homage to Bernini* (1967). Alongside these basic forms that revealed the process of their own production, Louise built a small, geometric, realistic *Maison* ["House", 1961] that would find a later echo in *The Curved House* of 1983. The change in scale constituted a new element in her œuvre. Meanwhile, a coarsely modeled *Figure* (1960) with neither head nor arms was a precursor of the *Femme-couteau* and *Fragile Goddess* of 1970.

Two lairs from 1963 to 1964 take the form of a teardrop or a leather flask, wide at the bottom and narrow at top. They hang from a hook and can thus be attached to the ceiling or the branch of a tree. Holes reveal the interior to be a veritable labyrinth of corridors and caves forming a nest-like home. These "dwellings" are not unlike the *Demeures* produced by French sculptor Etienne-Martin, with a similar interpenetration of inner and outer spaces, a similar organic form designed to serve as habitat. The two artists share other traits, such as a magical dimension to their work, a free and solitary approach to creativity. Above all, they both use the structure of the childhood home as the primary source of their art.

"[A] lair is a protected place you can enter to take refuge. . . . A lair is not a trap. . . . The fear of being trapped has become the desire to trap the other. In that sense, I am the eternal hunter."[6] The shift from passive to active and the inversion of the function of lair from refuge to prison are typical of the paradoxical implications of Bourgeois's philosophy—a constant turning of tables. Two lairs illustrate the polarity between tenderness and violence. The title of the first, *Fée couturière* ["Tailor-bird"], reinforces the idea of nest. "The tailor-bird is a little bird. The title was French right from the start. It's a piece with holes, several floors, and is like a labyrinth. You can put your hand in it, and you don't know which is the entrance and which is the exit. It is a bird's nest hanging in a tree. There's a hook on top, and the piece can turn around. It was exhibited at the Rodin Museum (the garden of the Rodin Museum, by the way, is very hospitable, and a very pleasant place to show work)."[7] The "tailor-bird" of the title, furthermore, alludes to Louise's mother, whose needlework evoked the concept of sewing or tailoring, a notion that evolved into the web-spinning *Spider* series of 1994.

The other lair is entitled *The Quartered One*, alluding to a carcass hanging in a butcher's shop. It is a slab of meat to be drawn and quartered. This lair has several small square or rectangular openings in the front that suggest doors and windows. It also has two pockets on the sides. Such matrix-like forms, in which the interior is more important than the surface, could also become more twisted and complex, suggesting parts of the human body.

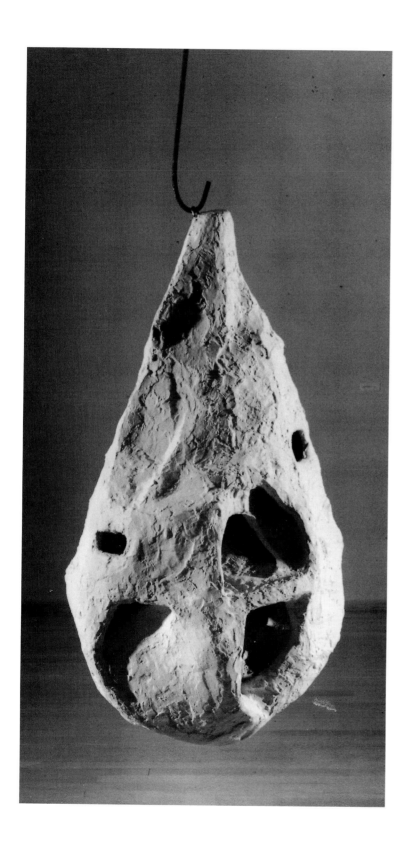
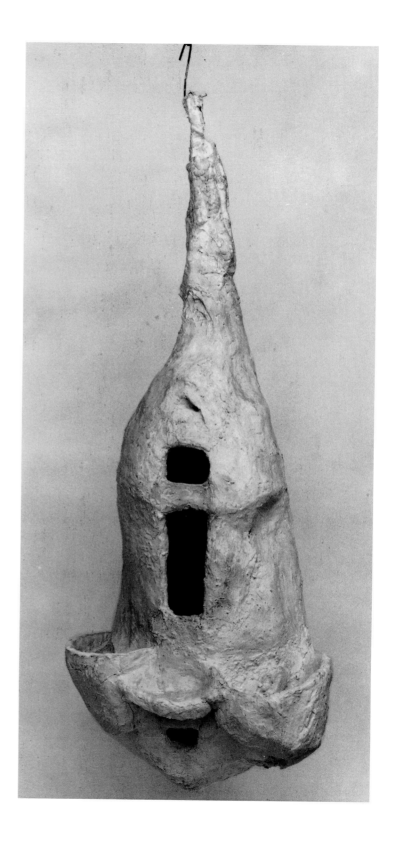

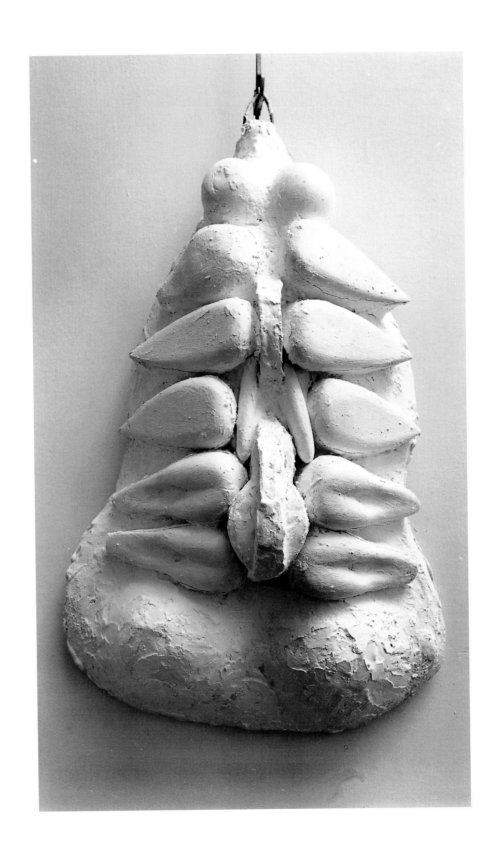

Pathological Anatomy

In *Inner Ear* (1962) Bourgeois explored the meanders of the cavernous inner ear with its network of fine membranes. The ear is a key organ for Bourgeois, because it serves as a receptacle for all sounds: "The ear enables us to perceive that a crystal vase is cracked or that mussels don't have any water in them," she says, "because the timbre rings hollow. . . . Now, when a vase rings hollow, don't press too hard, because it's cracked—a metaphor for the heart."[8] This voyage to the interior of the body has spawned quasi-anatomical sculptures that not only reveal her interest in medicine but also allow Bourgeois to express profound, intense, hard-to-depict sensations such as suffering, lovesickness, solitude and fear. "My body becomes material—and I express what I feel through it."[9] In *Torso/Self-Portrait* (*c.* 1963–4), Bourgeois molded spine and ribs to resemble stem and flowers, framed above and below by twin spheres representing breasts and buttocks. This interest for thorax, trunk, torso—also evident in her drawing—comes from the fact that it enables Bourgeois to get directly to the center, the heart, the essence of the body, the site of breath and of life, the basic architecture of human beings. The torso is also the part of the body that can perform a twisting action, illustrating the torsion that results from pressure in two opposing directions. Here, the plaster suggests the hardness and whiteness of bones. Other parts of the body depicted include the *Heart* (1970), and the hanging entrails and bare viscera entitled *Portrait* (1963). This flayed figure recurred in more dramatic and complete fashion in *Rabbit* (1970). "A rejected person is like a dead animal, so dead, poor thing, that if you look closely at it, it's an oven-ready rabbit. All the entrails hang out, it's somebody who is in pain. That's the tragedy of isolation."[10] The heart is the seat of the emotions and feelings, and yet is merely a soft muscle full of arteries, a piece of flesh that can be easily broken, in the literal and figurative sense of the term.

The sculptures from the 1960s are probably the most violent, repulsive, and disturbing that Louise has ever produced. The *Portrait*, originally owned by her friend Arthur Drexler, was exhibited in the famous "Eccentric Abstraction" show organized by Lucy Lippard at the Fischbach Gallery in 1966. Previously, in 1964, Bourgeois had presented a series of plaster and latex sculptures at the Stable Gallery, provoking great surprise. "When the January 1964 exhibition at the Stable Gallery opened, brilliantly installed by Arthur Drexler, it was as disturbing to those who recalled the artist's earlier work as it was to those unacquainted with her past. Radically transformed, the techniques and forms appeared to reverse outward manifestations. It was as if an old acquaintance once darkly lean, elegant and aloof, had come back from a long journey transformed: fleshy, chalky, round and organic. These new sculptures seemed to have the capacity to quiver and ooze. No longer would one immediately associate them with

Untitled, 1968.
Watercolor on paper,
48.8 x 64.4 cm.
Mrs. Jolie Stahl Collection,
New York.

Facing page:
Torso/Self-Portrait, c. 1963–4.
Plaster, 62.8 x 40.6 x 18 cm.
The Museum of Modern Art,
New York.

Portrait, 1963.
Latex, 39 x 31.5 x 10.5 cm.
The Museum of Modern Art, New York,
gift of Arthur Drexler.

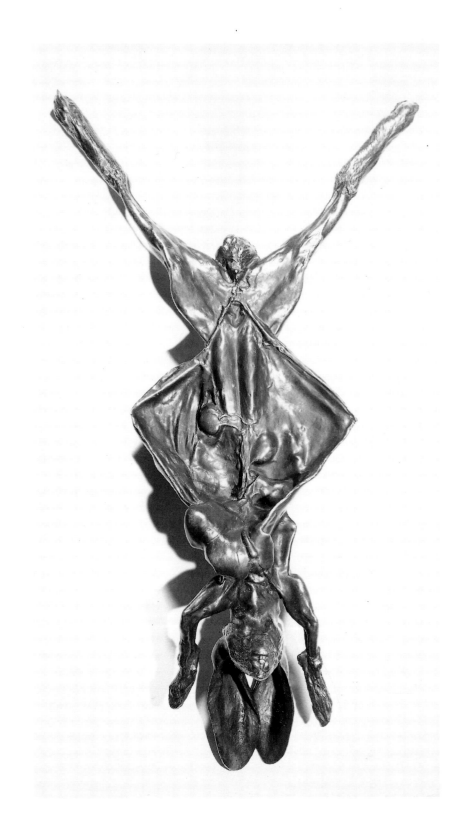

Rabbit, 1970.
Bronze, 73.6 x 39.3 x 12.7 cm.
Robert Miller Gallery, New York.

figures: no longer did their scale appear analogous to our own. . . . The effect of this exhibition was not ingratiating, for the work was powerful but rather repellent. It exerted much the same fascination as an aching injury, demanding an effort from us, drawing our concentration."[11]

This development in Bourgeois's œuvre corresponded to a watershed in American art, as revealed by Lucy Lippard in the show that included, among others, the work of Eva Hesse and Bruce Nauman. "The makers of what I am calling, for semantic convenience, eccentric abstraction, refuse to eschew imagination and the extension of sensuous experience while they also refuse to sacrifice the solid formal basis demanded of the best in current non-objective art."[12] Lippard argued that abstraction is a more powerful vehicle for the bizarre than representation, that erotic impressions thrive in the unexpected.

Invitations to the show were made of pink rubber, thereby celebrating the triumph of soft sculpture and the use of new materials to express organic, biomorphic qualities, free from the formalism and puritanical excesses of minimalism. Although she referred to Meret Oppenheim, Dali, Tanguy and Claes Oldenburg, Lippard stressed the new movement's differences with surrealism. "Eccentric abstraction" was not a simple outgrowth of surrealism, but a response to the relative failure of that movement in the visual arts. "The internal–external, earthly–visceral aspects of Louise Bourgeois's flexible latex molds imply the location of metamorphosis rather than the act. Her work is less aggressively detached and more poetically mature than that of the younger artists, but like them, she does not ignore the uneasy, near repellent side of art," wrote Lippard in the invitation that served as catalogue to the show.

Landscapes

Starting in 1967, Bourgeois produced a series of works based on the motif of landscape. Clusters of bulbs, mounds or mushrooms were sculpted in latex, rubber or alabaster, thereby running the gamut from entirely soft to entirely hard. In *Double Negative* (*c.* 1963), Bourgeois contrasted solid with hollow, positive with negative, above ground with underground. Her determination to see and depict the hidden side of things is typical of a dualistic vision of the world: every element has its inverted opposite. Sometimes, Bourgeois let her material flow and spread to form surprising craters, folds and wrinkles similar to the human body. These mysterious *Soft Landscapes* (1967) betray her interest in nature—an anthropomorphic nature—in which bumps and holes have a strong sexual connotation even though they primarily allude to the landscape around Paris that Bourgeois discovered as a child during promenades from Choisy to Clamart.

Le Regard, 1966.
Latex and fabric,
12.7 x 39.3 x 36.8 cm.
Robert Miller Gallery, New York.

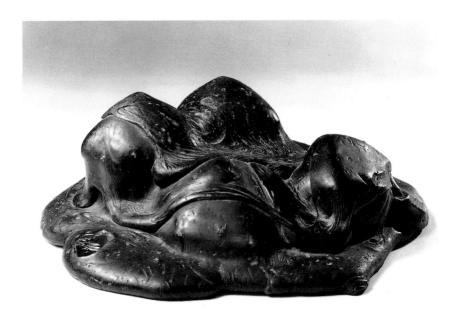

Soft Landscape I, 1967.
Latex, 10.1 x 30.4 x 27.9 cm.
Robert Miller Gallery,
New York.

Double Negative, c. 1963.
Plaster and latex,
49 x 95.2 x 79.6 cm.
Galerie Lelong, Zurich.

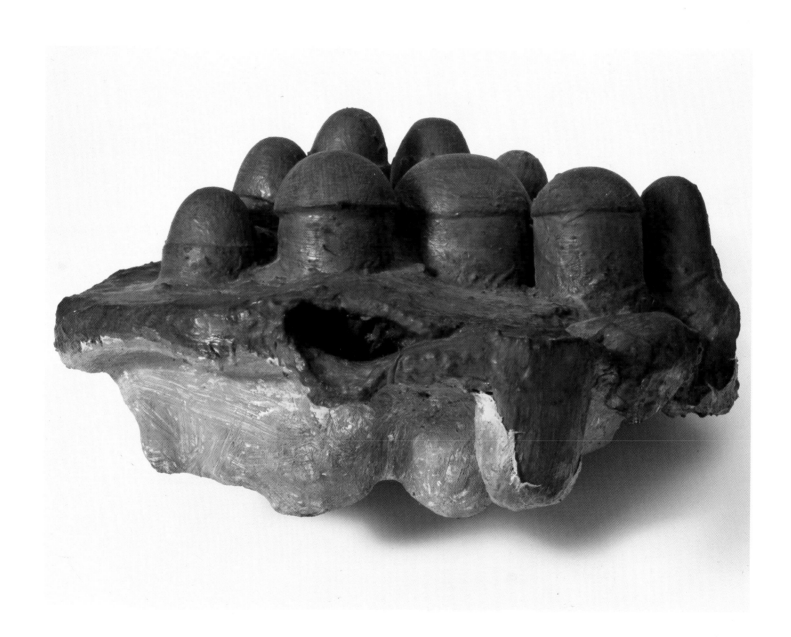

They suggest maps, panoramic reliefs and observatories like the Biret Tower that Bourgeois most especially recollects. Ultimately, these landscapes are like extroverted *Lairs*: "In a refusal to come to grips with the problem, you project yourself at the horizon. The landscapes explode in a desire to escape, to distance yourself and dissolve the anxiety. Terror is turned outwards towards the understanding of the universe. The introjection of the landscape is the lair."[13] These works should also be related to the skein drawings that show the landscapes of the Massif Central in France, where her maternal grandparents lived.

Partial Objects

Between 1967 and 1968, Bourgeois produced her most suggestively erotic objects—*Fillette* (1968), *Sleep II* (1967), and *Janus fleuri* (1968). *Fillette* is perhaps the most typical and the most famous example of her art; thanks to Robert Mapplethorpe's notorious photograph, it has become a sort of secondary attribute, her identifying emblem. The hanging latex sculpture symbolizes the ambivalence of masculine and feminine, hard and soft, strength and weakness. The ironic, tender and cruel aspect of Bourgeois's mentality surfaces in the title she gave to the work—by calling a penis *Fillette* ["Little Girl"], she escaped conventional expectations and artfully dodged all interpretation. The title endows the work with a simultaneously childish and feminine character. Woman can indeed perceive the male sexual organ as a tiny infant, given its color, softness, skin and shape. For Bourgeois it represented a "baby" to be rocked and protected, as confirmed by the pose she struck for Mapplethorpe's photograph. "When I carry a little phallus like than in my arms, well, it seems like a nice little object, it's certainly not an object I would wish to harm, that's clear. The niceness is directed toward men."[14] She went on to assert that "it's a loved object", and her own mocking little smile means: "I'm watching you—I may not look like it, but I'm on very good terms with all my men." The sculpture is also a toy, a weapon, a marionette. It was Bourgeois herself who decided to pose with this sculpture in her arms—"a portrait of the artist as *fillette*" in the words of Rosalind Krauss,[15] who moreover correctly interprets all these phalluses, breasts, vaginas and parts of the body as "partial objects," in other words, "a type of object targeted by partial drives, with no implication that a total individual is taken as the object of love."[16] For example, the breast is taken for the mother, the penis for the father, etc. In Melanie Klein's writing, the term *object* assumes all its psychoanalytic value: infantile fantasies endow the partial object (breast or other part of the body), with the characteristics of a whole person, so that the breast itself can be perceived as persecuting, reassuring, benevolent, etc. This is confirmed by Bourgeois when she describes *Fillette* in terms of a character:

Fillette, 1968.
Latex, 59.6 x 26.6 x 19.5 cm.
The Museum of Modern Art,
New York.

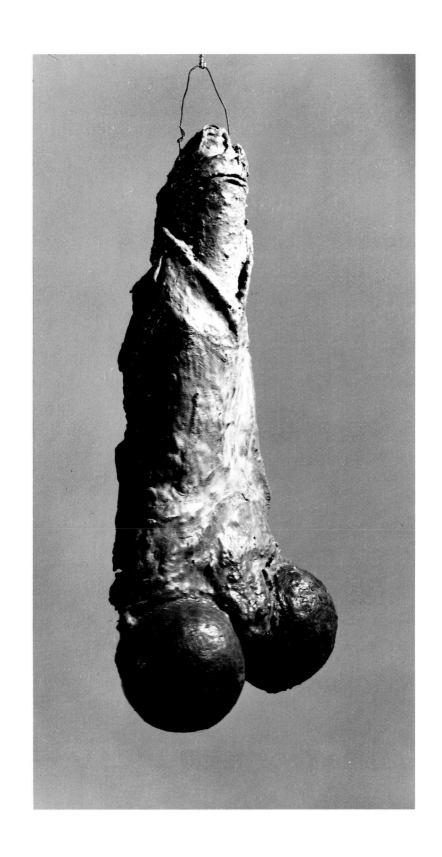

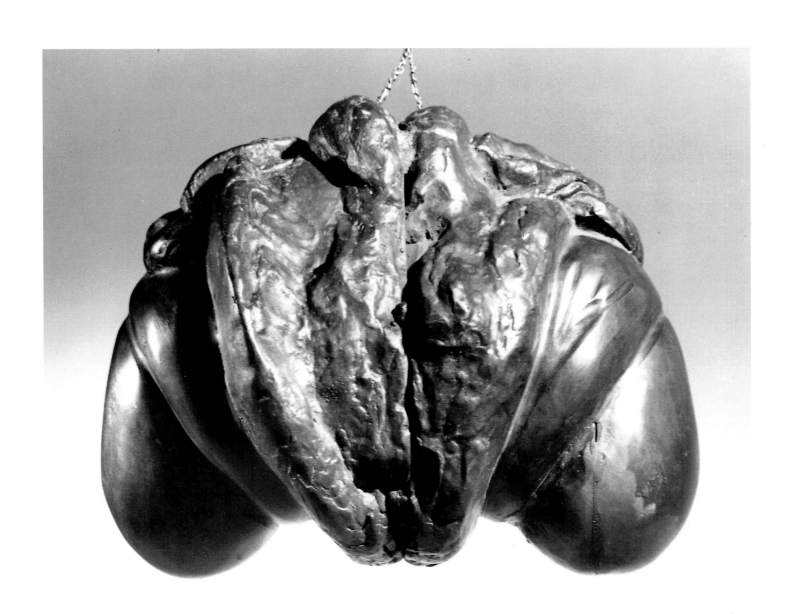

"If you take a look, you can see two eyes on top, a sort of thin mouth below."[17] Yet this psychoanalytic interpretation is not sufficient, since it accounts neither for the artist's sense of humor (evident in her mocking gaze in the photo) nor for the venerable tradition behind the genre. Indeed, in antiquity the phallus functioned as the representation of a virile organ, an object of veneration that played a central role in initiation rites as a symbol of the power of fertility and virility. The phallic dimension of *Fillette* also alludes to Greek priapic myth. Meanwhile, the fragility that Bourgeois simultaneously intends to convey stems from a youthful recollection. "I remember the model in life-drawing class at the Beaux-Arts getting an erection. He was embarrassed and I was amazed at how vulnerable he really was. . . . The sexual impulse of women is not so visible and can be denied. Her impotence can be faked. A man's cannot, he cannot lie and that's why men are so nice."[18]

Fillette is made of layers of latex over plaster. Bourgeois sees latex as a medium halfway between painting and sculpture—it is a liquid that solidifies yet remains supple and almost skin-like, characteristics that are highly appropriate to the objects depicted. It was her favorite material in the 1960s. She had already produced an eye in latex, *Le Regard* ["Gaze," 1966], a sort of gaping hole with slits and folds that evoked the female sex organ while alluding to the ocular cavity. It is soft, damp and concave, with a sort of pupil at the back of the eye that almost constitutes a feminine version of Giacometti's *Point to Eye*, that is to say a metaphor for a woman's "lack" of gaze.

Bourgeois produced other hanging pieces that ultimately became the *Janus* series (*Hanging Janus, Janus in Leather Jacket, Hanging Janus with Jacket*, 1968). These double phalluses spin around; in one, *Janus fleuri* ["Flowering Janus"], the coarsely modeled junction evokes a vaginal slit. Once again Bourgeois juxtaposes feminine and masculine in a twin-faced organ that could be viewed either as paired breasts or penises. This ambivalence or duality, underscored by the title *Janus* (symbolizing a double gaze toward past and future), is found in all the work from that period. "*Janus* is a reference to the kind of polarity we represent. The polarity I experience is a drive toward extreme violence and revolt—and a retiring. I wouldn't say passivity, but a need for peace, a complete peace with the self, with others, and with the environment."[19]

The series from that period that features bulbs, mounds and spherical or oval growths evoke both bosom and phallus. Bourgeois entitled the series *Cumul*, from the round clouds called cumulus. "They are clouds, cloud formations. I myself don't see them as sexual shapes."[20] This particular series was produced in black or white marble. Bourgeois began using marble more frequently after her stay in Pietrasanta, Italy, in 1967. Although hard and resistant, marble could be polished to evoke the silky sheen of skin. The first work in marble was *Sleep II* (1967, p. 64), an initial, smaller version of which had been executed in plaster. Composed of three circular blocks stacked at an angle, it looks like a leaning tower, a segment of broken column, a form simultaneously

Janus fleuri, 1968.
Bronze, 25.7 x 31.8 x 21.2 cm.
Robert Miller Gallery, New York.

Facing page:
Colonnata, 1968.
Marble, 58.5 x 83.3 x 69.2 cm.
Robert Miller Gallery, New York.

emerging from and withdrawing into its protective sheath. The meaning Bourgeois attributes to this sculpture is even stranger and more mysterious: "It's a disguise for a woman who has fallen asleep; not the 'Big Sleep,' there's no question of death, it's just a little afternoon nap."[21] Elsewhere she has interpreted it as a self-portrait "that hung around for years and was incorporated into other pieces." According to Deborah Wye, Bourgeois identifies this piece with the incarnation of a shy presence in the animal world—it is "a little animal recoiled in upon itself in order to gather its forces for waking up the next morning and starting again."[22]

The idea of refuge, of course, relates to the earlier lairs. In this respect, *Sleep* is a pivotal, crucial work because it marks the shift from plaster to marble, from *Lairs* to *Cumuls*, from interior to exterior. The reversibility of the protuberant form is indicated by the position of the last third of the piece, which seems to want simultaneously to retract into and pop out of the hole. Meanwhile, the round, white forms of the series *Cumul I, II,* and *III* seem to emerge from a rippling fabric that is fine and soft like a layer of skin, whereas the black shells of *Colonnata* (1968) rise straight from their block of roughly hewn marble. *Colonnata*'s contrast of two materials, rough and smooth, is a technique that Bourgeois reiterated in the marbles of the 1980s. Its cluster of squat, huddled columns also echoes works from the 1950s like *Night Garden* and *One and Others*. Individual quest and introspection have given way once again to the idea of group, to a collective entity, to others. "My piece *Colonnata*, from 1968, represents the protest marchers of the 1960s: silent, young, black."[23]

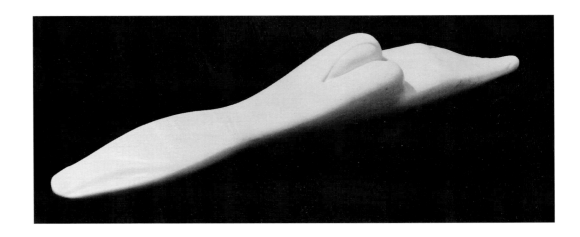

Femme-couteau, 1969–70.
Pink marble,
8.9 x 67 x 12.4 cm.
Private collection.

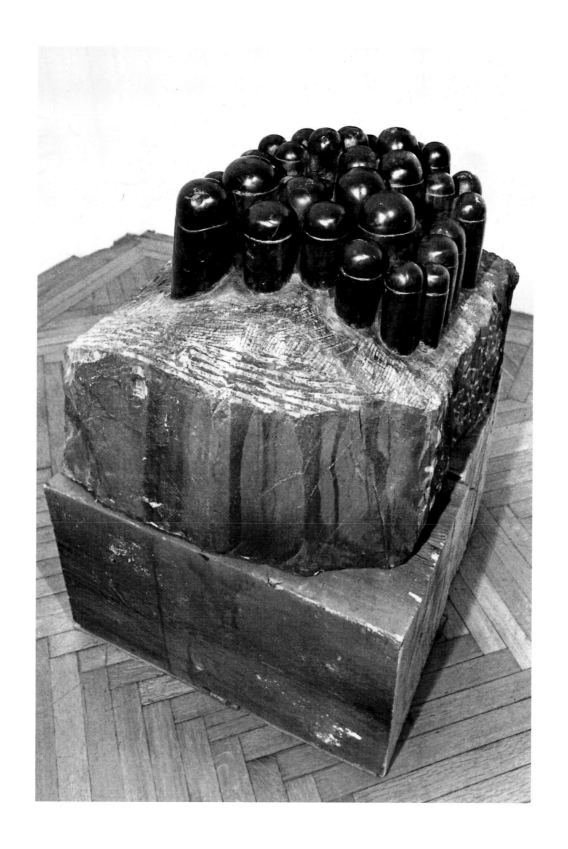

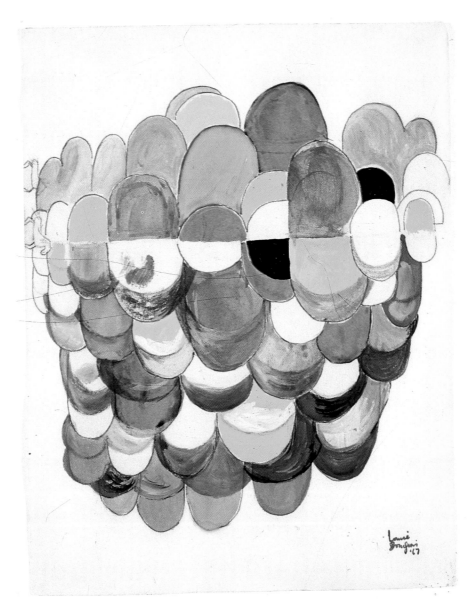

Untitled, 1967.
Ink and gouache on paper, 35.5 x 28 cm.
Private collection, New York.

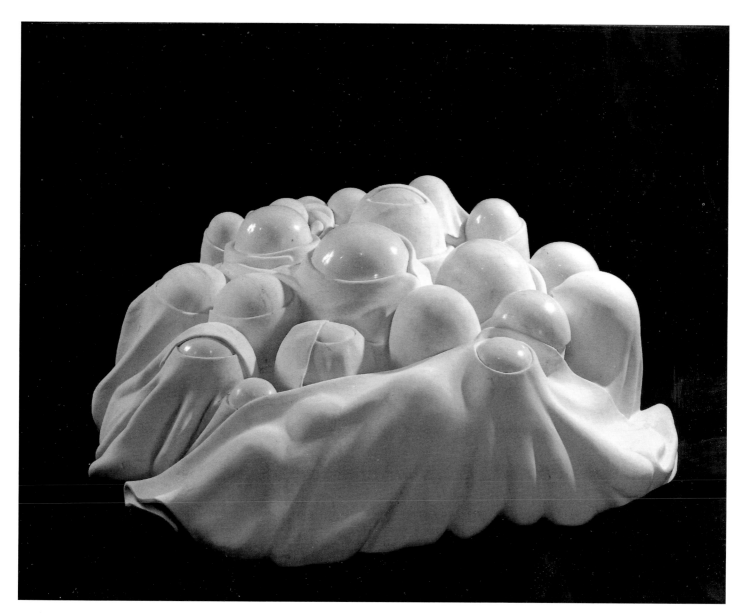

Cumul I, 1969.
Marble, 56.5 x 127 x 121.9 cm.
Musée national d'art moderne,
Centre Georges Pompidou, Paris.

The political dimension became more concrete in an incongruous piece entitled *Molotov Cocktail* (1968), a visual "sex bomb," and extended in the 1970s with works like *The No March* (1972). The subsequent development of her sculpture toward violence was also prefigured by the knife-like *Femme-couteau* ["Knife–woman"] and *Fragile Goddess*, primitive, headless idols. Here it was the bodies of women that became a sharp, pointed, phallic object, as though the entire eroticized body of a woman was the equivalent of a penis. The "knife–woman" symbolizes defence and vulnerability. She is defending her children, claims Bourgeois; the knife is not aimed at men but at people who want to attack. This tool can also be used to cut off arms and head, retaining only the curves of belly, buttocks, breasts. "My knives are like a tongue—I love you, I hate you. If you don't love me, I am ready to attack. They're very double-edged."[24] The same series includes *Femme-pieu* ["Pike–Woman," 1970] whose belly, like a ball of yarn, prickles with needles. These protuberant forms are the source of the *Fragile Goddesses*, pregnant women who are also headless and armless, their essence being condensed into a uterine form with two spheres for breasts and a point for the head. These basic matrices combine male and female attributes, constituting the core of Bourgeois's entire œuvre. "[Their] pregnancy is very important to them, whether you consider it erotic or not. For me, it's *erotic* because it concerns the relation between the two sexes."[25]

The 1960s were a period of maturity for Bourgeois, during which she experimented with diverse forms and materials: plaster, latex, rubber, bronze, marble. It was a very erotic period, where not only sexual organs but also the entire body with its interiority was mobilized to convey the complexity of human feelings: the confusion of a desire which has fallen prey to fear and fascination, the ambivalence of masculine and feminine. "Though I feel protective of the phallus, it does not mean I am not afraid of it. 'Let sleeping dogs lie.' You negate fear like a lion tamer. There is danger and the absence of fear."[26] The fear of fear. "The fear of sex and death is the same. Attraction and fear move back and forth. Which is the cause and which is the effect? It's important to know."[27]

Fragile Goddess, 1970.
Bronze, 26.6 x 14.6 x 14.6 cm.
Galerie Lelong, Zurich.

NOTES

1. Christiane Meyer-Thoss, *Louise Bourgeois, Designing for Free Fall*, (Zurich: Ammann Verlag, 1992), p. 181.
2. Camille Guichard, *Louise Bourgeois,* (Paris, 1993).
3. Gaston Bachelard, *The Poetics of Space* (Boston: Beacon Press, 1969), pp. 98–9.
4. J. Michelet, *L'Oiseau* (1858) quoted in Bachelard, p. 101.
5. Meyer-Thoss, p. 179.
6. *Ibid.*, p. 136.
7. Guichard, *Louise Bourgeois.*
8. Interview with the author, December 1994.
9. Paola Igliori, *Entrails, Heads & Tails,* (New York: Rizzoli,1992), n.p., note. 8.
10. Guichard, *Louise Bourgeois.*
11. Daniel Robins, "Sculpture by Louise Bourgeois," *Art International*, October 1964, pp. 29–31.
12. Lucy Lippard, "Eccentric Abstraction," *Art International*, November 1966, pp. 28–29.
13. Meyer-Thoss, p. 180.
14. Guichard, *Louise Bourgeois.*
15. Rosalind Krauss, "Portrait de l'artiste en fillette", *Louise Bourgeois* , exhibition catalogue, (Lyon, 1989).
16. J. Laplanche and J.B. Pontalis, *Vocabulaire de la psychanalyse,* (Paris: PUF, 1971).
17. Guichard, *Louise Bourgeois.*
18. Meyer-Thoss, p. 188.
19. *Ibid.* p. 192.
20. Guichard, *Louise Bourgeois.*
21. *Ibid.*
22. Deborah Wye, *Louise Bourgeois,* exhibition catalogue, (New York: Museum of Modern Art, 1982), p. 26.
23. Meyer-Thoss, p. 122.
24. *Ibid.*, p. 178.
25. Quoted in Jean Frémon, *Louise Bourgeois*, exhibition catalogue, (Paris: Maeght, 1985).
26. Meyer-Thoss, p. 181.
27. *Ibid.*, p. 196.

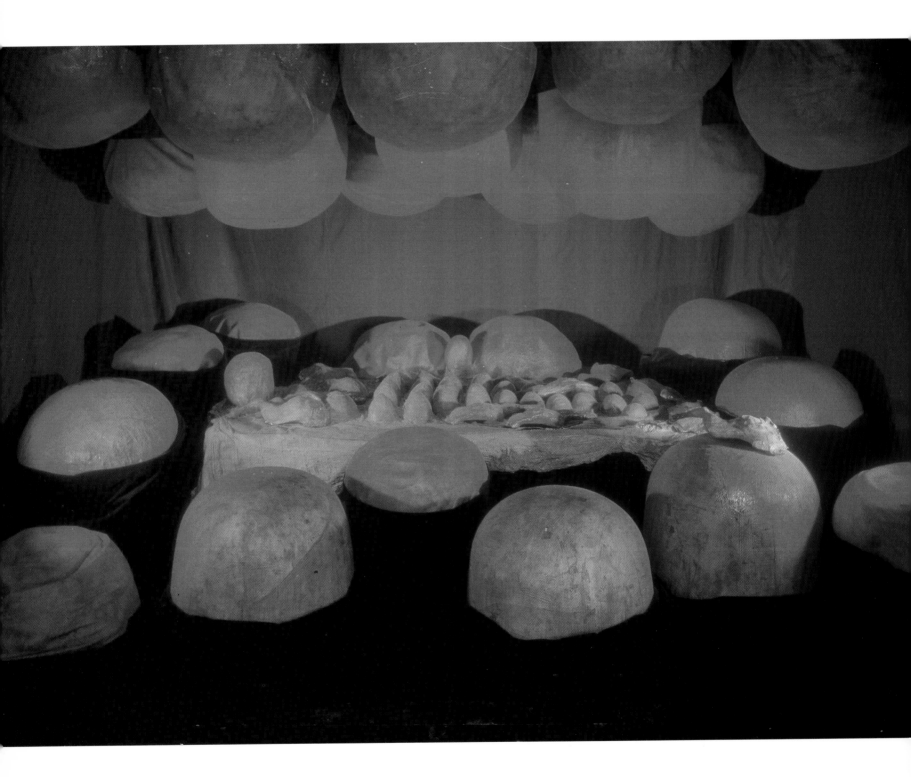

DESTRUCTION OF THE FATHER

It is a very murderous piece, an impulse that comes when one is under too much stress and one turns against those one loves the most.[1] L.B.

Page 88:

The Destruction of the Father, 1974.

Plaster, latex, wood and fabric,

237.8 x 363.3 x 248.7 cm.

Robert Miller Gallery, New York.

Molotov Cocktail, 1968.

Bronze, 10.5 x 20.14 cm.

Robert Miller Gallery, New York.

Facing page:

The No March, 1972.

Marble, 25.4 x 17.7 x 25.4 cm.

Storm King Art Center Collection,

Mountainville, New York;

installation at the Whitney

Museum of American Art,

New York.

The early 1970s was a period of marked social and political awareness on the part of Louise Bourgeois. It was also a decisive epoch in terms of her life and œuvre. Her husband died in 1973, and the ordeal of mourning coincided with a confrontation with her past, concretized in two key works: *The Destruction of the Father* (1974) and *The Confrontation* (1978). These two environments lent a new dimension to her sculpture, their funerary rituals serving as veritable initiation rites that seemed to free her from all constraints, enabling her to fully exploit the wealth of her unconscious. The end of that period finally culminated in public recognition of Bourgeois, as though the path she had long chosen—solitary, autobiographical, and expressionist—henceforth corresponded to the needs of a new generation of artists.

Although not really labeling herself a feminist (she considers herself instead a specialist in femaleness), Bourgeois participated in many feminist demonstrations and activities; she also closely followed the student movement. It was this climate that brought forth such works as *Molotov Cocktail* (1968), *Colonnata* (1968), and *Number Seventy-Two*, also known as *The No March* (1972). In the latter work, she developed the idea of a group or crowd, a shapeless mass of distinct individuals, by assembling dozens of little marble columns cut at an angle. These little shafts came from Italy, and were in fact discarded pieces of marble from hollowed-out vases and other tourist items, alluding once again to a dialectic between solid and hollow, content and container, positive and negative. The fragments were placed side by side on the floor in a corner of the Whitney Museum in 1973 (they were then transposed to an outdoor site at the Storm King Art Center in Mountainville, N.Y., which nudged the work in the direction of nature and germination, organic proliferation being a constant motif in Bourgeois's œuvre, as seen in drawings like *Eccentric Growth, c.* 1965). Human relationships and communication are one of the major themes in her œuvre, always presented as a counterpoint to solitude. "People feel each other, perceive each other, turn toward or away from each other . . . fated to walk together as part of an ongoing phenomenon . . . always perceiving others and adjusting to them."[2]

A few isolated sculptures like *Trani Episode* (1972), *Eyes* (1972) and *Eye to Eye* (1970) provide a transition between the works of the 1960s and those that followed. *Eye to Eye* is compositionally similar to *One and Others*, but entails diminutive figures with square faces, small-scale versions of the 1950s figures that also anticipate the geometric forms of *Confrontation*. The very title of *Eye to Eye* evokes a face-off or confrontation with the other. *Eyes*, composed of a rectangular base topped by two spheres for the eyes, is the first of a series of sculptures devoted solely to eyes. This monumental piece was installed in front of the Metropolitan Museum, symbolically placing the function of the gaze in perspective.

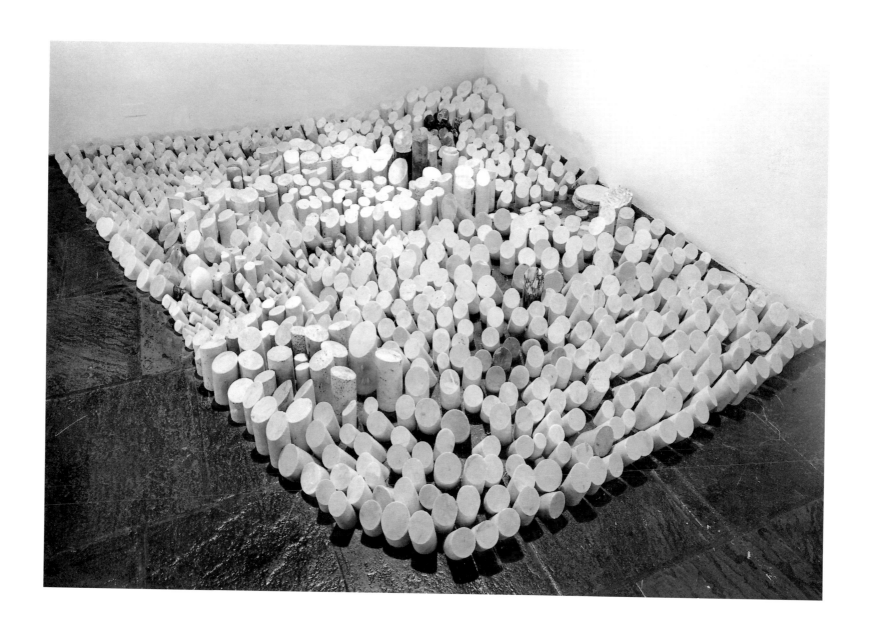

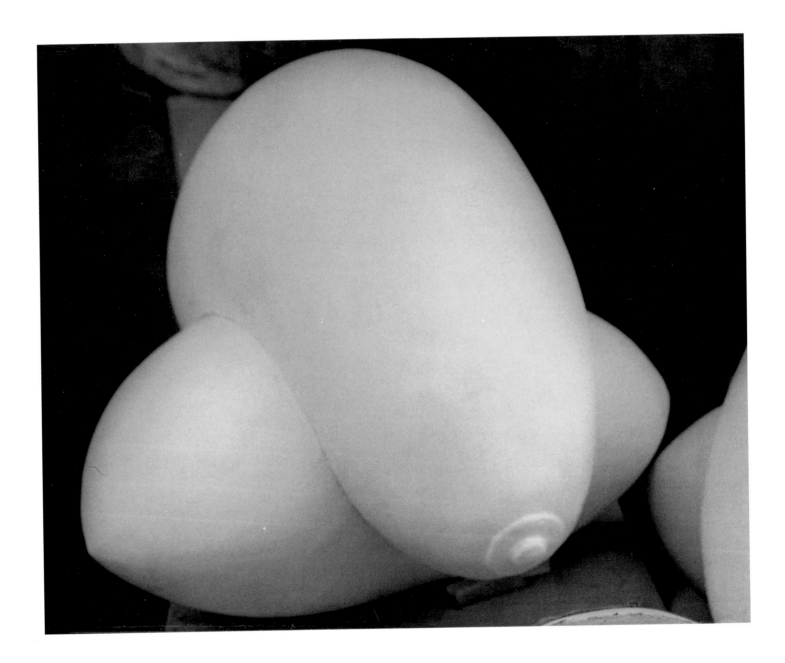

Trani Episode adheres to the logic of masculine–feminine ambivalence (Trani is a place in Italy). But here the form is further simplified and condensed in a sort of embryo of distended breasts that also evoke phalluses. The novelty here entailed stacking two elements on top of one another so as to form a kind of box. "The forms were hollow, so it therefore represents a box—the inside is empty. You have to lift the top to discover the secret box."[3] The elementary, primordial forms that populate the imaginative universe of Louise Bourgeois often recur, in various ways, in her œuvre—in plaster, in bronze, in alabaster, or with an electric light inside (as in *Precious Liquids*, 1992). "This is a place for my heart," she says, "a very secret place. . . . I have an intense need for privacy."[4] Indeed, Bourgeois has managed to evoke the secret refuge of the maternal breast and the warmth of bodies nestled together, for the swaying forms of *Trani Episode* also suggest the rocking of the cradle.

Facing page:
Trani Episode, 1971–2.
Marble, 60 x 60 x 58 cm.
Private collection, New York.

A Feast for Cannibals

An accumulation of maternal and phallic forms served as the basis of *The Destruction of the Father*: "The shapes were obtained by accretion rather than cutting away. Modeling was involved, and therefore the intentions are different," says Bourgeois, stressing the paradox between the process of construction and the idea of destruction.[5] The piece takes the form of a table covered with a table-cloth of globular mounds made of latex. In the center, two large half-spheres and a protuberance suggest the realm of erections and phallus. From the ceiling are hung spherical forms similar to breasts, buttocks, clouds. This cluster of shapes stems directly from the upside-down landscapes of the 1960s and the *Cumul* series, but the installation here evokes the inside of a mouth or a cavern with nooks and crannies, as though it were a life-size development of the lairs.

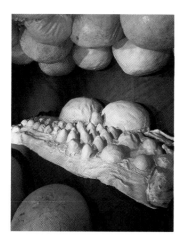

The installation's enclosed atmosphere sparks feelings of imprisonment, violence and claustrophobia among spectators. The other title that Bourgeois has given to this key work is *Evening Meal*, which suggest the idea of a ritualistic, cannibalistic meal, insofar as the soft, pink and red forms could be associated with bloody intestines and scattered limbs. Here the title alludes to family meals and to Louise's ambivalent love–hate relationship with her father. The scene is a three-dimensional depiction of something she experienced sixty years earlier, when she imagined the entire family taking vengeance by devouring him during a meal: "The piece is first of all a table, the horrible and terrifying table presided over by the father, who pontificates from his chair. And what can the others—the wife and children—do? They sit there silently. The mother, obviously, tries to appease her husband, the tyrant. The children get restless. . . . My father was overcome with annoyance when he looked at us—he was always telling us

The Destruction of the Father, detail.

what a great man he was. So much so that we became exasperated, seized him and threw him on the table, tearing his limbs apart and devouring him."[6] This cannibalistic aspect had already been relived in one of the short tales in *He Disappeared into Complete Silence* (1947), and became one of Bourgeois's recurring themes, for she eats either her children or her parents in ogre fantasies dating back to her earliest childhood. This macabre butchery is Louise's imagined vengeance for the trauma she suffered due to her father's betrayal; it also helped to rid her of the guilt of being just a girl, of which her father made her painfully aware: "A daughter is a disappointment. If you bring a daughter into this world, you have to be forgiven, the way my mother was forgiven because I was the spitting image of my father. That was my first piece of luck. It may be why he treated me like a son he always wanted."[7] Many of her sculptures perhaps reflect this problem of sexual identity stemming from birth (since her father wanted a boy, she was given her father's first name; her own sons have subsequently adopted her family name). It is probably no coincidence that Bourgeois produced this violent piece shortly after the death of her husband; just as she threw out the domestic stove (the symbol tool for feeding the family) thereby freeing herself from the attributes of mother and wife, she created this banquet into order to "liquidate" the imposing image of her fathers, of "authority figures."

A Banquet, A Fashion Show of Body Parts

Several years later, Bourgeois produced *The Confrontation*, another step toward accepting herself and the violence of her feelings. "*The Confrontation* represents a long table surrounded by an oval of wooden boxes, which are really caskets. The table is a stretcher for transporting someone wounded or dead. So, there is one personage on one side, and one on the other. One creature is old, and as you can see by the shape, they are crinkled, they are definitely wrinkled and old. The other is absolutely fresh representing youth Usually, we have the state of affairs where someone dies of passion for someone younger than himself, passion that is never achieved, never consummated. . . . Each of these boxes represents one of us. We have to stop running and take our places in the circle and face ourselves in front of each other. That is to say, to face how limited and uninteresting we are. Every one of us has to do this in front of everybody else. At that point, we have grown up. Nothing can let us escape this confrontation."[8] This enormous sculpture, which evokes yet another "crucial scene," is composed of a soft, organic center, and a rigid, geometric circumference of niche-like triangles in which people can sit. Exhibited at the Hamilton Gallery of Contemporary Art in 1978, *The Confrontation* was the most monumental and spectacular work in Bourgeois's œuvre to date. It included ele-

ments from *The Destruction of the Father*, thereby evoking once again the idea of a banquet with protagonists seated around a table of viscera, and it re-employed an abstract architecture of anthropomorphic characters, the human element being provided by the presence of real bodies in these niches.

Indeed, Bourgeois turned this piece into a performance by inviting visitors to sit in the booths, and then having her friends parade by in latex garb with multiple breasts, thereby associating them with the future victim. The performance, entitled *A Banquet, a Fashion Show of Body Parts*, has been interpreted in various ways by Bourgeois herself. It is a commentary on the old loving the young, or the young loving the old—a love which, in both cases, leads to death. It is also a comment on gender switching, since the men were decked out with breasts (a nod, she states, to Marcel Duchamp's persona of Rrose Sélavy). This costume—which she herself wore, and had many of her friends wear—illustrates her black humor, for it is suggestive of sarcasm: "Ridicule kills," she says. "It seems that men like breasts, so we'll give 'em plenty. . . ."[9] Whatever the truth of the anecdote, *The Confrontation* condenses all the factors found in Bourgeois's art: a combination of the visceral and the architectural, of isolation and assembly, food, sex and death.

Furthermore, the niche-like structure of the boxes would recur in a series of constructions made of little triangles of wood stacked on one another, painted in various colors, entitled *Structure* (1979). Finally, *The Confrontation*'s status as an actual, usable environment prefigured the *Cells* of the 1980s. Bourgeois likes to have her friends participate, using them as live material, observing their behavior and emotions. "[*Confrontation*] depends to some degree on the pleasure that the actors feel. Gert Schiff is one of the performers. He is pleased as punched with his costume, partly because of the personality it gives him, but also because of the sheer pleasure of exhibitionism."[10] Bourgeois apparently takes mischievous delight in placing people in situations where they have to confront themselves and others. Knowing oneself, accepting oneself, is for her one of the main goals of life.

Partial Recall

The final works of the 1970s followed the vein of geometric abstraction, as though Bourgeois felt a need to react against sensual, carnal, emotive excesses. A new version of the femme-maison appeared—*Maison Fragile* (1978). These houses are not only empty but fragile, perched on high legs. Their frail structure of steel, simple and minimalist in form, nevertheless conveys the inner strength and vulnerability of a woman. Although they appear fragile, in fact never fall, which Bourgeois feels is one of the characteristics of

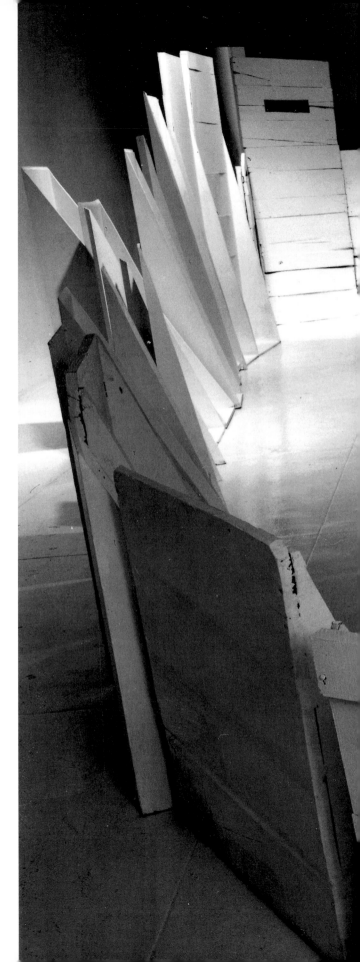

The Confrontation, 1978.
Painted wood, latex and fabric, 11.3 x 6.10 m.
The Solomon R. Guggenheim Museum, New York.

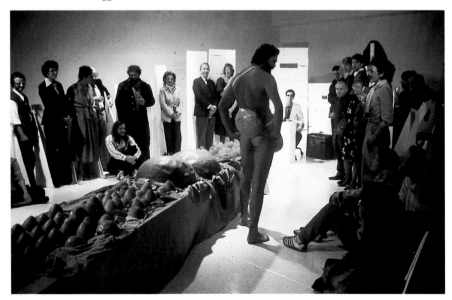

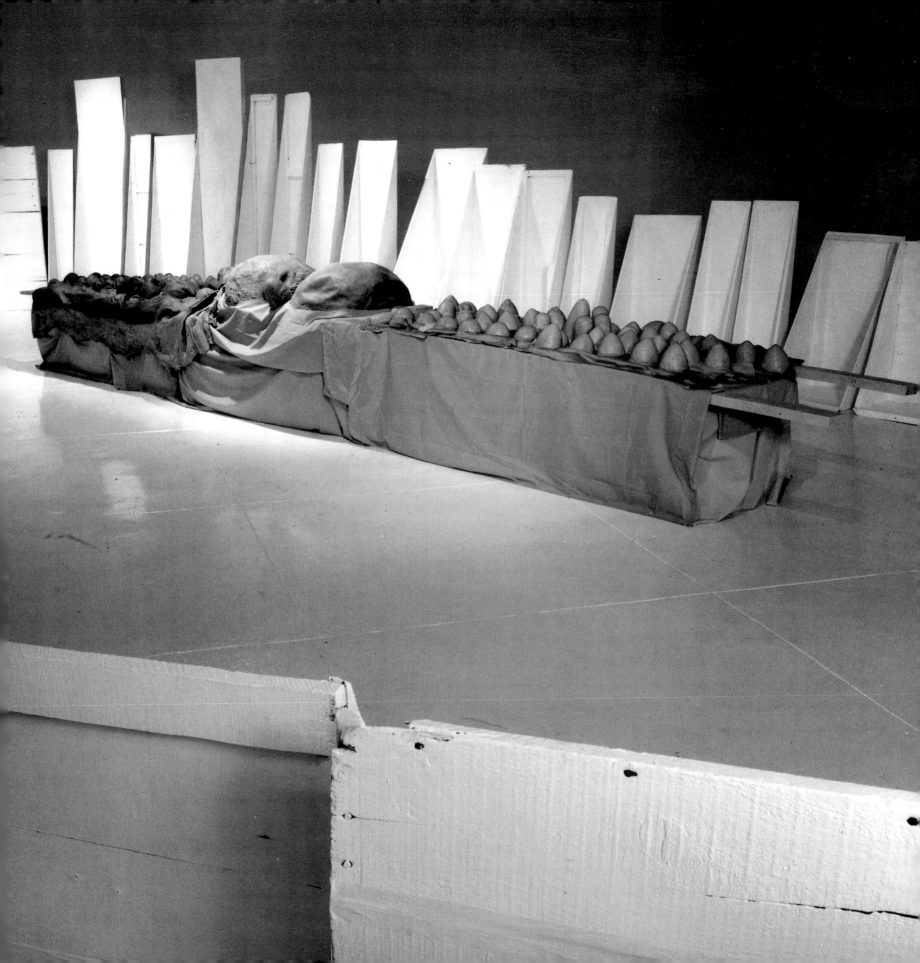

Facing page:
Maison fragile, 1978.
Steel, two parts,
183.1 x 48.5 x 36.2 cm.
Robert Miller Gallery, New York.

femininity. Steel, a fine yet strong material, was also used for *Lair of Seven* (1978), composed of seven pipes nestled one inside another and cut on an angle, yielding ovoid spirals, a shape that would recur in a series of drawings in 1993–4. The principle of cutting at an angle recalls the columns of *Number Seventy-Two*. These *Lairs* are impenetrable, because already occupied; the repetition of the same round module nevertheless creates a labyrinthine surface, as Bourgeois exploits the rules of geometry to create new plastic forms.

The final major sculpture of this phase was *Partial Recall* (1979), an assemblage of rectangular plinths topped by semicircles progressing from the smallest to the largest. They evoke the budding forms of the *Cumul* series, but flattened. The color—blue and white—is a sign of peace, of reconciliation, of acceptance of past memories. After theatricalizing her past, Bourgeois here finds a certain serenity in limited recollection. "*Partial Recall* has to do with forgiveness and with integration, as aggression has to do with explosion and disintegration. It is difficult to recall forgiveness, one needs to be blessed at the moment. Aggression is very easy to recall."[11] The dominant features of this piece are the repeated motif and the progression from small to large. "There is a repetition of forms, all the forms are together, huddled against one another, they begin small down front and progressively grow in height. Like Romanesque architecture, the windows are small, then get taller and taller toward the top."[12] This fecund maternal image, whether suggesting fertile field or cloudy sky, is reassuringly geometric, a configuration simultaneously celestial and terrestrial, paternal and maternal (a dialectic also found in several drawings). In this respect, it functions as an antithesis to *The Destruction of the Father*. Here Bourgeois is finally confronting, via her childhood memories, the character of Sadie, her father's mistress: "The story of Sadie is almost as important to me as the story of my mother. The motivation for [*Partial Recall*] is a negative reaction against her."[13]

Lair of Seven, 1978.
Steel, seven parts,
22.2 x 135.8 x 43.8 cm.
Robert Miller Gallery, New York.

NOTES

1. Deborah Wye, *Louise Bourgeois*, exhibition catalogue (New York: Museum of Modern Art, 1982), p. 95.
2. Christiane Meyer-Thoss, *Louise Bourgeois, Designing for Free Fall*, (Zurich: Ammann Verlag, 1992), p. 180.
3. Interview for the film, *Louise Bourgeois* by Camille Guichard (Paris, 1993).
4. Meyer-Thoss, p. 137.
5. Guichard, *Louise Bourgeois*.
6. Jean Frémon, *Louise Bourgeois*, exhibition catalogue, (Paris: Maeght, 1985).
7. Meyer-Thoss, p. 185.
8. *Ibid.*, pp. 182–3.
9. Guichard, *Louise Bourgeois*.
10. Meyer-Thoss, p. 123.
11. *Ibid.*, p. 182.
12. Guichard, *Louise Bourgeois*.
13. Meyer-Thoss, p. 182.

Partial Recall, 1979.
Wood,
274.3 x 228. 8 x 167.6 cm.
Private collection, New York.

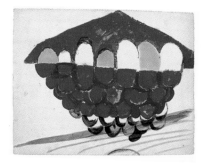

Untitled, 1969.
Watercolor and gouache on paper,
50.5 x 65.6 cm.
Robert Miller Gallery, New York.

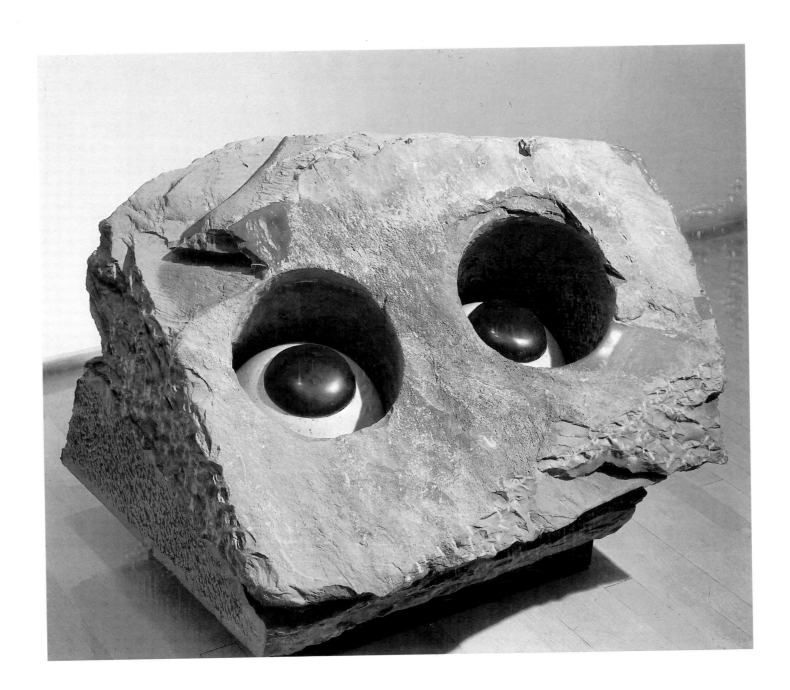

BODY PARTS

Suddenly I move my leg, or suddenly I move my arm, suddenly I move my thumbs, so we are in the physical, we are in the body's languages now. The stone becomes the body. . . . What happens to my body is repeated in the stone, except that then it has to add a formal meaning.[1] L.B.

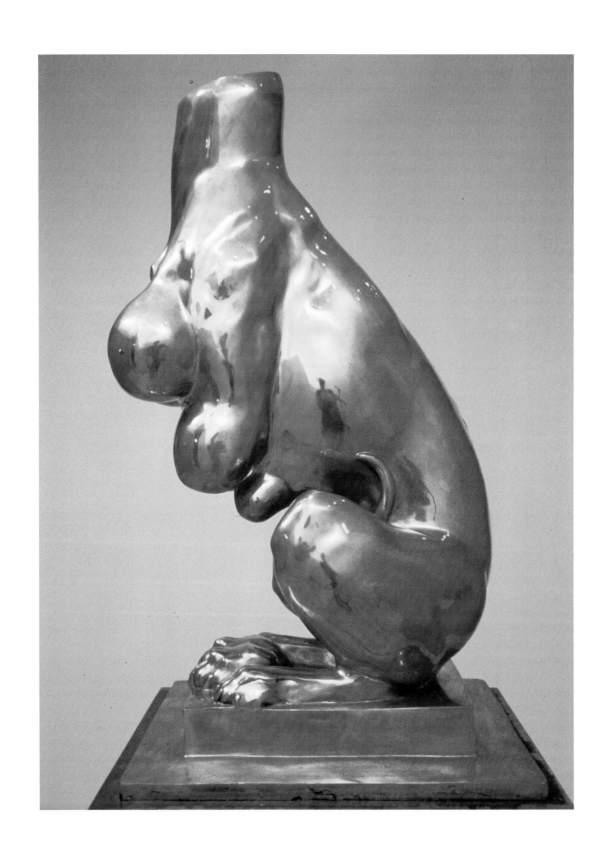

After having dared to confront and destroy the traumatizing image of the Father, Louise Bourgeois pursued her devastating thrust by cruelly yet tenderly depicting tutelary figures, paternal and maternal, incarnated by two mythical animals with symbolic functions—the Sphinx and the Fox (which strangely resembles a she-wolf). These headless divinities masterfully inaugurated the sculpture of the 1980s which either reworked and redeveloped the fundamental themes of her œuvre (femme-maison and lair), or explored new paths: the body in pieces, a castrating dismemberment already prefigured in *Fillette* (1968). The period in fact was marked by fragmentation and severance; the human body was perceived as a unity composed of various parts, in which each "partial object" could allude to a specific person. "Well, the body is always dismembered, of course, what a child does to a toy."[2] Bourgeois executed "nature studies" of eyes, legs, feet and hands—mainly in marble, her favorite material during the 1980s—in which representational and abstract forms were increasingly combined.

In exploring her childhood memories, Bourgeois truly relives her past; the psychic experience is expressed through her body, the site of emotions. The 1980s ended with life-size installations, assemblages of found objects that allowed for the physical representation of past anxieties and prefigured the *Cells* of the 1990s.

Tutelary Figures

The first *Nature Study*[3] (1984) depicts a freakish creature halfway between human and animal, male and female. It is a headless sphinx with claws, to which Bourgeois added three pairs of breasts, thus extending the sarcastic humor already present in the latex garment made for *The Confrontation* (the motif of multiple breasts is a standard image of fecundity inherited from Artemis of Ephesus). The animal is a heterogeneous collage of disparate elements—certain accurate features, like the thighs, are juxtaposed with exaggerated forms like the feet. The forced marriage of these elements spawns mannerist distortion; the long, slim human back does not correspond to that of an animal. Bourgeois managed to compose a truly hybrid being that is both imaginary and lifelike. The sculpture is raised on a base in order to loom above the viewer, whose eyes reach the genital level, enabling him or her to see that the creature is strangely sexless, though the long tail curling between its legs suggests a penis. Bourgeois herself declares that the animal represents her father. "Since I was demolished by my father, why shouldn't I demolish him? I take a really masculine animal and I give him breasts, in ridicule. And after having given him breasts, why not give him a second pair of breasts? And then I cut off his head. It's a way of teasing. As I was teased, so shall I tease."[4] The mixture of male and female attributes, the inversion of roles, once again refers back to the presexual

Page 102:
Nature Study, Velvet Eyes, 1984.
Marble, 66 x 83.8 x 68.5 cm.
Michael & Joan Salke Collection, Boston.

Nature Study, 1984.
Bronze with patina,
76.2 x 48.2 x 38.1 cm.
Whitney Museum of American
Art, New York.

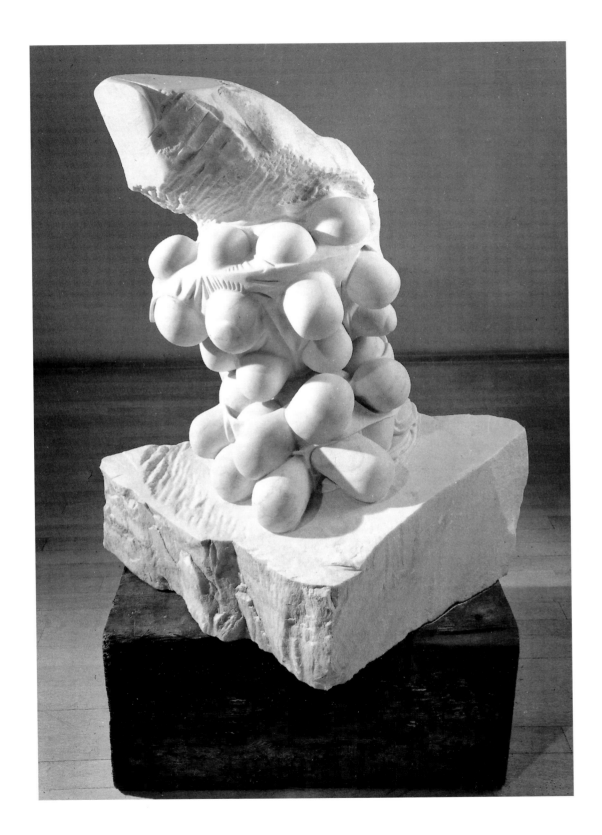

Blind Man's Buff, 1984.
Marble.
91.5 x 89 x 63.5 cm.
Robert Miller Gallery.
New York.

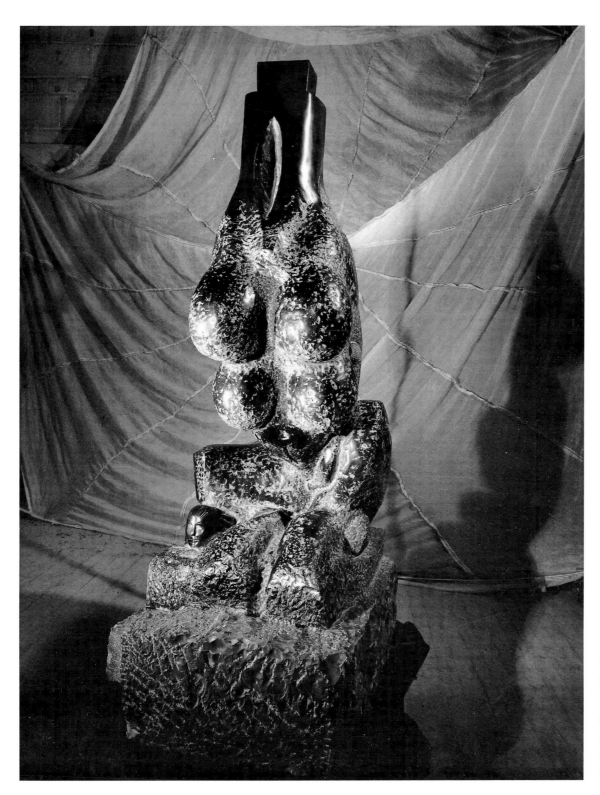

The She-Fox, 1985.
Black marble,
179 x 68.5 x 81.2 cm.
Olivier Hoffman Collection,
future bequest to the
Museum of Contemporary Art,
Chicago.

Facing page:
Femme-maison, 1983.
Marble, 63.5 x 49.5 x 58.5 cm.
Jean-Louis Bourgeois Collection,
New York.

stage of perverse, polymorphous infancy, before sexual difference has been established.

The gleaming, polished, mirror-like surface of *Nature Study* is counterbalanced by the somber, disturbing black marble of a female animal entitled *The She-Fox* (1985), a portrait of the mother as fox with, between her paws, a tiny head of Louise (taken from the sculpture *Fallen Woman,* 1981). This is a protective yet frightening image of maternity. The fox's shrewd nature seems to accurately reflect Louise's mother—patient, clever, calculating and long-suffering, qualities Bourgeois would later associate with spiders. The rough surface of the coarsely carved marble, the dark color, and the poorly defined forms place the mother on the side of wild and undifferentiated nature; she represents the "dark continent" that contrasts with the learned, brilliant image of the male Inquisitor. The beheaded bodies obviously carry sexual connotations, every headless body being a metaphor for the phallus. But this mutilation is also a type of exorcism, betraying the child's sado-masochistic feelings toward her parents. The threatening aspect of the mother frightened Louise and spurred her to violence: "So, I would try to hurt her, and this time I did. I cut her head off. I slit her throat. Still, I expect her to like me. The tragedy is: Is a person who I have treated like this still going to like me?"[5]

The third work in this series, the white marble *Blind Man's Buff* (1984), constitutes yet another version of a phallus with breasts. Halfway between *Labyrinthine Tower* (a tilting erection) and the *Cumuls*, this disturbing piece is designed to be more touched than seen, as the title indicates. Indeed, the proliferation of bulbous forms protruding from the marble block invites caresses from sightless hands. The round, sensuous, silky forms that poke through the sheet of marble contrast with the rough, coarse finish of the block.

Houses

The Curved House, 1983.
Marble, 29 x 8.5 x 60 cm.
Kunstmuseum, Berne.

The initial works from this period were devoted to the theme of femme-maison ["house–woman"], a theme that Bourgeois only began sculpting some forty years after having first painted it. She produced two opposing versions, one figurative and mannerist, the other abstract and geometric. *Femme-maison* (1983) shows a figure draped in a pile of folds and coils, with a small square house crowning this organic, fluid mound. The piece returns once again to the polarity between architectural rigidity (here reduced to its tiniest dimensions) and fleshy, feminine masses (suggested by the folds of fabric). The second house, entitled *The Curved House* (1983), is a slightly curved, rectangular block of marble. A miniscule door has been carved in the middle, while the top has been cut at an angle to represent a sloping roof. This house, with its horizontal shape and its blind façade devoid of doors and windows, is unique in Bourgeois's œuvre and does not

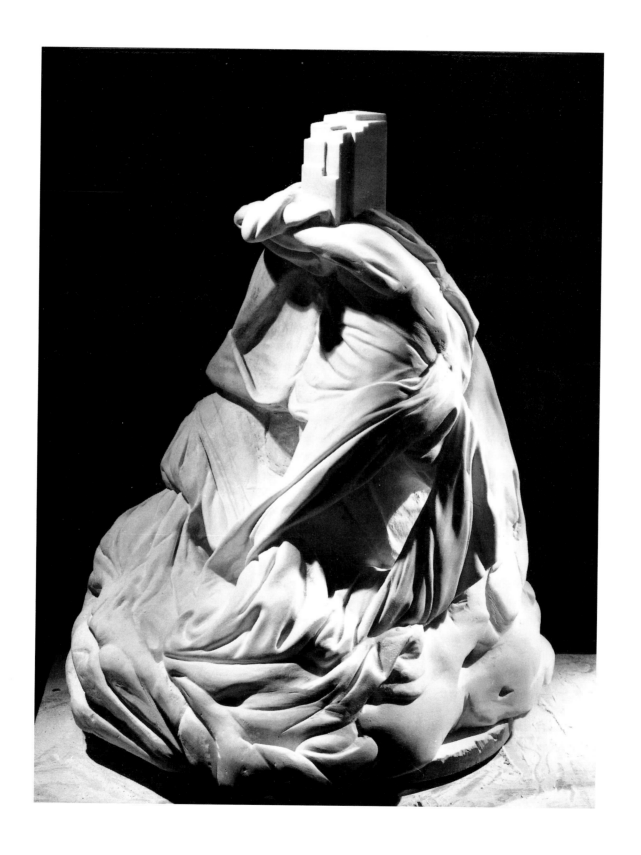

appear to correspond to a real house. The massive, solid block of marble thus functions as the antithesis (i.e., the solid core) of the *Maisons fragiles* of 1978. Once again, then, there is an antinomy between solid and void.

Eyes

Bourgeois produced a series of monumental eyes, either singly as in *Bald Eagle* (1986) or in pairs, seen in the 1984 series *White Eyes, Velvet Eyes,* and *Pink Eyes* (an allusion to Yvonne, an albino baby-sitter with pink eyes). Bourgeois has said that "velvet eyes" refers to the softness of a loved one's eyes; two large holes were carved into a block of gray marble, to receive two eyeballs handled in realistic fashion, including white corneas and black pupils. "The eyes," quotes Bourgeois, "are the window of the soul, reflecting feelings and truth. They are the best way to communicate with the world, with others." This stress on the organ of sight, already handled in the drawings and in latex in 1965, can be explained not only by the erotic metaphor of the eye (the pupil is a black hole awaiting penetration) but also by the fact that the disembodied eye paradoxically alludes to blindness and castration. Bourgeois is obsessed by the myth of Œdipus, and many of her works hinge directly or indirectly on that primal conflict.

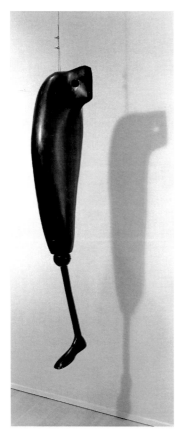

Legs

When recalling her childhood, Bourgeois rarely evokes the presence of her elder sister Henriette, except to mention that she limped. In fact, Henriette's physical handicap, due to a hip problem, must have disturbed Louise, for her feelings are a mixture of compassion and fascination; she called Henriette a "happy cripple" because the girl was unashamed of her infirmity. Yet Bourgeois was thinking of her sister when she produced not only *Henriette* (1985), an artificial leg with ball joint, but also *Legs* (1986), two long rubber legs, one of which is shorter than the other. "I was sorry for her, and later I needed to include her in the story of my life."[6] *Henriette* also represents a variant on the strategy of hanging, one of Bourgeois's favored ways of presenting pieces, and introduces rubber, a material that is simultaneously hard and soft, the use of which she would develop in *Articulated Lair* (1986).

Nature Study

A second series of *Nature Studies*, executed in 1986, consists of roughly hewn blocks of marble that serve as base for rope spirals, loops of knots that twist or wrap around fat fingers. The repetition of an obsessive motif being a key feature of Bourgeois's work, it is normal that the spiral—expressing the torsion of opposing forces—should recur in marble after earlier examples in plaster. Here, however, the umbilical-like aspect and vigorous tension of the form lend a visceral violence to the work, as though it were a piece of flesh ripped from the formless block. There is a contradiction between the hardness of the marble and the pliable, malleable forms drawn from it. The harder and more unyielding the material, the tougher and more painful is the battle, because resistance is linked to the content to be expressed. Alluding to Bachelard, Bourgeois has claimed that she has to hack away at marble as though she is hacking away at herself.[7]

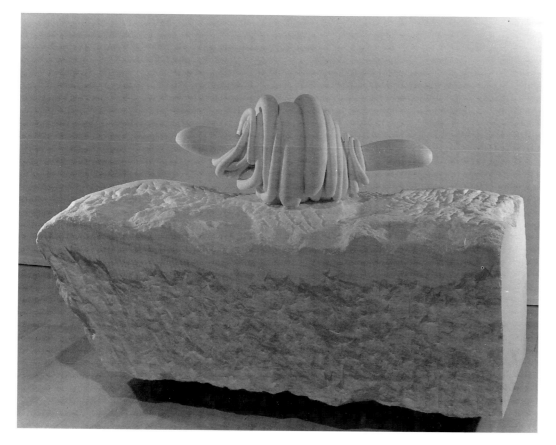

Facing page, top:
Untitled, 1947.
Ink on paper, 25.4 x 14 cm.
Robert Miller Gallery, New York.

Facing page, bottom:
Henriette, 1985.
Bronze, 152.5 x 33 x 30.5 cm.
Robert Miller Gallery, New York.

Nature Study, 1986.
Marble, 88.9 x 155 x 74 cm.
Artist's collection.

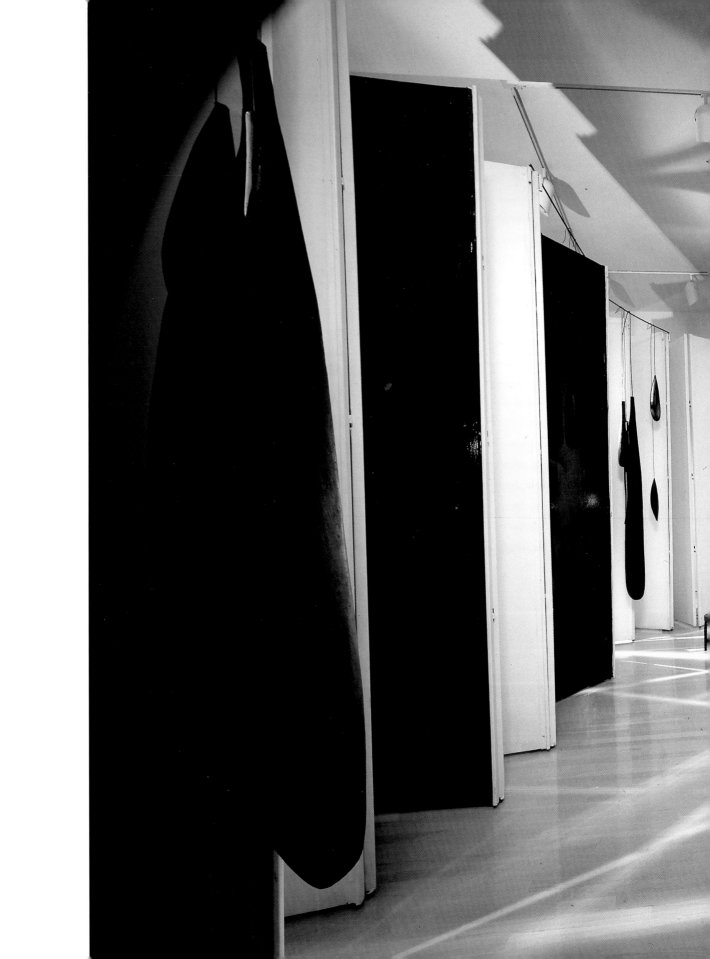

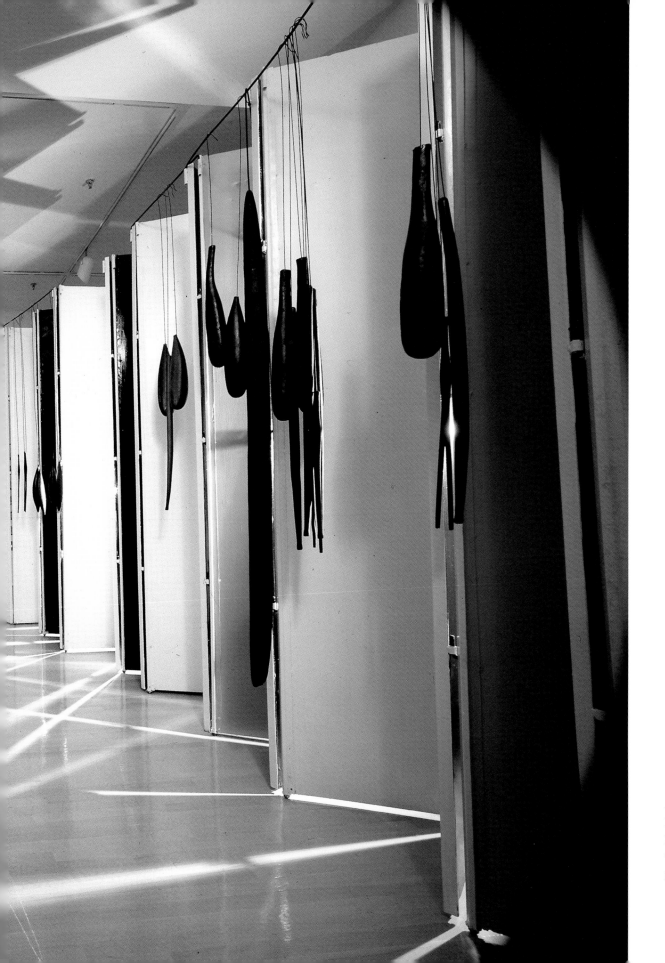

Articulated Lair, 1986.
Painted steel and rubber,
h. 335 cm.
The Museum of Modern Art,
New York.

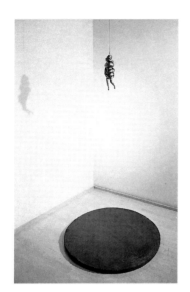

Spiral Woman, 1984.
Bronze and thread,
29.2 x 8.9 x 11.4 cm;
disk, diam., 86.3 cm.
Dannheisser collection.

The *Spiral Woman* (1984) hangs in the air, a spiral torso with legs and arms poking out. It harks back to the idea of the fickle woman, but seems more vulnerable. The small, swirling figure conveys a feeling of great psychic suffering, a mixture of loneliness, confusion and impotence. "Spirals—which way to turn—represent fragility in an open space. Fear makes the world go round."[8]

The tall, steel house entitled *Maison* (1986) is composed of several floors comprising a vertical arrangement of clusters of proliferating ovoid forms. The shelf-like presentation was prefigured in a drawing of 1946 (*Untitled,* Whitney Museum, New York), and suggests the idea of collection as later found in *Le Défi* ["The Challenge," 1991] and other works in the same series, all constructed around an accumulation of objects that are similar in nature.

A second environment, after *The Confrontation*, dates from 1986 and is called *Articulated Lair*. After having built nests, lairs and small houses, Bourgeois felt the need to construct spaces that she herself—or the spectator—could actually enter. *Articulated Lair* is composed of forty-two bent and crumpled metallic doors arranged in a circle. In the middle is a small stool for sitting alone or meditating, while doors in front and in back suggest that escape is possible. At the top of the doors are hung oblong objects in black rubber, similar in shape to drops of water or to a weaver's shuttle. Bourgeois sees these objects that hang from the ceiling as "frightening, accusing presences"[9] in the form of symbols. "By symbols I mean things that are your friends but that are not real. Symbols are indispensable because symbols allow you to communicate at a deep level with people."[10]

The same shape exists on its own, pierced by a square tunnel, in *Lair* (1986), and recurs in *Towers* (1994) and the two *Red Rooms* (1994). Its meaning alters as a function of the environment. It is in any case a hybrid of several formal elements. *Articulated Lair* once again establishes an opposition between architectural rigidity and organic, oscillating forms, but the meaning of this environment remains ambiguous—the fan-shaped structure of the shelter effectively allows the space to dilate or contract. In this, the first empty cell, it seems that nothing specific is expected, yet it provokes a simultaneous desire for and fear of solitude. Its black color underscores the idea of sadness, and the feeling it evokes lies halfway between the safety of a hiding place and the isolation of a prison cell.

Maison, 1986.
Plaster and steel, 190.5 x 52 x 23 cm.
Fundacion Cultural Televisa, Mexico.

Untitled, 1946.
Ink and gouache on paper,
61.5 x 46.4 cm.
Whitney Museum of American Art,
New York.

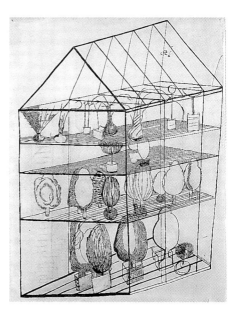

No Exit

Pursuing the logic of her work on confinement, Bourgeois produced two pieces with stairways that might initially appear as fire escapes or paths leading upwards. But in fact, the stairs in *No Exit* (1988) and *No Escape* (1989) lead nowhere. Even though they suggest the idea of ascent, they oblige the gaze to climb and fall perpetually, like Sisyphus on his mountain. It is hard not to think back to the ladders knocking against the ceiling in one of the engravings from *He Disappeared into Complete Silence* (1947), which also evoked the idea of lack of escape, an illusory flight from reality. In *No Exit*, the wooden staircase is surrounded by a screen of doors painted blue and black. In front sit two large balls of wood that transform the staircase into an erect phallus inside a feminine circle. Behind the staircase, in a secret corner that recalls childish hiding places, there hang a pair of hearts made of pale blue rubber. This secret cache of affection lends a note of happiness to an otherwise pessimistic vision of life. "Our salvation is in two hearts. The issue is how much do you care for somebody else. It is how much you have been able to trust. . . . Trust is a thing I've never been able to reach. It's pretty sad. It's sad, but you get used to it."[11] Within this environment, interior and exterior spaces interpenetrate to abolish the frontier between inner and outer, just as the black oblong shapes dangling into *Articulated Lair* intrude to disturb the inner, peaceful space of the doors. A door is normally either open or closed, but with Bourgeois the two possibilities coexist. Both of these sculptures suggest an antinomy between contrary elements, a tension between opposing thrusts. *No Exit* is a translation of the title of Jean-Paul Sartre's play *Huis Clos* [literally, "closed doors"], in which Sartre claimed that "hell is other people." But, adds Bourgeois, hell is also the absence of other people. (The reference to existentialism is explicitly acknowledged by Bourgeois, who claims to be fascinated not only by Heidegger's concept of *Angst* but also by the introduction of humor into the tragic.)

Alongside these monumental pieces typical of the most recent period of her œuvre, Bourgeois extended the concept of "nature studies" through a series of sculptures done in pink marble. Their titles—*Untitled (with Foot), Untitled (with Hand),* and *Untitled (with Growth)*—immediately indicate that they entail a mixture of abstraction and representation. In this respect, the titles Bourgeois gives to her pieces are significant, oscillating as they do between abstract generalization and representational or autobiographical anecdote. With this series, blocks of roughly hewn marble serve as bases for smooth spheres from which there may emerge an arm or a leg. This primal form, conflating womb and embryo in a single element, evokes Brancusi's *Newborn* and alludes to birth and procreation. Each piece of material contains a human element. During this same period, a commission from the city of Chicago resulted in a granite sphere from which emerge numerous hands, including the hands of workers of various races;

No Exit, 1988.
Wood, painted metal, rubber and wood from Gummi, 209.5 x 213.3 x 243.8 cm. Ginny Williams Family Foundation, Denver.

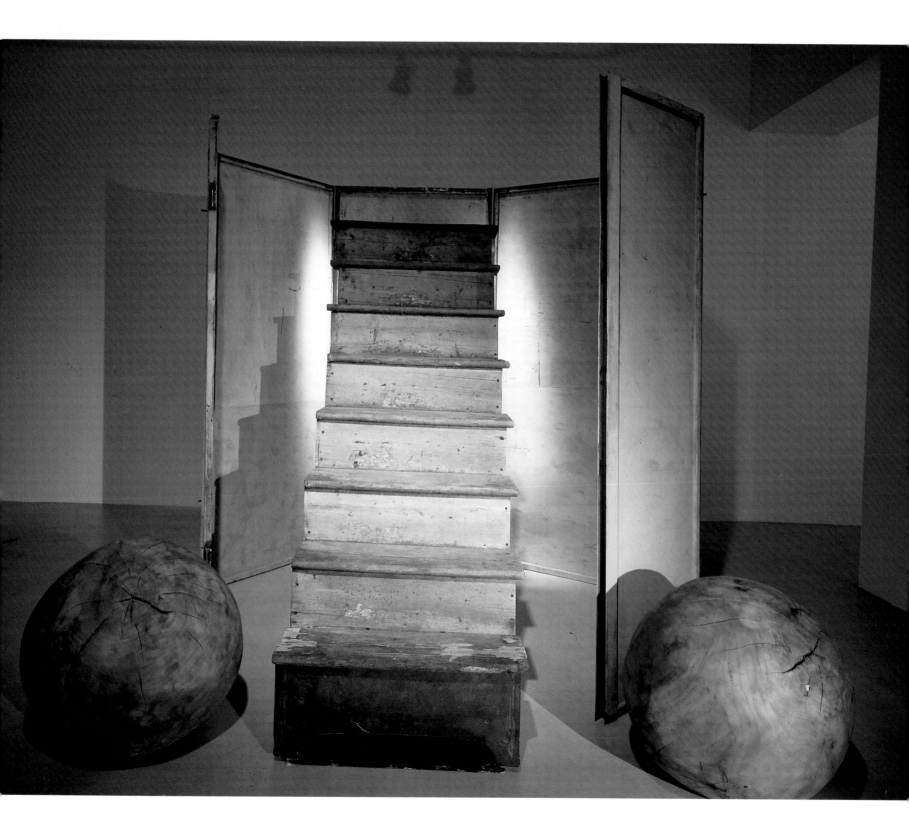

Bourgeois sees the piece as a social and political manifesto. The final work in the series depicts pistils emerging directly from a block of marble. As in *Germinal* (1967), Bourgeois managed to coax life from the hardest and coldest of materials. The emotion provoked by this vital force, this apparition of human beings, is underscored by the inscriptions etched in triplicate on to the bases of these works: "I love you" on *Untitled (with Hand)*, "Do you love me?" on *Untitled (with Foot)*, and "We love you" on *Untitled (with Three Hands)*, all of 1989. The same phrases can be found on drawings and fabrics, becoming a sort of affective, obsessive credo that stresses the incommunicability of love.

Also from the same period are two monumental sculptures in marble, *Sail* (1988) and *Cleavage* (1991). The former, riddled with holes and tunnels, opposes a smooth surface (with an eye-like slit) with another surface marked by meandering grooves that flutter like sails in the wind. The latter piece, more bloated, alternates holes with breast-like protuberances; both its title and form simultaneously evoke the concepts of fissure and

Untitled (with Foot), 1989.
Pink marble,
76.2 x 66 x 53.3 cm.
Artist's collection.

Untitled (with Hand), 1989.
Pink marble,
78.7 x 77.4 x 53.3 cm.
Robert Miller Gallery, New York.

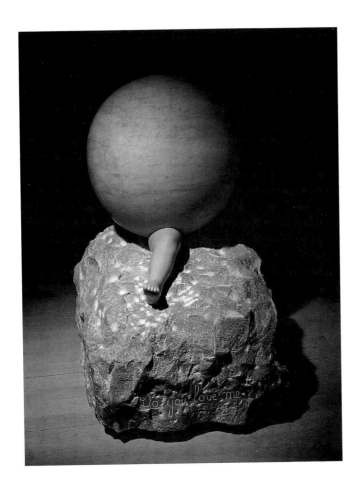

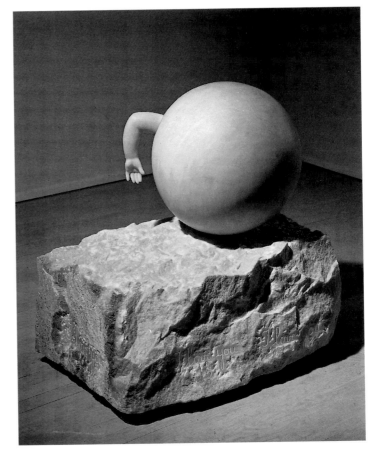

the curve of the breasts. It thereby reflects the artist's psychic makeup by creating solids from a void, by juxtaposing male and female organs, indeed fusing them through "the fantasy of introjection."[12] The holes in the marble recall the *Lairs* and prefigure the dwellings, even as they turn these sculptures into a form of desiring machine.

The last work of the 1980s devoted to a part of the body concerns the hands. *Décontractée* ["Relaxed," 1990] presents a cast of long, thin hands, open and confident, that seem content to place themselves in the sculptor's hands. This relaxation serves as a counterpoint to earlier tension, pointing to a more serene and happy period in the artist's life.

NOTES

1. Paola Igliori, *Entrails, Heads & Tails*, (New York: Rizzoli, 1992).

2. *Ibid.*

3. In French, one historical meaning of "nature" is "the genital parts, especially of female animals" (*Dictionnaire Littré*).

4. Interview for the film *Louise Bourgeois* by Camille Guichard, (Paris, 1993).

5. Robert Storr, "Meanings, material and milieu–reflections on recent work by Louise Bourgeois," *Parkett*, no. 9, June 1986, p. 82.

6. Guichard, *Louise Bourgeois.*

7. Storr, "Meanings, material and milieu," p. 83.

8. Christiane Meyer-Thoss, *Louise Bourgeois, Designing for Free Fall*, (Zurich: Ammann Verlag, 1992), p. 179.

9. Interview with the author, December 1994. The mysterious *Articulated Lair* was exhibited in the "Magiciens de la terre" show organized by the Centre Georges Pompidou, Paris in 1989.

10. Storr, "Meanings, material and milieu," p. 83.

11. Meyer-Thoss, p. 183.

12. Rosalind Krauss, "Portrait de l'artiste en fillette", *Louise Bourgeois*, (Lyons, 1989), p. 236.

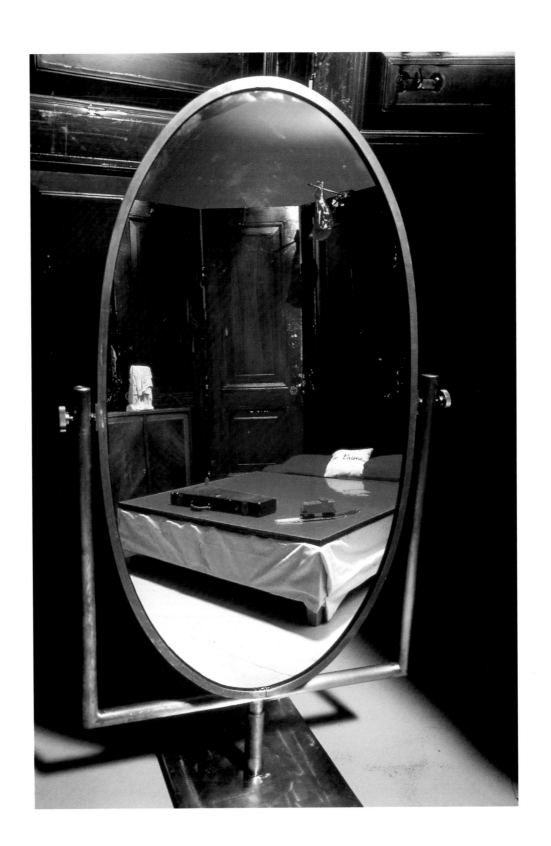

SITES OF MEMORY

The Cells represent different types of pain: the physical, the emotional and the psychological, and the mental and intellectual. . . . Each Cell deals with fear. Fear is pain. . . . Each Cell deals with the pleasure of the voyeur, the thrill of looking and being looked at.[1] L.B.

The work of recent years reveals that the central theme of Louise Bourgeois's entire œuvre is indeed the house, which has consistently provided a basic organizational framework. Whether expressed as femmes-maisons, as lairs, or as cells, her work has been articulated around the house as a metaphor for the body, a dialogue between container and content, between exterior and interior; indeed, passages and connections between the two terms are embodied by architectural doors and windows. Her system of joining doors to form an enclosure, as employed in *Articulated Lair* (1986) and *No Exit* (1988), opened the way to the monumental sculpture–environments that typify the latest period. These half-closed places, open to the viewer's gaze, are magical rooms where some secret ceremony takes place, where an ancient wound or fear is being re-enacted, exorcised. The older Bourgeois gets, the more it seems she goes back in time, getting ever closer to her earliest childhood memories, and the more she thinks big, making "life-size" reconstructions of childhood feelings. The cells, whether round or square, allow her to pile up symbolic objects, gather scraps of memories, assemble the eternal protagonists of the family drama.

The work of the 1990s has been coordinated around major international shows, to which Bourgeois is now invited and for which special works have been produced—*Cells I* to *IV* for Pittsburgh (1991), *Twosome* for "Dislocations" (1991), *Precious Liquids* for Documenta IX in Kassel (1992), and *Cell (Arch of Hysteria)* followed by five *Cells* for Venice (1993). Alongside these monumental pieces, Bourgeois has produced individual sculptures like *Ventouse* (1990), *Le Défi* (1991) and *Mamelles* (1991). Now over eighty years old, Bourgeois continues to reinvigorate her artistic idiom, discovering new approaches and new materials in an unceasingly dynamic process. Each discovery seems to take her into new territory. A short time after the *Cells*, she produced a series of large, curved *Needles* that allude to her parents' tapestry workshop; then came the spiders, another form of homage her mother as a "spinner." The most recent installation to date, entitled *Red Rooms* (1994), represents a synthesis of her entire œuvre, at the same time explicitly evoking the fundamental moment of the primal scene by depicting the bedrooms of parents and children, complete with a range of links between those two sites.

Sensory Cells

The word "cell" evokes not only a living organism, a tiny packet of life containing all the information required by the whole being, but also the idea of solitary and contemplative withdrawal into a monastery or prison. The first *Cells*, numbered I to VI, were exhibited at The Carnegie International in Pittsburgh. *Cell I* resembles a bedroom, since

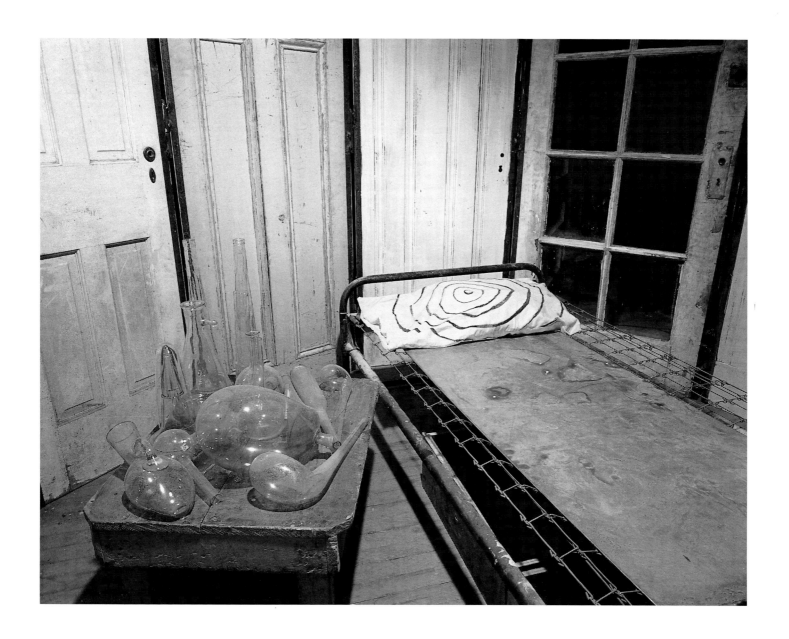

Cell II, 1991.
Mixed media, 210.8 x 152.4 x 152.4 cm.
Carnegie Museum of Art, Pittsburgh.

Cell III, 1991.
Mixed media, 281.9 x 331.4 x 419.4 cm.
Ydessa Hendeles Art Foundation, Toronto.

it contains an iron bed covered with a coarse cloth on which is written, "I need my memories. They are my documents." The pillow, meanwhile, is decorated with a target. There is also a low table on which are set various glass objects such as tubes, bottles, distilling devices. Glass has been a favored material during this period, for it appears in almost all the *Cells* in various forms: found objects recovered from oil lamps or laboratory equipment, flasks, vases, bottles, blown glass. Bourgeois appreciates glass for its transparence (symbolizing truth) and its inherent combination of hardness and fragility. The link between the empty bed (suggesting rest, sleep, dreams) and the distillation of emotional fluids prefigures the alchemical machine of *Precious Liquids*. An impression of abandonment, emptiness and absence predominates here. The voyeur–spectator is plunged into an atmosphere of expectation and anguish.

Cell II juxtaposes nine empty Shalimar perfume bottles of different sizes with a pair of pink marble arms (hands joined and fingers turned inward), all set on a round, mirror-topped table. The perfume symbolizes the sense of smell. (After years of focusing on the sense of sight, Bourgeois incorporates all five senses in these rooms, especially those senses linked to orifices.) But the perfume also symbolizes the evanescence of pleasure, a brief whiff of the past, the essence of a person or place. It is often smell—which triggers an instantaneous physical sensation—that opens a door to memory, suddenly allowing the past to intrude on the present. The scent of the past is the most subtle and most lasting souvenir. Its evocative power is so strong that Bourgeois said she once fainted on entering a hotel room where there was a typically French odor of sewers. She used to say that things "smelled of France," and sometimes she still finds it physically difficult to confront the past (which makes mourning inevitably painful). Most of these pieces, then, play on the opposition between two conflicting forces—here the frivolous lightness of costly perfume contrasts with the painful tension of the contracted, supplicating hands, as though pleasure and suffering were indissolubly linked.

Cell III, with its black and white doors, presents a more violent scene, a threat of danger. Indeed, the sense of drama waxes and then wanes throughout the series of six cells; *Cell II* and *Cell IV* are the largest, most heavily charged and most representational, whereas the first and last are the smallest, sparest and most abstract. In a corner of *Cell III*, the blade of a black paper-cutter rises above a small feminine figure arched backward, prefiguring the arch of hysteria even though the curve here is harmonious and graceful, more soaring and orgasmic than painful. But the menacing blade seems to forbid or punish this erotic pleasure. Nearby, a leg with clenched foot (position of hysteria) emerges from a block of marble. Between the two, an oval mirror reflects a third image (the eye-like mirror is another leitmotif running throughout the cells). On one of the doors of the enclosure is a faucet with two taps, hot and cold, evoking the liquid element. The poised blade also seems to suggest that it is impossible to separate orgasmic pleasure from suffering, thereby prefiguring the guillotine in *Cell (Choisy)* and the band saw in *Arch of*

Cell IV, 1991.
Mixed media,
208.2 x 213.3 x 213.3 cm.
Ginny Williams Family
Foundation, Denver.

Hysteria. The disproportion between the feminine figure and the masculine leg evokes the relationship between child and adult.

Cell IV alludes to the sense of hearing. An enclosure of white doors contains three elements: a wooden pedestal, a large ear carved in marble, and a sort of gong formed by a disk against which hangs a metallic stick attached to a string. The room here serves as amplifier to the large ear which suggests not only the depth of the inner canal—receptacle of all sounds and refrains of the past— but also the talismanic sacrifice of artists, the famous ear cut off by Van Gogh. In a way, the violence of amputation was prefigured by the paper-cutter. Indeed, the cells are closely linked to one another so that each one, although autonomous, is merely one chapter of a fuller story.

Cell V closes completely upon itself; the four doors, two of which includes small-paned windows, offer a glimpse of two large wooden spheres. Such spheres already appeared in *No Exit* and *Gathering Wool* (1990), and would recur in *Precious Liquids*; they represent a childhood memory of balls of wool used in the weaving workshop in Choisy. Here they are grossly enlarged in order to reduce Louise to the stature of a little girl. Spheres of every material can be found in Bourgeois's œuvre—glass, marble, rubber, wood—and they may symbolize people or individual entities; assembled in groups of three or five, they represent the Bourgeois family, as seen in *Cell (Three White Marble Spheres)*. The sphere is the perfect form of unity, the primal shape of birth.

Cell VI functions as a conclusion. It presents an even smaller and more hermetic space, harboring the small stool seen in *Articulated Lair*. To escape confinement, the only possible way out seems to be up. This refuge, cut off from the world, could be perceived as a hiding place or a dungeon.

These six cells present varying voyeuristic situations; spectators are invited to look either through a window or through a more or less open door, but they can never enter the interior. They remain helpless witnesses to a drama to which they have nevertheless been summoned. The partial vision of the inside of the cells furthermore arouses curiosity and intensifies the mystery. "The *Cells* attract or repel one another. They urge completion, merger or disintegration."[2] These cells spark auditory and olfactory memory, pain and pleasure, artistic solitude. Each one is the concretization of a feeling, incarnating a complex and contradictory emotion that resonates with all the others.

Cell VI, 1991.
Painted wood and metal,
160 x 114.3 x 114.3 cm.
Robert Miller Gallery, New York.

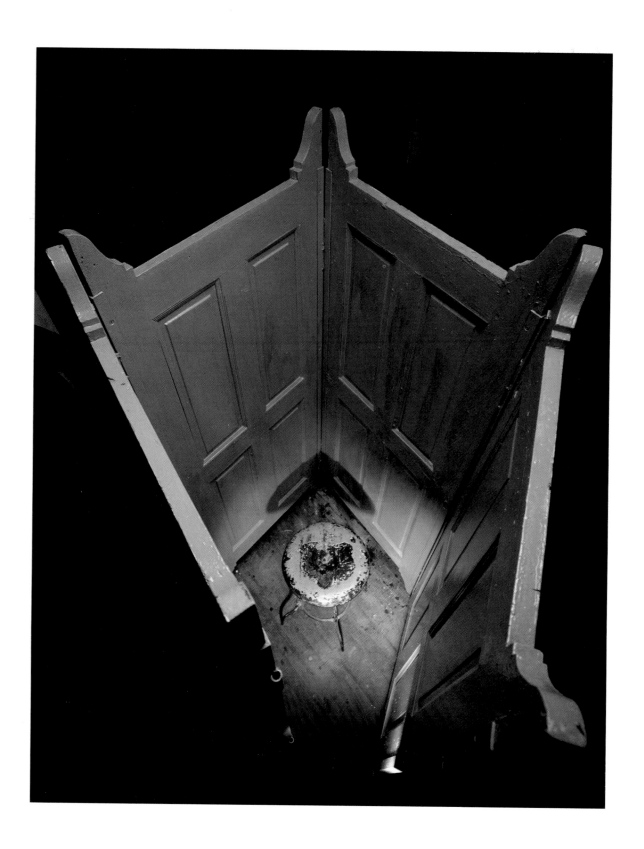

Twosome

For the "Dislocations" exhibition organized by Robert Storr at New York's Museum of Modern Art in 1991, Bourgeois—now one of the leading lights of contemporary art—produced a spectacular if atypical kinetic sculpture. The verticality of the houses and cells here gave way to the horizontality of two enormous cylinders on rails, the smaller one sliding in and out of the larger one. The cylinders, in fact, were once gas tanks designed to hold polluting oils, and they came from Connecticut where Bourgeois has a country home. The door and three windows cut into one of the cylinders constitute a "portrait" of that home. The inside is lit in red. The sexual and erotic connotations are obvious, for the mechanism that moves like a piston accentuates the impression of a "fucking machine."[3] However, this fundamental relationship between two elements also symbolizes, according to Bourgeois, a child who leaves the mother's womb yet continually returns because the umbilical cord is never cut. *Twosome*, she has said, represents a child who seeks independence at any cost, who constantly flees parental tyranny, yet who does not know what to do with that independence, and thus continually returns home. But *Twosome* also refers to a dialogue between a woman and a man. "It is a psychological relationship. Everyone wants to see it as a sexual relationship, but it's presexual. It's the attraction of the feminine element and the masculine element before fornication."[4] An alternation between attraction and repulsion, along with an oscillation between receptacle and penetration, are constant features of Bourgeois's work and are revealing of the way she conceives eroticism as encompassing desire, maternity, seduction—indeed every form of twosome, from resistance to acceptance. "It relates to birth, sex, excretion, taking in and pushing out. In and out covers all our functions. In and out is a key to the piece. . . . Two people constitute an environment. One person alone is an object."[5] *Twosome*, produced with the help of a computer, is one of the artist's favorite pieces. Probably because it entails not only new techniques but also unconscious meanings that escape her. "There are several levels of interpretation. The deepest and least known level is the question of pleasure, and that question of pleasure is erotic."[6] Whatever its exact meaning, the red lights inside indicate that, in both cases, a tragic situation is involved. The colors red and black used in *Twosome* would become the dominant colors of the *Red Rooms* (1994).

The two series of *Cells* are complemented by a number of individual works, each of which in its own way echoes themes addressed in earlier or subsequent pieces. *Ventouse* ["Cupping-glass," 1990], a block of black marble covered with actual cupping-glasses (some of which are lit from within), alludes to Bourgeois's mother, ill with emphysema, and to the therapeutic glasses that Louise herself often applied. The relationship between art and illness, whether physical or psychic, is directly expressed here.

Twosome, 1991.
Steel, paint and electric light, varying length, approx. 11.50 m, diam. 1.60 m.
Robert Miller Gallery, New York.

Facing page:
Le Défi, 1991.
Painted wood, glass and
electric light,
171.4 x 147.3 x 66 cm.
The Solomon R. Guggenheim
Museum, New York.

Untitled, 1990.
Orange peel, stitched
on to cardboard,
35.5 x 21.5 cm.
Karsten Greve Gallery, Cologne.

Le Défi ["The Challenge," 1991] is a shelf of rough wood painted blue, filled with glass containers. The challenge involves stacking all that glass without breaking any, overcoming the unconscious desire to smash everything. On the bottom shelf are placed round mirrors and lids, on one of which is written: "Je t'aime." The piece incorporates an electric light that gives it a translucent feel. Once again it employs the basic materials used in the *Cells*, namely glass and mirrors. The various shapes and sizes represent, for Bourgeois, the classification of memories. Transparence evokes not only clarity, but also the fragility of truth and confidence. Accumulation and repetition are driving forces behind her œuvre, partly because her work is based on the unconscious (and the unconscious repeats itself), and partly because Bourgeois is an obsessive collector who reassures herself by accumulating things.

Mamelles ["Teats," 1991] is a wall relief composed of pink rubber molds of breasts, forming a horizontal frieze with little doors and holes that resemble tunnels. This accumulation of nourishing female forms represents, says Bourgeois, "a man who lives off the women he courts, making his way from one to the next. Feeding from them but returning nothing, he loves only in a consumptive and selfish manner."[7] This type of interpretation is revealing of the projections made by Bourgeois on to Don Juans and other "devourers of breasts." It all appears as though she were fulfilling, in a way, their desire. Her ambiguous feelings toward fickle men are vestiges of her mixed feelings toward her father. In the same spirit, Bourgeois produced a collage entitled *Orange Episode*, the meaning of which is only comprehensible with the story that accompanies it. "It's a game that my father learned in the trenches, and that he often played with us at the table after meals, with an orange-peel. With a knife you cut the shape of a woman in the peel—head, shoulders, breasts and belly—in such a way that the stem of the orange is where the 'genitals' would be. So when you peel it everything opens out, and you have a figure with fine hair and something dangling between the legs. My father would then say, 'Look, children, it's wonderful, look what she has. This little figure is a portrait of my daughter. Not Henriette, Louise—but Louise has nothing, there!'"[8] This figure of phallic woman alludes once again to the artist's masculine side, and consequently to the difficulty Bourgeois would have in assuming her femininity in the face of an immodest, mocking father who held the female species in contempt.

Precious Liquids

Precious Liquids was produced for the 1992 Documenta IX exhibition in Kassel, and represents a key work and pivotal link between the two series of *Cells*. It is a synthesis, and perhaps the most emblematic work of the period. Unlike the open, transparent spaces

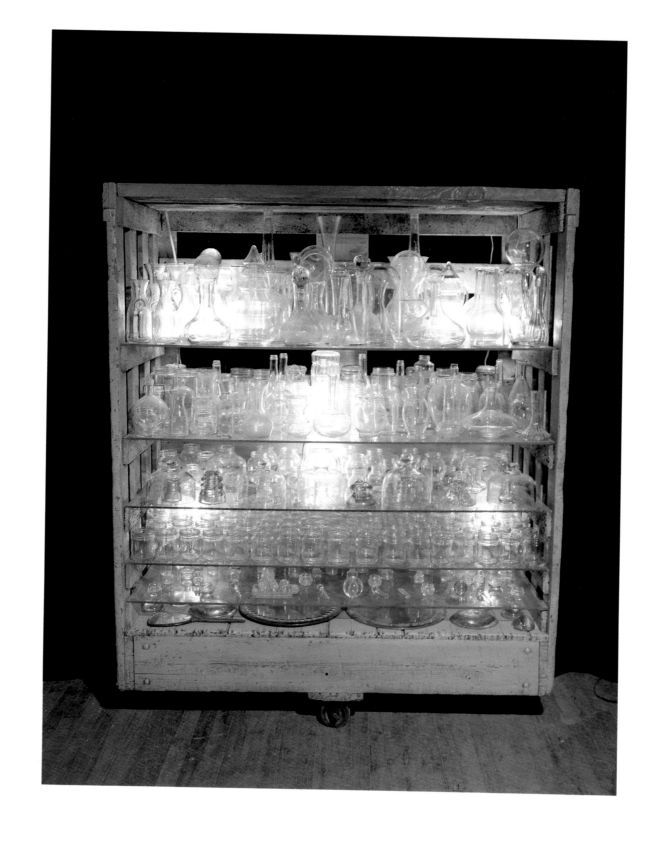

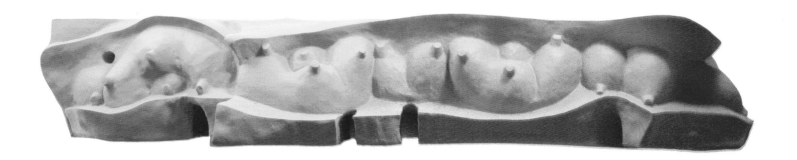

of the earlier pieces, *Precious Liquids* entails a closed and dark space, one that can nevertheless be traversed. A cause and effect relationship exists between container and content insofar as the interior of this immense cask—a water tower typical of New York roof tops—is devoted to the distribution of liquids. The choice of water tower as dwelling place is significant in many respects: the "little house" perched in the sky reminds Bourgeois not only of her first workshop on the roof but also of the sculptures that she made with redwood from those very same water tanks. For Bourgeois, the precious liquids are those that issue from the body: blood, urine, milk, sperm, tears, all the fluids that flow as a result of an emotional shock like love, fear, pleasure or suffering. "Since the old fears were linked to bodily functions, they resurface via [the body]. *For me, sculpture is the body. My body is my sculpture.* Glass becomes a metaphor for muscles. It represents the subtlety of emotions, the organic yet unstable nature of the mechanism. When the body's muscles relax and untense, a liquid is produced. Intense emotions become a material liquid, a precious liquor."[9] Within the wooden tank is an iron bed with a little puddle of water, surrounded by four uprights holding various glass containers. Facing the bed are two wooden spheres, above which is a man's enormous overcoat, wrapped around a little child's garment embroidered with the words *Merci/mercy*. On the other side are two balls of rubber, and a previous work in luminous alabaster, *Trani Episode* (1971–1972). The whole ingenious contraption has various meanings and works in various ways, as epitomized by the stagnant water on the bed that evaporates though the glass tubes, condenses, and flows back down again. The large coat symbolizes the Father, a repressive authority figure. "The little dress taking refuge in the overcoat represents the child who experienced strong emotions and who was able, through her own process of maturation, to feel sorry for the Great Extravagant Show-Off."[10] The coat is also a metaphor for the unconscious: "The little girl takes refuge in the same way that artists do." The linguistic pun embroidered on the dress expresses the feeling of gratitude and pity that Louise feels for her father. The special place she occupies in the coat's heart would tend to prove that her liberation is at last complete. "The little girl has become an adult," explains Bourgeois, "and finally discovers passion rather than terror." This passion is evoked by the presence of *Trani Episode*. Indeed, it would seem that *Precious Liquids* is the site of an endearing experience for Bourgeois, as witnessed by the maternal, reassuring nature of a work that is simultaneously masculine and feminine. The warmth and subdued light of this piece also express the immaterial nature of desire; Rosalind Krauss has pointed out that Bourgeois's entire œuvre can be related to Marcel Duchamp's "bachelor machine."[11] *Precious Liquids* —a key work constituting a synthesis of an entire period of her art—incorporates prior elements from *No Exit* and *Cell I* , and thus could indeed been seen as an inverse, feminine pendant to Duchamp's *Large Glass*, in which the relationship between the bachelors and the bride is mirrored by that between the girl and her father (or fathers). The mechanism of fluids here

Mamelles, 1991.
Rubber,
48.3 x 304.8 x 48.3 cm.
Artist's collection.

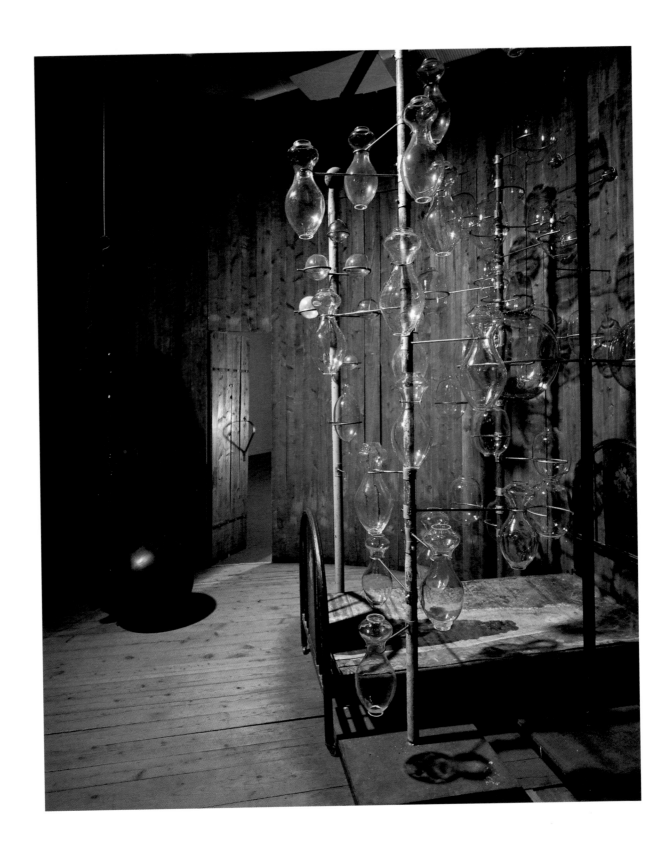

suggests fear and sweat. The flatness of the *Large Glass* is countered by the volume of *Precious Liquids*, transparence is countered by obscurity, the dry sterility of bachelorhood by the moist fecundity of maternity (suggested by the "pregnant" male coat, the two balls, the breasts of *Trani Episode*, the leaky liquid on the bed evoking the amniotic fluid of birth or, in the case of Bourgeois, of rebirth and renaissance). The moral of the work is engraved on a hoop outside: "Art is a guaranty of sanity." Its exorcising function is thus asserted once again: "Understanding and controlling fear helps you move forward day after day."

Facing page:
Precious Liquids, 1992.
Installation, redwood,
glass, alabaster, fabric, water,
427 x 442 cm.
Musée national d'art moderne,
Centre Georges Pompidou, Paris.

Childhood Cells

Chosen to represent the United States in the American pavilion of the 1993 Venice Biennial, Bourgeois produced a new series of five square cells in the form of wire cages, preceded by a manifesto-like piece entitled *Cell (Arch of Hysteria)*. The entrance to *Arch of Hysteria* is different from the other cells, because an enclosure of metal doors blocks all sight of the interior, forcing spectators to pass through a walled corridor. This labyrinthine system accentuates the effect of surprise. *Arch of Hysteria* is probably the most violent piece produced by Bourgeois during this period. On a bed embroidered with the words "Je t'aime" stretches a man whose back is arched in the typical pose of hysteria. His arms and head have been cut off, as though the band saw next to him had already been at work. The disturbing effect of this vision is produced first of all by the role reversal, then by the threat of dismemberment of a body about to be sawed into pieces. Bourgeois, known for her passionate interest in medicine, is fully familiar with Charcot's work on hysteria. "The hysteric is not a woman, as thought in the late nineteenth and early twentieth century, but a man, because men are hysterical, too." The model who "lent his anatomy" was Jerry Gorovoy, Bourgeois's friend and assistant; the elimination of useless limbs gave greater visual impact to the tension. "The use of Jerry as a model has nothing to do with Charcot's staging of hysteria," she asserts. "Jerry is not 'staged,' he participates in a drama for two but is not participating in theater. It is psychodrama."[12] The drama is played out between the declaration of love written on the bed, the threat of the saw blade that appears as a punishment, and the mixture of delight and suffering suggested by the pose of the body, purportedly representing what is taboo. Bourgeois claims to be more interested in nervous disorders than in mental illness. Indeed, she sees the nervous system as a link between the physical and the psychic, the human body's basic emotional and affective network. The inversion of male–female roles that so often occurs in her work inevitably raises the question of whether it is her own femininity that she projects on to the loved being via identification and fusion, or

Precious Liquids,
external view.

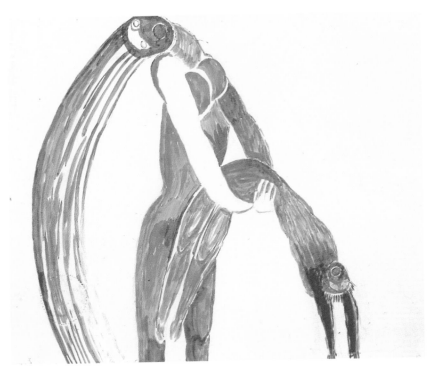

Altered States, 1992.
Gouache, ink, pen and pencil on paper,
48 x 60.5 cm.
Artist's collection.

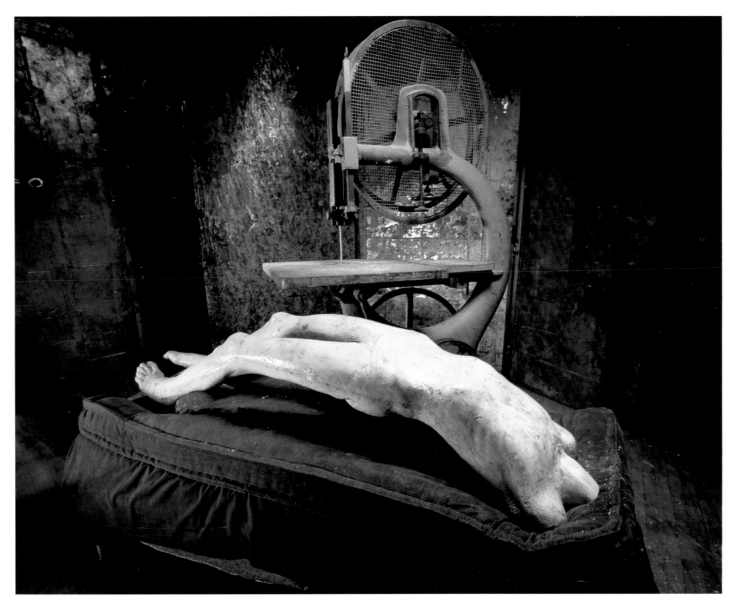

Cell (Arch of Hysteria), 1992.
Steel, bronze, cast iron and fabric,
302.3 x 368.3 x 304.8 cm.
Artist's collection.

whether it is the other who lends his masculine anatomy to a feminine pose. These two possibilities are united here in a single image. Reflecting back to the first appearance of this vision—in *Cell III* (1991), where a female figure in hysterical arch was opposed to a man's leg with clenched feet—sheds light on how much ground has been covered in order to arrive at this synthesis of a loving relationship; once again, it is a question of love. The body, originally of plaster, was ultimately cast in polished bronze, which gives it mirror-like quality and guarantees longevity; it recurred in another sculpture, also of bronze, *Arch of Hysteria* (1993), which was even more arched since the arms met the feet to form a circle, hanging from a thread. This position of extreme tension represents a threshold between strength and fragility, provoking uncertainty about whether the body will collapse or take flight.

Cell (Choisy) is perhaps the most explicit work in the series. It not only inaugurated the motif of prison-like cages, but also permitted a complete view of the interior. Wire mesh alternates with large panes of frosted or transparent glass, thereby creating various points of view. Bourgeois here depicts her childhood home in Choisy-le-Roi in pink marble. Overhead, the menacing blade of a guillotine is a double reference to France and to her past, since the guillotine "is there to show that people guillotine themselves within the family. The past is also guillotined by the present."[13] Bourgeois is well aware of the weight of that past; she heeds her memories, which often serve as the raw material of her work, and which she explores and exploits in order to exorcise and rid herself of them. Otherwise, she claims, it would be impossible to live, she would slide into melancholy and nostalgia. "You have to stop repeatedly suffering like an animal, it's dumb." So this mother–house, matrix of all houses, has finally been named, rebuilt, incarnated in a sculpture, finally enabling Bourgeois to confront the past, to confront herself.

Cell (Eyes and Mirrors) is devoted the artist's visionary gaze, to the need to look oneself in the face, to accept oneself. "The mirror, for me, is not a symbol of vanity, the mirror is the courage to look yourself in the face."[14] It thereby encourages self-criticism. Once again, Bourgeois diverts myth to her own ends: it is impossible to decide whether her Narcissus drowned himself because he was infatuated with his own beauty or because he could not accept his own image. In the middle are the eyes, represented by two spheres set in a block of marble, while mirrors are arranged all around. Of various sizes, these mirrors can move and tilt, reflecting a multitude of viewpoints. Two visions are thus juxtaposed—that of art versus that of reality. However profound the gaze, everything is artifice and reflection, mendacious.

Cell (Glass Spheres and Hands) alludes to education, to the relationship between teacher and pupils, mentor and disciples, parent and children, thereby reinvoking the old theme of *One and Others*. The clasped hands laid on a table (already employed in *Cell I*) are placed opposite five glass balls set on small chairs or stools. "The balls are

closed, self-contained organisms. If you touch them, they break. The Mentor is confronted by a brittleness that's unbroachable. They are in precarious, unstable equilibrium. So there's a constant threat, which can be accommodated but never changed. Change doesn't exist, the thing is immutable."[15]

Cell (You Better Grow Up) sums up, in a way, the whole series. In a single site it brings together mirrors, glass balls and clasped hands. Here, three hands are carved in a block of pink marble, set like a tray on two uprights. "Sitting on three pieces of wooden furniture are objects: a glass tower and three perfume bottles, a ceramic container with three openings, and a stack of glass shapes. The three hands are a metaphor for psychological dependency. The one large hand is holding the two small childlike hands as if to protect them. It is the hand of a mentor or guide, of an active, compassionate, reasonable adult. The little hands are helpless and dependent. They are in a state of fear and anxiety, which makes them passive."[16] Mirrors set on the walls and ceiling enlarge the enclosed space of the cell by offering visual escape. The multiplicity of reflections alludes to the "many difficult realities" that can thus make the world seem distorted and disordered to a child. Bourgeois tirelessly repeats her message, with increasing explicitness, apparently addressing herself as much as other artists or spectators. "Until the past is negated by the present, we do not live. . . . In our refusal to confront our fear, we retreat into nostalgia. Fear condemns us to a rejection of the present. The present is kept intolerable. We must call for help from the past to solve the problems of today."[17] Torn between past and present, between conscious and unconscious, active and passive, adult and child, Bourgeois finds herself trying to square the circle. This contradiction nevertheless appears to be a necessary condition for artistic creativity. "The artist, like the child, is passive. The artist remains a child who is no longer innocent yet cannot liberate himself from the unconscious. The acting out of his terror is self-involved and pleasurable. Some artists act all their lives instead of thinking. Self-expression excludes learning."[18] The price to pay for artistic sublimation is a total lack of self-knowledge. But Bourgeois does not feel that psychoanalysis is inevitably harmful to artists, because she thinks that self-knowledge can make them better artists. "The self-indulgent shapes in glass and in ceramic are a form of romanticism, a state of abandon, a *laissez-faire* attitude, a childlike dream" says Bourgeois, referring to *You Better Grow Up*. "The perfume bottles [create] a nostalgic mood. . . . The tiny figure inside the stacked glass shapes is cut off from the world. That's me. The little hands are mine. They are self-portraits. I identify with the dependent one. . . . So the moral of this Cell is, you better grow up."[19] This piece and Bourgeois's own interpretation of it show the extent to which art is therapeutic for her, a tool of knowledge, a philosophy of life expressed in Socrates's "Know thyself," which she often cites.

The last cell of the series, entitled *Cell (Three White Marble Spheres)* is again a summing up, an extreme simplification of everything that has gone before. Two of the

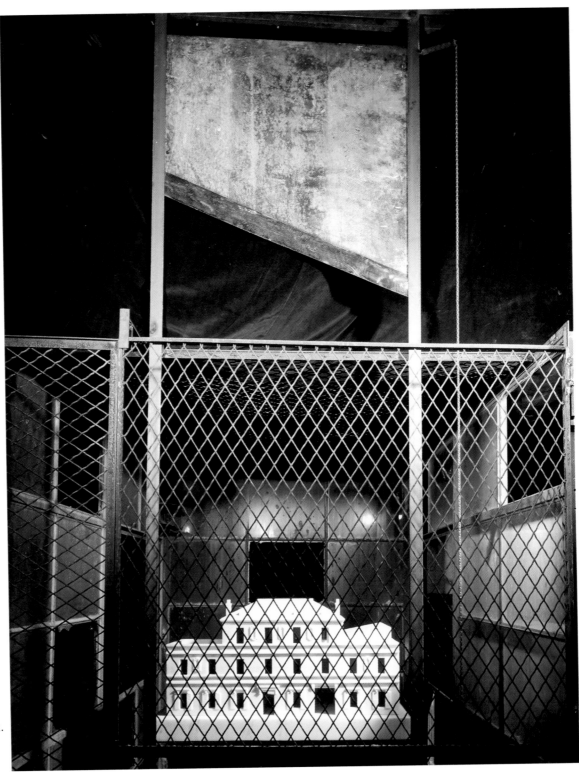

Cell (Choisy), 1991.
Metal, glass and marble,
302.3 x 368.3 x 304.8 cm.
Ydessa Hendeles Art
Foundation, Toronto.

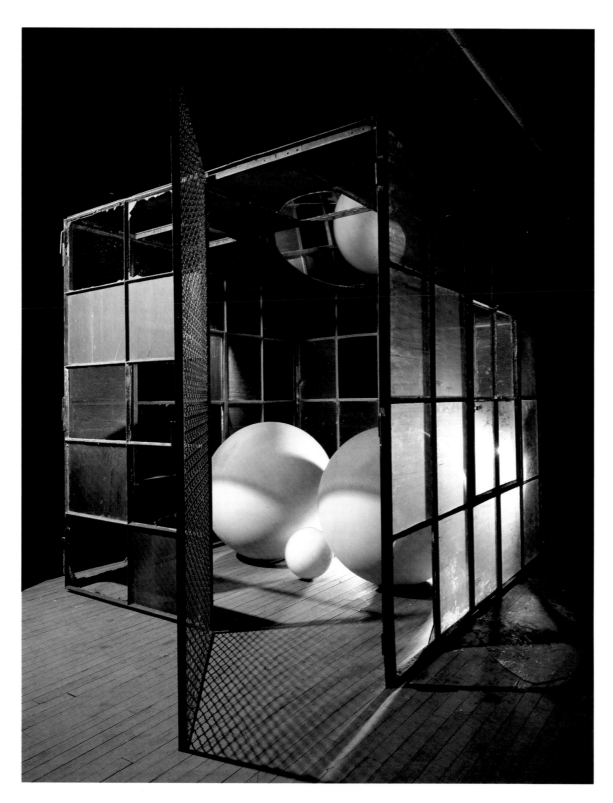

Cell (Three White Marble Spheres), 1993. Steel, glass, marble and mirror, 213 x 213 x 213 cm. Artist's collection.

three white marble spheres in the half-open cage are large, the third small: parents and child, the triangular family, the basic trio of her entire œuvre. Here again Bourgeois returns to the language of abstraction, to pure geometric forms, spheres in a square.

In this suite of cells, Bourgeois brought together all the recurring themes in her work, focusing on the role of the past in the creative process, the weight of familial authority, and masculine–feminine relations. Sex is much less present than previously—these pieces constitute a development of *The Destruction of the Father*. Her most recent work, in contrast, has been devoted to her mother, and consequently to her own role as mother.

Needles, Spindles, Spiders

Bourgeois's mother has always been associated with tapestry restoration and everything either directly related to it (needles, thread, distaffs, weaving) or metaphorically linked to it (spiders and the webs they spin). In 1992, Bourgeois exhibited a new series of sculptures in the Karsten Greve Gallery in Paris. Various items were hung from the end of tall, curved shafts of steel: flax, an eye, aquariums filled with water, a garment. If the object looked like it might make the needle tip over, Bourgeois attached a counterweight in the form of several metallic weights. This arrangement, even when unnecessary, lent greater tension to the items offset against one another. *Needle (Fuseau)* (1992) is the most literal piece in the series: the eye is threaded with a skein of flax wound in a flat circle on the floor. The two spheres on either side provide a phallic connotation. These thread-like sculptures, embroidered in space, convey extreme precision and testify to Bourgeois's acute attention to detail. Here she may hang two small blue balls like eyes, there a crystal pendant, elsewhere an eye pierced with needles inside a bell-jar.

The needles were followed by vertical towers made from tubing and other found materials, and from which strange objects also hang. For instance, a bloody red heart and glass jewelry dangle from *Tower* (1992). Bourgeois would extend the logic of weaving and spinning by producing a series of metallic uprights bearing numerous bobbins of pink, black or white thread. *In Respite* (1993) was endowed with a pink rubber pendant recalling the black shapes of the earlier *Articulated Lair*; the organic object serving here as a target for the many needles stuck into it. Bourgeois has pointed out that when she was young, "all the women in my house were using needles. I've always had a fascination with the needle, the magic power of the needle. The needle is used to repair the damage. It's a claim to forgiveness. It is never aggressive, it's not a pin."[20]

The accumulation of balls and skeins of yarn which evoke weaving, and therefore the Three Fates, is also a metaphor for human fate—the thread of life, time that unravels, death. It was those threads, that framework, which provided the point of

Needle, 1992.
Steel, flax, mirror and wood,
276.8 x 256.5 x 142.2 cm.
Artist's collection.
Karsten Greve Gallery, Cologne.

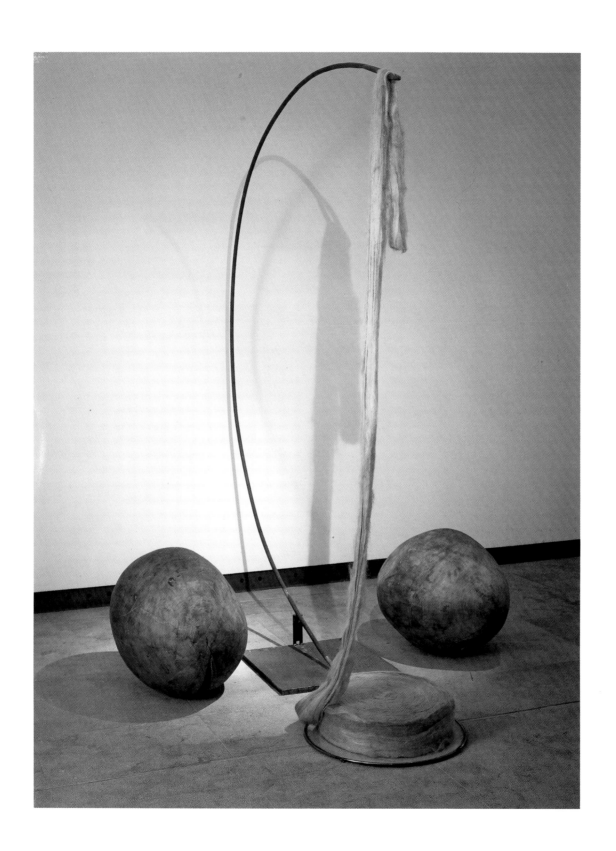

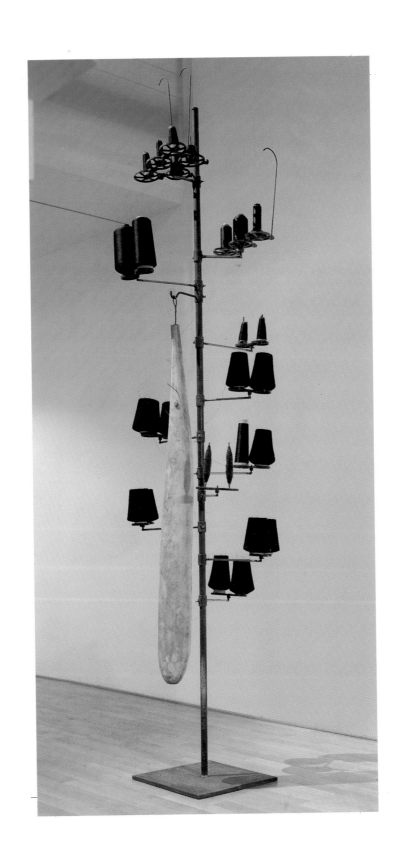

departure for her spiders. On the back of one spider drawing she wrote, in a mixture of French and English: "Spider, the mother cuts the spider's web," and on the back of another: "The friend (spider, why spider?). Because my best friend was my mother, and she was . . . [as] clever, patient, neat, and useful as a spider. She could also defend herself." Bourgeois sees spiders as beneficial animals since they eat flies and mosquitoes, even though they symbolize fear of death and female genitals for some people (for men, a spider is often imagined as a furry beast that lures victims into its web to devour them). The numerous drawings Bourgeois has produced on this subject are accompanied by a few sculptures of varying dimensions: a moderate-sized *Spider* (1994) with smooth and pointed legs, whose belly is a jar filled with blue water; a giant, terrifying *Spider* (1994) with twisted legs that she exhibited shut up in a little room at the Brooklyn Museum show; and a family of five spiders entitled *The Nest* (1994). Once again, the family recurs. The spider is her mother. "I'll never tire of picturing her," she wrote on the back of a drawing. Having at last reconciled the two images of father and mother, having reconstituted the discordant couple, Louise could then confront the "primal scene" by depicting her parents' bedroom.

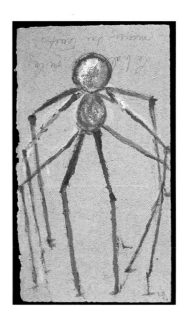

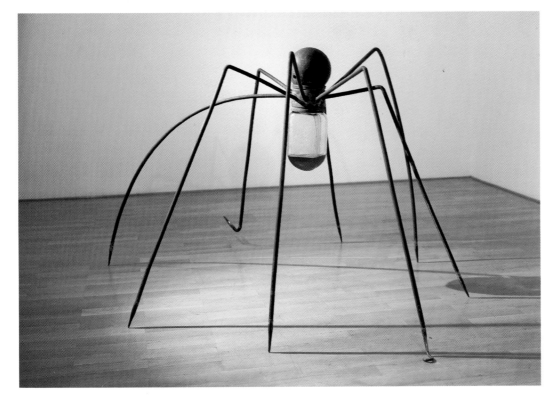

Above:
Araignée, 1994.
Ink, gouache and pencil
on paper, 31 x 18.4 cm.
Robert Miller Gallery, New York.

Left:
Spider, 1994.
Steel, glass, water and ink,
116.2 x 198 x 164.5 cm.
Karsten Greve Gallery, Cologne.

Facing page:
In Respite, 1993.
Steel, thread, rubber,
328.9 x 81.2 x 71.1 cm.
Karsten Greve Gallery, Cologne.

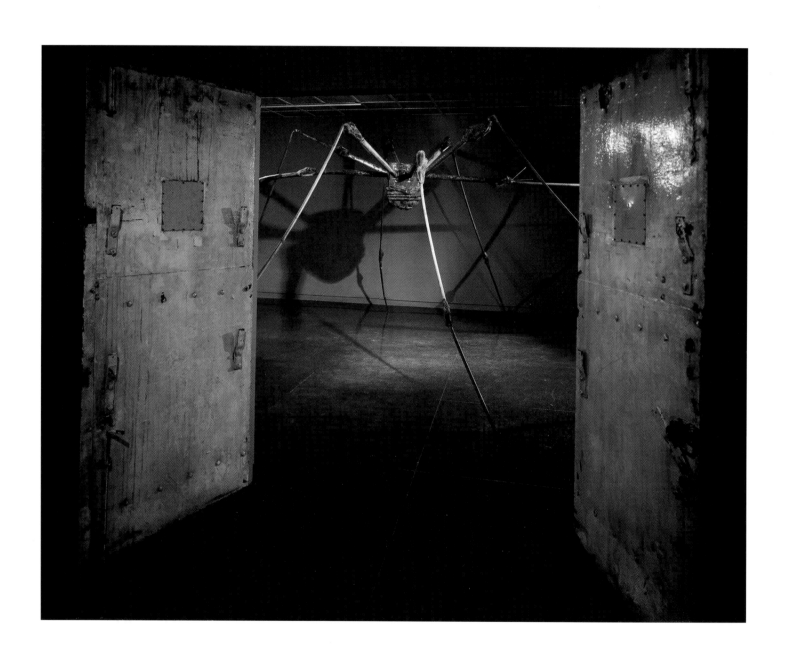

Red Rooms

This piece was presented at Peter Blum's gallery in New York to accompany the 1994 publication of a book of photographs of Bourgeois's childhood (the title was taken from a 1947 painting). Red, for Bourgeois, is the color of passion; when combined with black, it signifies tragedy. The symphony of red and black that she orchestrates in *Red Rooms* is composed of two distinct cells, formed by dark wooden doors taken from theater boxes or hotels, representing the children's bedroom and that of the parents. The latter bedroom features a red double bed on which are placed a child's train and a musical instrument (a xylophone) in its case. On either side, two small cabinets serve as bases for two sculptures of veiled women. Opposite is an oval mirror on a swivel base. The space is spare, ordered, symmetrical. It suggests the harmonious relationship of a couple, with allusions to children symbolized by the little toys lying around. Only two details cloud this vision and threaten the domestic peace implied by the pillow embroidered "Je t'aime": a soft, organic, unidentifiable object hanging over the bed, and a rubber finger, needle stuck into it, that emerges from the bed. Indeed, it is the demon of sex that may upset the equilibrium of a family.

The children's room is the exact opposite—a disordered treasure-trove of heterogeneous objects made of glass, cloth, rubber, some manufactured, some found. There is also a familiar spindle rack, holding spindles of primarily red thread, with three optimistic notes of blue (the three Bourgeois children, or Louise's own children). Enormous sausage-like hour-glasses evoke the inexorable passing of time and the precariousness of life that hangs only by a thread. Another shelf holds little embroidered garments.

The blood red color of these two rooms confers dramatic intensity on the work. The weaving of the two sites—the relationship between child and adult, adult and child—and the sense of prohibition hovering over the conjugal bed as the locus of both erotic ceremony and the mystery of conception, go to the very heart of both the artist's personal unconscious and a collective unconscious.

By reliving the traumas of childhood through her work, Bourgeois has given form to the basic myths of the unconscious (especially the Œdipal complex) and the reproductive cycle of life and death. This "primal scene" therefore relates to her early work on the theme of maternity, pregnancy and childbirth, which are in fact the threads linking all of her work. Maternity is intended here in the broadest sense of a nurturing matrix—the capacity to give birth, germinate, reproduce, fulfilling the function of refuge, home and erotic "receptacle" since, for Bourgeois, even pregnancy, the result of sexual encounter, is erotic. Things have come full circle. Bourgeois, like other artists (Titian,

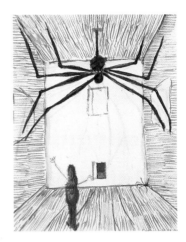

Araignée (L'Indispensable),
1994.
Ink, watercolor and gouache
on paper, 25.5 x 20.3 cm.
Robert Miller Gallery, New York;
Karsten Greve Gallery, Cologne.

Facing page:
Spider, 1994.
Steel,
247.7 x 802.6 x 596.9 cm.
Karsten Greve Gallery, Cologne

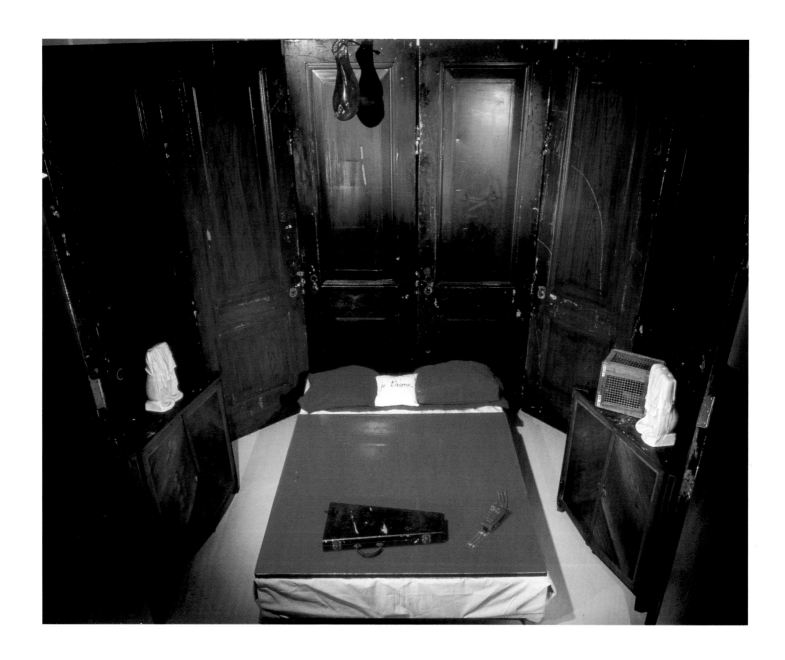

Red Room (Parents), 1994.
Installation, wood, metal, fabric, mirror,
245 x 419 x 419 cm.
Courtesy Peter Blum, New York.

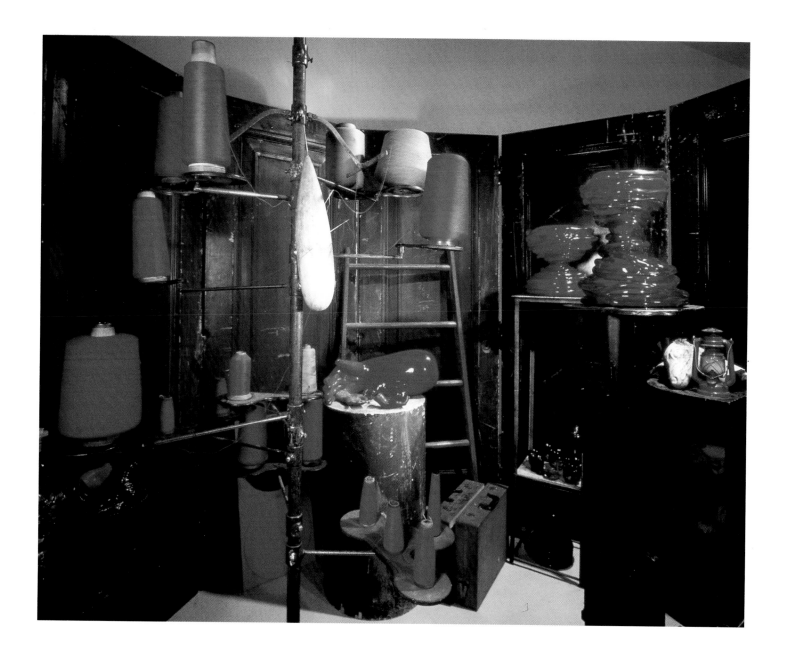

Red Room (Child), 1994.
Installation, wood, metal, thread, glass,
211 x 348 x 259 cm.
Courtesy Robert Blum, New York.

Rembrandt, Picasso) is now taking full advantage of the extraordinary vitality and creativity of old age. Age for her means delving into the very sources of her being and personality with unbridled freedom. It means liberation from all repression, giving her almost unlimited dynamism and creative power; she is henceforth in direct touch with the "black hole" of the unconscious. "The unconscious is my friend," she says. "I trust the unconscious."[21]

NOTES

1. Christian Leigh, *Louise Bourgeois*, exhibition catalogue, (New York: Brooklyn Museum, 1994), pp. 25 and 41.
2. *Balcon*, (Madrid), nos. 8–9, 1992.
3. Leigh, *Louise Bourgeois*, p. 65.
4. Interview for the film *Louise Bourgeois* by Camille Guichard, (Paris, 1993).
5. *Dislocations*, exhibition catalogue, (New York: Museum of Modern Art, 1991), p. 37.
6. Interview with the author, June 1993.
7. Quoted in Charlotte Kotik, "The Locus of Memory,"*Louise Bourgeois*, exhibition catalogue, (New York: Brooklyn Museum, 1994), p. 24.
8. Guichard, *Louise Bourgeois*.
9. Note by Louise Bourgeois to the Musée National d'Art Moderne, Paris, after its acquisition of *Precious Liquids* (November 5, 1992).
10. *Ibid.*
11. Rosalind Krauss, "Portrait de l'artiste en fillette", *Louise Bourgeois*, (Lyon, 1989).
12. All quotes in this paragraph are from interviews for the film *Louise Bourgeois* by Camille Guichard.
13. *Ibid.*
14. *Ibid.*
15. *Ibid.*
16. Artist's statement published in Marc Dachy (ed.), *Et tous ils changent le monde*, exhibition catalogue, Lyons: Second Lyons Biennial, 1993), pp. 236–7.
17. *Ibid.*
18. *Ibid.*
19. *Ibid.*
20. Christiane Meyer-Thoss, *Louise Bourgeois, Designing for Free Fall*, (Zurich: Ammann Verlag, 1992), p. 178.
21. Guichard, *Louise Bourgeois*.

THE CRITICS:
Articles on Louise Bourgeois, 1995

DRAWING ORIGINS

This essay by Geneviève Breerette of Le Monde, *was written to accompany an exhibition of Louise Bourgeois's drawings, chosen by the artist, at the La Box Gallery, Bourges, from 30 January to 18 March 1995.*

Louise Bourgeois has always drawn, but more or less in waves. She calls this activity a "necessity", a need to represent the "void of anxiety", and a "kind of intimate diary." Paradoxically, there are fewer confidences and autobiographical references to be found in her drawing than in her sculpture, and this is indeed the case in the works chosen by the artist for the exhibition at La Box—the fifteen shy, silent pieces of paper which offer no anecdotal reference. Produced between 1946 and 1992, these drawings form the most elliptical of Bourgeois's artistic trajectories, and lead to a reflection on drawing itself—its specificity, (the pen or brush stroke), its spontaneity, its form-giving capacity, and its ability to reveal a secret store of memory images.

Almost half of these works belong to the crucial 1946–50 period, during which the artist stopped painting in order to devote herself to sculpture. She also drew a great deal, and pursued her engraving, a process of emptying and replenishing which took on a different rhythm, and gave a breath of fresh air to her creativity in the open, infinite space of the sheet of paper, a locus of movement, ferment, growth and interaction.

At that time the presence of the Surrealists in New York, their quest for the secret forces and deep impulses of the individual, and their focus on the unconscious, probably provided Louise Bourgeois with the impetus to search for ways to free herself from all her constraints. These means would allow her to escape from the well-ordered imagery of her most recent paintings, and leave her high-security dwelling, the domestic universe in which she as wife and mother—but also artist—was

trapped and emprisoned. This is indicated in her use of images which link female destiny to that of the house, to the extent that her body is transformed into a kind of "exquisite corpse." Drawings by children and the psychotic provided her with early models which aided her escape. Two 1946 works refer to this transition: one piece of paper shows a fertilized egg, the other a spider's web whose threads extend into garlands and arms. At the same time, Bourgeois, refusing any restriction or emprisonment, ventured into unexplored areas in which, on the basis of her own inheritance—her past—new lives might develop.

Choosing this "inner mode" and a kind of automatic writing, she drew numerous wild and woody landscapes which resembled the sea, the earth, tresses of hair, or an unfenced space open to the innermost parts of consciousness. She tore up sinewy curtains, to discover forms which resembled a cocoon, a side of ham, a goatskin, or haricot beans—in short a material which simultaneously evoked the animal and the vegetal. These deliberately indeterminate forms grew in an unstable equilibrium, hung from an unknown ceiling by threads of memory—recollections of childhood places, houses, and the skeins of silk and wool from the tapestry restoration workshop which her family owned on the banks of the river Bièvre. By the end of the 1940s the basic themes and forms which lay behind all her future work and her sculptures in particular, had been established in the practice of her drawings. Bourgeois would not know, nor be able to foresee, when and if her drawings—an art-form which showed a period of time telescoped into a moment—would emerge spatially in one or more of her sculptures.

If for Louise Bourgeois, drawing created the link between the artist's *œuvre* and the past, it also took part in the cleansing process. Drawing brought the past to the surface in order to destroy it; it dealt with personal experience by strangling it, by getting rid of the narrative. The practice of engraving, where the artist learnt to attack obdurate material (this is also the process of sculpting), helped the artist and provided her with the additional artificial weapons which map the memory and its random movements. This artist's stroke abstracts, hardens, reduces, erases, sharpens, cuts harder and renders geometric, while it ripens organically, filling out expansively and repetitively to give

life to this development of stylized forms. These are the two sides of the artist's stroke—linked but implacable—which show that she has no time to waste on virtuosity but seeks and moves directly towards the essentials. This stroke—simple, direct, harsh and sometimes playful—creates the rules, albeit in a hesitant, emotional but discrete way. Louise Bourgeois is not the kind of artist who pours out her soul, and her drawings are indicative of this. Moreover if they exactly reflect her as a person in this way, they reveal more about her aesthetic methods as an artist who does not produce feelings but produces her *œuvre*, an artist who needs, as she says, "more than what she can make visible on paper" and for whom "it is necessary that this [more] becomes tangible." These are the remarks of a sculptor for whom drawing is not an end, but a beginning, an art which cannot offer the possibility of facing up to the resistance of a material in a constructive way. This is the source of Bourgeois's occasional abandonment of drawing as an incomplete, limited activity, which renews links with the past and unravels them but does not re-create the past. This is not the role of drawing— the latter calls forth buried images which only sculpture can create spatially.

The originality of Bourgeois's drawings comes from this intersection between spontaneous map-making and abstract stylized forms, a criss-crossing which bears witness to certain preoccupations with form, as opposed to the habitual products of biographical drawing. In the latter, form is sacrificed to narrative before seeking out an aesthetic impact and before affording a general meaning to the contents of a personal mythology. Louise Bourgeois tends towards the general, as she has the means to transform the memory of a string of onions or a necklace of dried beans into an image of vital importance. Her training in the school of Cubism in Paris between the wars provided her with several arguments on the level of form. It is also probable that her engraving work, accompanied by short stories in the series *He Disappeared into Complete Silence* (1947), allowed her to connect the relationships of form with those of narrative, to link images with words. This work, a series of parables on loneliness and the difficulty of communicating, consists of openwork constructions, cages, a clock-tower, and scaffolding,

all set in a non-Euclidean perspective where geometry is not neutral but figurative, a geometry which, one might say, embodies or disembodies man. Bourgeois developed this fantastic geometry—which is found in certain Surrealists, notably Ernst—through her earliest sculptures, for example, the famous work *The Blind leading the Blind* (1947–9), which presents a procession of wooden bench-legs linked together by a plank.

As a student of mathematics, Louise Bourgeois enjoyed solid geometry, and this love re-emerged in her work as an artist. A 1968 drawing, a construction made up of several layers, fragile, like puffs of smoke, recalls the attraction for straight-line constructions, which at the time were not yet the "geometries of pleasure" as Bourgeois described a series of burins (engraving tools) entitled *Le Puritain* (1990), her wry tribute to minimalism. These mock sketches which came out of her engraving work, are taken up again in her sculptures, and become part of the large family of totemic wood sculptures, themselves a product of the drawings, whose primitivism covers a wide range of forms evoking crutches, oars, awls, periscopes, seals' teeth, Brancusian columns, kidney kebabs, or garlands. All these figures take on masculine or feminine identities, and all are conceived as individuals in society, maintaining varied relationships, changing among themselves, and within the group.

Through her choice of drawings in this exhibition, Louise Bourgeois invites us to understand that the workings of her formal language are based on a fundamental game of primordial forms drawn from nature. These forms are mutated into geometric figures and vice versa, are filled with meaning and conversely, emptied of meaning. The festoon forms explain this evolution, reappearing everywhere, sometimes given depth by cross-hatching, sometimes flat: the former recall her drawings of the thorax, the latter recall an art deco motif, except for the nuance that one of the elements, in color, turns it into a parlor game, a family gathering rather than a simple mass on squared paper. These arches would not have the same resonance on a neutral background whether opaque or transparent. Louise Bourgeois loves and cultivates the highly symbolic form of the arch (symbolizing tension or alliance) and uses it in rows of white wood lined up like pupils on school benches, like

tombstones in a cemetery (for example *Partial Recall*, 1979), or like the drawing of the front door of her house.

Constantly mutating, the arch can also become the human body tensed in a paroxysm of desire, thus receiving a new, sexual charge. In the watercolor drawing, *Arch of hysteria*, which is related to a sculpture shown at the 1993 Venice Biennale, Bourgeois re-creates the vision of "convulsive beauty." In opposition to received ideas she refuses to make hysteria—the "grand poetic discovery," according to Breton and Aragon in 1928—a phenomenon confined to the pathological behavior of women. This is the result of the entire sexual thematic which Louise Bourgeois developed in her sculpture from the 1960s onwards. This theme becomes all the more overt since the artist defends herself against any triviality by using beautiful Carrara marbles to create her large sculptures, masses which are more phallic than coralline.

Sexuality, companion to the sculpting and refining of forms, is treated here as a source of the material's energy to produce complementary figures—hollow, rounded, feminine, masculine, fused, separated, symmetrical, equal and balanced—all of which complicate any feminist reading of Bourgeois's *œuvre*. On the contrary, perhaps her work confirms the words of Mondrian, the expert in combining symbols of both sexes: the artist has no sex?

Translated by Philippa Brinkworth-Glover

"WHY SO SEVERE?"

Philippe Dagen of Le Monde *writes on Louise Bourgeois in* Connaissance des Arts, *July/August 1995*

Louise Bourgeois has described the scene thus: "Marcel Duchamp and I were out walking together, when I noticed two snails clamped together, copulating. I pushed them off the stone ledge, then with my heel I crushed them into the ground. 'Why so severe?' Duchamp said to me. 'You don't need to be so emotional.'"

Louise Bourgeois does not say what her response was. Perhaps she did not give one, as it seemed clear to her that the severity and the emotion were indeed necessary, and that she only existed in such extreme states. This was certainly not Duchamp's attitude, so the conversation was bound to come to a halt. Despite its brevity this scene is no less instructive, to an almost allegorical degree. Duchamp's question: "Why so severe?" betrays his astonishment, embarrassment, disapproval, sudden recoil, a sense of some distaste.

These feelings, stated or implicit, have surrounded Louise Bourgeois's work for half a century. The period which took Duchamp as its model could not, in fact, be otherwise. It was bound to misunderstand an artist who seemed so alien, an artist so estranged from the imperatives of neutrality and detachment that the era had created, an artist so embarrassing, so out-of-place. She thus paid the price for the incongruity of her sculptures and drawings. It is true that she held her first solo exhibition in 1945 at the age of thirty-four, seven years after moving to New York. But the lack of follow-up is telling: just two exhibitions in the 1950s, another two in the 1960s, first participation in the Whitney Biennale in 1973, and first public commission in 1978, at the age of sixty-seven.

This marked the beginning of her recognition, overdue to say the least. In 1982 the Museum of Modern Art gave Bourgeois her first retrospective, and at the same time Robert Miller became her dealer. She mounted shows in London and Paris in 1985, finally showing more and more as the honors and historians crowded in upon her. In 1992 she was invited to the Documenta in Kassel, and in the following year to the Venice Biennale. French museums, well-known for regularly showing caution towards artists who cannot easily be categorized, finally decided, in 1995, the year of her eighty-fourth birthday, that it was safe to celebrate Bourgeois, the woman who was born on boulevard Saint Germain one Christmas day, who grew up in Choisy-le-Roi, who was the pupil of Léger, Friesz and Lhote, and who lectured at the Musée du Louvre in the 1930s.

Visitors to her studio-apartment on 20th Street are sometimes astounded at her violence, at her wariness, and at the tricks she uses to incite her interviewer into betraying what she thinks is a dislike of her work. She admits to acting in this way, and the present author can testify to such an experience, having undergone a preliminary interrogation which exhibited deep suspicion. Such behavior is hardly surprising, however, when the institutions, the public and supposed art establishment kept Louise Bourgeois at arms' length with such obstinacy. What did they object to? More or less what Duchamp himself could not accept: namely her contempt for half-measures, elegant allusions, easily ignored innuendoes, and that she forces the eye and the mind to contemplate what they would ordinarily refuse to consider—the reality of the human condition.

A 1966 work in fabric and latex, is aptly called *Le Regard*. It is, crudely, an eye with swollen lids, perhaps puffed up with pustules. They open on to an oval orifice, the eye socket but not the organ itself which is not indicated in any way. At the bottom of the cavity grow amorphous, soft protuberances. The central organ of painters and sculptors, often celebrated in self-portraiture, is no more than a badly healed wound, an injury which only arouses disquiet and disgust. It demonstrates powerfully the organic nature of man, and reminds him that he is made of

and lives among some unsavory substances. It strongly denies him any idealization, any lyrical illusions, any fanciful stylizations.

For many years sculpture had peopled parks and palaces with fine lies, with the admirable forms of goddesses and heroes. Beginning in ancient times, sculpture brought forth delightful nymphs, swooning, androgynous and athletic saints. Rodin himself found it hard to transgress the rules to create *The Helmet-Maker's Beautiful Wife*, an old woman with withered limbs, and drooping breasts, whose muscles and tendons are hardened with age. To over-simplify brutally, until the beginning of this century sculpture was on the side of ideal beauty, and invented marble and bronze lies designed to make one forget bodily reality. At the end of this line came Brancusi who used ellipsis to get rid of whatever destroyed the symmetry of the form, whatever destroyed its polished surface, in order to hark back to the anonymous sculptures of the Cyclades.

Louise Bourgeois, as in Giacometti's *Woman with her Throat Cut*, moved her art away from this age-old tradition, pulling back the skin to reveal the tissues, the humors, the blood, the mortal flesh and the promise of ultimate corruption. She rubbed sculpture the wrong way, and implicated it, so to speak, in an enterprise rigorously opposed to the uses of statuary as understood and cultivated from Phidias to Maillol. Traditionally the female body was glorified, and its curves and its movement celebrated—one need only think of Greek marbles, of Jean Goujon, of Clodion or of Pradier. In order to reject these conventions, Louise Bourgeois decided to model her own body inside out. *Torso. Self-Portrait* is a bronze from 1963–4: on a barely anthropomorphic base, breasts are stuck together alongside folds which suggest a vulva. The overall piece itself, viewed directly opposite and from slightly below suggests the same motif, though overly repetitive and overly present and with nothing of the erotic charge that Courbet elicited from the visual material of *The Origin of the World*. *Torso. Self-Portrait* arouses the same disquiet as representations of Artemis of Ephesus and allegories of fertility whose torsoes are covered in many layers of breasts.

Here, once again, a crudely depicted anatomy and a mercilessly exhibited organicism burst through the surface.

Even more violent, *Nature Study* of 1984 takes up again the imagery of abundance by presenting a headless female monster with distended breasts in an ironically gilded and polished bronze. It squats on a square plinth in a most humiliating position, its feet that of an animal, a cruel variation of the classical sphinx. The same thematic register is taken up by *Blind Man's Buff* and *The She-Fox*, marbles produced in the same year.

For the male body the metamorphosis is no less painful, and no less unpleasant: all that is left of the heroes of Praxiteles and Michelangelo are the genitals, linked together back to back, entitled *Janus-fleuri*, or shown in erection. The phallus appears with regularity in the pieces of the late 1970s, from *Fillette* (polychrome latex) to the marble groups called *Colonnata* and *Cumul*, either isolated as if a mutilation, or in pieces. There is nothing glorious—no amorous, pagan celebration—in these representations where the repetition of the cylindrical form forbids any lyricism or physical sensuality. They culminate in a piece made more intense by the use of color : *The Destruction of the Father* is a mass of male and female protuberances in pink and red latex. The color-scheme, the softness of the globular forms, the presence of other similar masses hanging from the ceiling all contribute to the feeling of a kind of plunge into organicism, a descent into a blood-colored hell. The title leaves no doubt as to the autobiograpical allusion and the tension which it reveals. "A very murderous piece," says Louise Bourgeois herself. Much the same could be said about the installations she presented at the Venice Biennale of 1993, theaters of mutilation and hysteria, of emprisonment and condemnation to death. The blade of the guillotine threatens the marble model of the family house at Choisy. The headless model of a male body twists under a band-saw.

These few details lead to several observations. The first is historical and aesthetic: although she had the opportunity to make friends with the French surrealists exiled in New York between 1940 and 1945, and although her early engravings and paintings are not completely devoid of traces of De Chirico and perhaps of Magritte, Louise Bourgeois in no way belongs to surrealism. Further, an insuperable incompatibility separates them, as evidenced by the words with which she describes Breton as "searching for the grandiose and the religious," and as possessing "a pontificating side." The author of *Nadja*, the lyric poet of *amour fou*, cannot suit her because she recognizes in him, beneath the stylistic rhetoric (however powerful), a revival and rehabilitation of the old idealistic romanticism. Whether convulsive or quiet, Breton's orchestrated eroticism—a defense of desire, emblems of the female body, hymns of praise, and cults of beauty—totally overlooked any sense of tragedy, of resentment, of nightmare and pain, unlike Masson who broke with him. Breton's version of Surrealism adopts the flattering poses of the seducer, of the intellectual mentor, indeed the figure of the inconstant father, the artist's own father whom she accompanied to nightclubs and whom she saw one night choosing a prostitute in a kind of grotesque and pitiful re-enactment of the Judgement of Paris.

Bourgeois's words deserve close attention: "Breton and Duchamp," she says, "made me violent. They were too close to me and I reacted sharply against them, against their pontificating manner. I was on the run, and over here [in the USA] I found these paternal figures repellent. *The Blind leading the Blind* is a reference to these old men who push you over the precipice." These old men who push you over the precipice, these are the coaxers, the cheats, the charmers, and against their rhetoric, against the poetry of passion, Louise Bourgeois opposes the physical and psychological reality of sexuality—in the same way as she confronts the charms of overly attractive colors with the blackness of her drawings, strafed in black ink, and she confronts overly pure and perfect forms with damaged features, sharp angles—or alternately with limp and flattened lines. There is no temptation to surrealism in her work.

Neither is there any concession to Dadaism as it was revived in 1950s New York when Duchamp acquired a crucial impor-

tance, inspiring Rauschenberg and Johns and later many others. Although she sometimes introduces manufactured objects into her work, Louise Bourgeois concedes nothing to the ready-made. The scarlet scissors and shears of the 1986 watercolors are almost symbols. The distilling devices and the glass receptacles which are assembled on tables and shelves in the most recent installations suggest laboratories, hospital wards, tests, chemistry, medicaments. As to the perfume bottles in *Cell II*, arranged in order of size on a mirrored tray, they are almost religious relics, and the two marble hands cut neatly off at the wrists lie at their side like morbid fragments. It is not only that the idea of the found object is completely alien to Bourgeois, but she is also venturing in the direction of symbolism, whether in the form of the ovoid or globular glass bottles, or in her choice of materials—glass, which breaks into sharp splinters.

Moreover, this is the originality behind her sculpture and drawing: Louise Bourgeois takes up diverse materials in piece after piece and feels in no way constrained by the tradition of marble and modeling. Rubber, several kinds of stone, multi-colored wood, fabrics, resins, wire mesh, glass, mirrors, and even a disembowelled rabbit cast in bronze: everything for her is valid to the exact extent that the material, in its tactile and chromatic qualities, resonates with the desired emotion—the emotion one must exorcize by precipitating it into the solid matter of sculpture. Louise Bourgeois allows herself no other formal law.

She has recourse to strange associations, such as those produced by *In Respite*: a steel tube carries bobbins of black thread mounted on fly-wheels, and hanging down the length of the central axis, suspended from a hook, is a long teardrop of pink rubber. Is this Ariadne's thread or the thread of the Fates? Are these gun-metal and meathooks? The pink rubber suggests the color of flesh and visions of the slaughterhouse; needles are stuck into the rubber like a sacrilegious attempt to rework the image of St Sebastian. *In Respite* dates from 1993 but its diversity and motifs originate much earlier: the *Portrait of C.Y.* of 1947–8 consists of a tall, narrow piece of wood pierced in its upper part (its head perhaps) by a rectangular opening, and

transfixed by a clump of carpenters' nails. More than 40 years later, Louise Bourgeois continues to follow this course—too forceful, too driven by her fears and denials to allow herself to be side-tracked. Her coherence is that of creativity dominated by an inner need.

Inner need, indeed. If Louise Bourgeois eludes historical classification, if she cannot be categorized in any way, if critics resort to embarrassed and awkward terms to describe her (for example, "eccentric abstraction") the reason is simple. Free from any system, she says, "the artist can express her problems" (the latter word is weak). "However it is not a cure, since expressing oneself is not educative, it is a discharge and that is why such an expression constantly repeats itself." Sculpture and drawing are just two ways of being and knowing oneself, two ways of bearing the unbearable human condition. And again she says, "exorcism is healthy. One must cauterize and burn in order to cure. It is like pruning trees. Therein lies my talent—I'm good at that."

Therein lies her talent which is more than just talent. This is why her contemporaries find it so hard to get used to Louise Bourgeois and ultimately to look at objects that mirror them so unpleasantly. It is the old story—that of the artist who, in seeing too clearly, reveals a truth which her contemporaries prefer to ignore. It is the story of an unwelcome truth.

"Why so severe?" asked Duchamp? Because it matches the violence of men in society. Because one cannot be otherwise.

This article was first published in Connaissance des Arts, *July/August 1995.*

Translated by Philippa Brinkworth-Glover,
with thanks to Deke Dusinberre

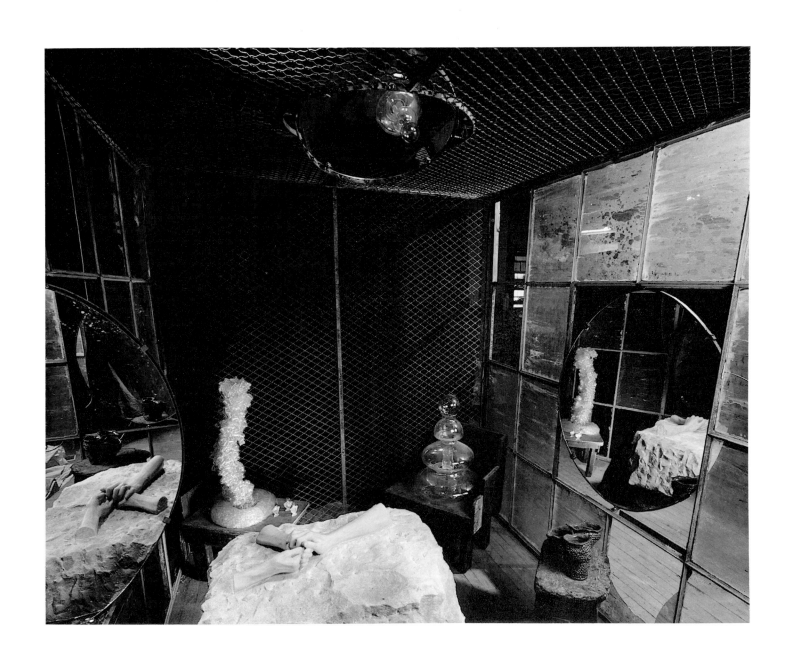

Cell (You Better Grow Up), 1993.
Metal, glass, marble, ceramic
and wood, 210 x 208 x 212 cm.
Karsten Greve Gallery, Cologne.

BIOGRAPHY

Compiled in collaboration
with Laure de Buzon-Vallet.

*Our sincere thanks go to Deborah Wye
for permission to use elements
of her chronology in* Louise Bourgeois,
*catalogue of the exhibition at the Museum
of Modern Art, New York, 1982.*

1910–20

Joséphine Fauriaux,
Louise's mother.

Louis Bourgeois,
Louise's father.

Right:
Louise and Pierre with
their mother at 172
Boulevard Saint-
Germain, Paris.

Louise Bourgeois was born on Christmas Day, December 25, **1911**. The second daughter of Joséphine Fauriaux and Louis Bourgeois, she was in fact their third child, for their first baby had died. Henriette, the eldest surviving child, was six years older than Louise, while a brother, Pierre, was born fifteen months later. Since it was anticipated that Louise would be a boy, she was named after her father, whom she resembled a great deal. According to Louise, her mother thought the name would be a consolation that might help to "sell a daughter." The family first lived at 147 Boulevard Saint-Germain in Paris, then moved to number 172, in an apartment over their tapestry gallery.

During the 1914–18 war, Louis, despite being father of three children, joined the infantry, and the family occasionally followed him to various camps. "He was a hero despite himself."[1] In 1915, he was wounded and sent to a hospital in Chartres, where Louise visited him. "My father was a pacifist, influenced by the ideas of Aristide Briand, and he was for peace with the Germans."[2] In **1912**, her parents bought a house in Choisy-le-Roi, outside Paris, where the family lived until **1918** (the house has since been demolished and replaced by a municipal theater; in 1993 the town commissioned a work from Louise Bourgeois to commemorate the site). Louise's earliest childhood memory dates from the war period. During an air raid, mother and daughters were forced to descend into the cellar. "The janitor came up and said to my mother, let me take her down—my sister was old enough to walk, and my mother was holding me. The janitor put his hands on top of her hand and I felt that he was making a pass at her. . . . I was conscious of that. He just put his hands flat on top of hers. She was giving him something to handle that was very precious to her. I was just a pawn. . . . I was absolutely repulsed by this. That is my first memory. I think I

The three children—Henriette, Louise and Pierre—with their mother in Choisy.

The Bourgeois family.

Louise in front of the house at Choisy.

was about three years old. I understood that he made a pass at her. I assumed that she liked it, because if a man makes a pass at a woman it is a compliment."[3]

Family links are crucial to Louise; her childhood memories and her relationships with her parents, brother and sister have had a determining impact on the structure of her personality, becoming, in a way, the inspiration for her artistic calling. "[My parents] are monumental," she has stated, "solid, my frames of reference."[4] In contrast: "I didn't like my brother, or my sister. They bugged me. I only learned to be kind when my own kids came along, it was a new world to me."[5] She claims to have loved the older generation, however: "My grandfather was kind, and my grandmother had beautiful blue eyes, I loved them."[6] But brother and sister, plus the cousins who lived with them once their own father died, were perceived as "rivals." Being a parent represents an enormous responsibility for her: "Children should be protected from the neuroses of their parents. . . . Otherwise we spend a lifetime recovering from the terrible abuse—abuse is a bad word—but from the terrible self-indulgence of our parents."[7] Her mother, an apparently solid woman, was originally from the Massif Central region of France, and was well-balanced, rational, fairly feminist, and patiently bore her husband's infidelities. Her only weak point was physical—she nearly died in the 1918 Spanish flu epidemic, and afterward suffered from emphysema. Her father, towards whom Louise has ambivalent love–hate feelings, was a fickle, seductive, lying, immature man. He was an authority figure who had a great influence on Louise's childhood, and despite himself played a key role in her artistic concerns.

From the age of ten, Louise helped her parents with drawings for tapestry restoration. She drew missing feet and other motifs. "The lower part of tapestries was often eaten away, which meant that the figures' feet were gone, and my task was to repair and redo all the feet, including horses' hooves."[8] Art was therefore part of the family. When Monsieur Gounod, the designer, was absent, Louise replaced him. Those drawings were her first contact with art: "When my parents asked me to replace Monsieur Gounod, it gave dignity to my art. Dignity: that is all I ask."[9] It also made Louise feel useful; the concept of usefulness often crops up in her comments: "The deal is, if you make yourself useful people will like you."[10]

In **1919**, her parents bought a house in the Parisian suburb of Antony, near the Bièvre River, where they set up a workshop for restoring old tapestries. Every Sunday, Louise walked with her father from Antony to Clamart, thus going from the Bièvre valley to the Seine valley, admiring the view of Paris. The Bourgeois family nevertheless kept its Paris apartment. Louise went to secondary school at the Lycée Fénelon, which she remembers fondly. Not only did she like her teachers, but high school was a way to escape the unbearable atmosphere at home. She worked well, and was first in her class in ninth grade. Her father, who had always enjoyed traveling, sent her at an early age to spend the summer in Brighton, England, in order to perfect her English. Most importantly, however, he installed his young mistress, Sadie, in the household. She was an exchange student from England,

Right :
Sadie and Louise on the Bièvre under the bridge at Antony.

A map of the Paris area tracing the trip from Choisy to Clamart, where Bourgeois's grandparents were buried.

some years older than Louise, and she spent ten years with the Bourgeois family. Sadie was to teach English to all three children, but her favorite was Louise, who thus learned to speak English very well.

From **1922 to 1932**, the Bourgeois family spent their winters in the South of France, first at Cimiez and later at Le Cannet where Matisse and Bonnard lived, since Louise's mother could no longer bear the damp Paris climate. Mother and children thus spent four months of the year on the Côte d'Azur. Louise attended the international *lycée* in Cannes. Certain photographs from that period show her to be very elegant, dressed in a Chanel knitted suit. She nursed her mother herself, using the old-fashioned cupping-glass technique (glass cups would later figure in several of her sculptures). It was this experience that sparked her interest in medicine.

Louis Bourgeois, his children
and Sadie
at the Palais de la Méditerranée
in Nice, *c.* 1922.

Louise and her parents in front of
Villa Marcel at Le Cannet.

Louise and her father
in Nice.

1930–40

Louise Bourgeois in Cimiez, 1932.

Louise passed her high school exam (*Baccalauréat*) in **1932**, the year her mother died. Louise tried to commit suicide by throwing herself in the Bièvre River. It was her father who had provoked Louise by joking about her distress, and who then dived in to save her. After studying mathematics at college, she registered at the Sorbonne to study geometry, which she particularly liked. But she quickly abandoned math, discouraged by algebra, and devoted herself to the study of art. She briefly attended the École des Beaux-Arts, but soon tired of its academic approach and therefore enrolled successively at the Ranson, Julian, Colarossi and Grande Chaumière art studios: "I did them all," she said, "I was looking for truth, for people who weren't phoney, looking for authenticity."[11] Bourgeois thus studied under Roger Bissière, Fernand Léger, Marcel Gromaire, Othon Friesz and André Lhote. She also studied at the École du Louvre. She has one very strange recollection from her time at the Louvre—she remembers going down to the cafeteria one day and finding herself among all the museum guards, many of whom were wounded veterans missing a leg or arm. This vision alarmed her, leaving a lasting impression. She earned some money by giving lectures in English, and also served as translator for American students at Léger's studio (in lieu of paying for her own lessons). Léger was her "best teacher." On seeing her drawings, he detected her true calling as a sculptor. Later she also studied under Paul Colin and Cassandre. "They were highly politicized, and accepted many foreign students. Cassandre had a great deal of talent, but little time for his students. Paul Colin was the most important. He produced posters for the theater, and in **1932** there was a major conference in Russia, in Moscow. That was how I went there for the first time."[12] She made a second trip in **1934**. She was also head student at Grande Chaumière, and chose

Louise (center) at La Grande Chaumière art academy, *c.* 1937.

At La Grande Chaumière.

The trip to Moscow with Paul Colin.

Louise on the ship sailing for the USSR.

the life models. "The prostitutes wanted me to give them work as models. They were very maternal, were obsessed with cleanliness and hated stains."[13] She showed a few works at the Salon des Indépendents and the Salon des Artistes Français.

In **1937**, Bourgeois met the American art historian Robert Goldwater, whom she married in 1938. Then she left to live in the United States, after having adopted a little boy, Michel. The adoption was probably a way for her to take a little piece of France with her, to "make amends" for leaving. "I was ashamed to leave France, I felt guilty, I wanted to do something for that orphan, it was moral."[14] According to Bourgeois, her husband and father did not get on together. Robert stood up to her father and ridiculed his supposedly funny stories. Her departure from France was crucial because it enabled her to flee the oppressive family atmosphere. "Sadie opened the way for my departure for America. In France, I wouldn't have survived the chaos of the family unit."[15] Moreover, the puritanical temperament of her husband and her new country seemed to her to provide an antidote to her father's Don Juan behavior.

On arriving in New York, Louise and Robert moved into an apartment on Park Avenue and East 38th Street. She immediately enrolled in the Art Student League and studied painting in Vaclav Vytlacil's studio for two years. Bourgeois valued her independence with regard to her husband. They had three sons: Michel, Jean-Louis (born in July 1940) and Alain (born in November 1941). Bourgeois managed to assume all three roles of mother, wife and artist.

In **1939**, the couple moved to East 41th Street, where they lived for two years. Bourgeois began to produce engravings. Her first participation in a group show took place at the Brooklyn Museum. During these early years, she regularly exhibited her engravings at the museum, as well as at the Philadelphia Print Club, the Library of Congress, and the Pennsylvania Academy of Fine Arts. She met Gertrude and Balcomb Greene, active members of the American Abstract Artist Group.

1940–50

In **1941**, they moved to an East 18th Street apartment block called "Stuyvesant's Folly," where they remained until 1958. It was on the roof of that building that Bourgeois began her initial sculptures in wood. The family also spent long periods in a country house bought in Easton, Connecticut.

During the war, Bourgeois participated in artistic activities related to the war effort, exhibiting with Masson and Calder in "The Arts in Therapy" show designed to encourage art and craft activity as therapy for wounded veterans. In **June 1945** she organized an exhibition, held at the Norlyst Gallery, entitled "Documents France 1940–1944: Art-Literature-Press of the French Underground."

June 1945: Bourgeois had her first solo show, "Paintings by Louise," at the Bertha Shaefer Gallery. She exhibited twelve paintings, including *Natural History, Mr. Follet* and *Connecticutiana*. That same year she exhibited paintings in several group shows, often with artists of the abstract expressionist generation. Her work was first exhibited at the Whitney Museum in the context of the American Art Annual of Painting. She began to work with S.W. Hayter at Atelier 17, where she did engravings for many years. Bourgeois made friends

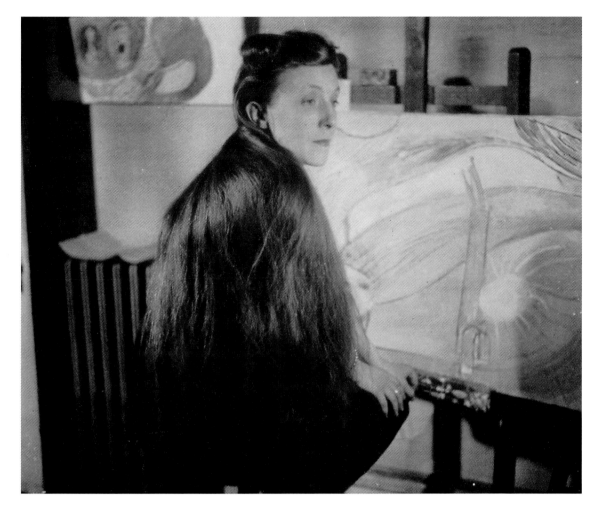

New York, *c.* 1946–7.

On the roof of the 18th Street building.

with artists such as Nemecio Antunez, Le Corbusier, Joan Miró, Yves Tanguy and Ruthven Todd. She also met Marcel Duchamp, Pierre Matisse and André Breton.

In **October 1947**, Bourgeois had her second solo show at the Norlyst Gallery, where she exhibited seventeen paintings, including *Conversation Piece, Jeffersonian Court House, Regrettable Incident in the Louvre Palace,* and *Roof Song.*

She published a series of nine engravings and parables, produced at Atelier 17, entitled *He Disappeared into Complete Silence.*

In **October 1949**, Bourgeois made her public debut as a sculptor with a show at the Peridot Gallery, at the invitation of gallery director Louis Pollock and his friend Arthur Drexler, an architect and art connoisseur who also helped mount the exhibition.

The titles of these sculptures, all in English as a sign of her "eagerness" to speak the language, evoke biographical details: *Portrait of C.Y., Woman*

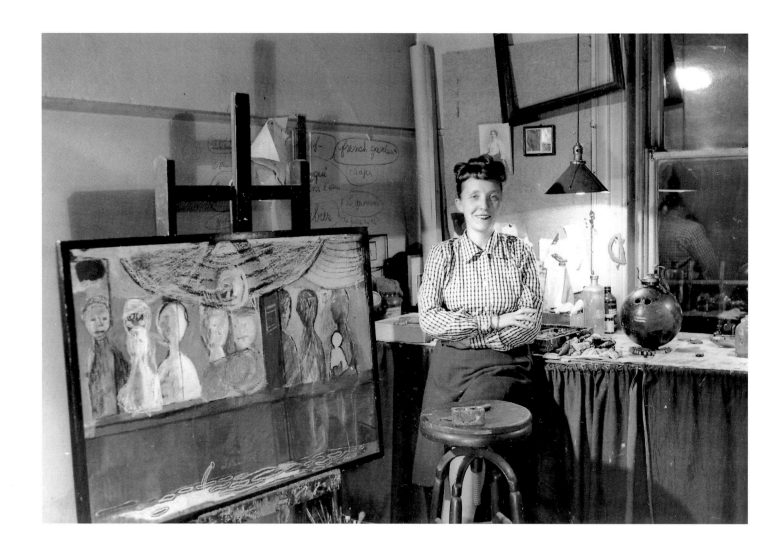

In the Stuyvesant's Folly studio, *c.* 1946.

Louise and her three sons at their country house in Easton, Connecticut, 1945.

in the Shape of a Shuttle, Dagger Child. It was also at this time that she produced a large wooden sculpture, *The Blind Leading the Blind*, painted red and black, which also exists in a pink version entitled *C.O.Y.O.T.E.*

Invitation to
Louise Bourgeois's
second solo show,
Norlyst Gallery, 1947.

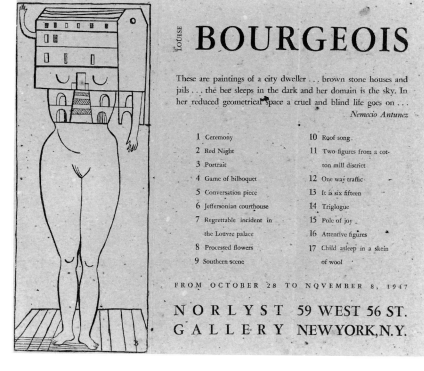

"Documents France
1940-1944," exhibition
arranged by Louise
Bourgeois for the Norlyst
Gallery, June 1945.

With Miró, his wife
and daughter, New York,
1947.

1950–60

Invitation to the "Louise Bourgeois, sculptures" show, Peridot Gallery, 1950.

1950

In **May**, Bourgeois joined the group of artists known as the "Irascibles," who were protesting against a planned exhibition of American painting at the Metropolitan Museum of Art in New York.

In **October**, she had another solo show at the Peridot Gallery, exhibiting fifteen pieces including *Sleeping Figure, Breasted Woman, Persistent Antagonism* and *Spring*.

1951

Her father died. Bourgeois became a US citizen. The Museum of Modern Art in New York purchased *Sleeping Figure*.

1952

January 19: *The Bridegroom of the Moon*, a dance piece by Erick Hawkins for which Bourgeois designed the set, was performed at the Hunter Playhouse in New York.

1953–6

In **April 1953**, Bourgeois had her third solo show at the Peridot Gallery, "Drawings for Sculpture and Sculpture." She showed two or three sculptures, notably *Forêt*, later known as *Garden at Night*, and a series of drawings in India ink. This work marked the beginning of her organic, protean sculptures that metaphorically evoke both nature and the human figure.

Goldwater mentioned Bourgeois and reproduced one of her works in wood in his article, "La sculpture actuelle à New York," published in *Cimaise*, **November/December 1956**.

She participated in numerous group shows at galleries like Allan Frumkin in Chicago and at the Stable Gallery and Poindexter Gallery in New York, as well as in the Annual Whitney exhibitions. The Whitney bought *One and Others* in **1956**.

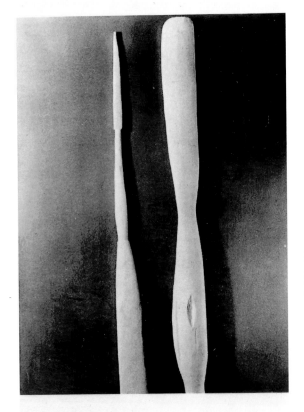

LOUISE BOURGEOIS

sculptures

1. Figure qui apporte du pain 2. Figure regardant une maison

3. Figures qui supportent un linteau

4. Figure qui s'appuie contre une porte

5. Figure qui entre dans une pièce 6. Statue pour une maison vide

7. Deux figures qui portent un object

8. Une femme gravit les marches d'un jardin

9. Figures qui attendent 10. Figures qui se parlent sans se voir

11. Figure endormie 12. Figure pour une niche

13. Figure quittant sa maison 14. Figure de plein vent

15. Figure emportant sa maison

PERIDOT GALLERY

6 E. 12th St., New York City October 2-28, 1950

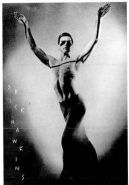

Costume for the dance by Erick Hawkins, *The Bridegroom of the Moon*, 1952.

Exhibition invitation, "Louise Bourgeois, drawings for sculpture and sculpture," Peridot Gallery, 1953.

With Robert Rauschenberg, at one of the annual "American Abstract Artists" shows at the Riverside Museum, New York, 1950s.

1958

Bourgeois left "Stuyvesant's Folly" for West 22nd Street, where she lived for four years.

1959

She participated in the Festival of Contemporary Arts at The Andrew Dickson White Art Museum, Cornell University, Ithaca, exhibiting eleven vertical wood sculptures including *Memling Dawn, Sleeping Figure, Figures for a Niche* and *One and Others*.

LOUISE BOURGEOIS
drawings for sculpture
and sculpture
AT THE PERIDOT GALLERY
6 east 12 street, new york
PREVIEW MARCH 30, 4 to 7 P.M.
through april 25, 1953

1960–70

1960

Bourgeois participated in a group show at the Claude Bernard Gallery in Paris, entitled "Aspects de la sculpture américaine."

She began teaching regularly at various American institutions.

1962

She moved from West 22nd Street to West 20th Street, where she still lives.

1964

January: Solo exhibition at Arthur Drexler's instigation at the Stable Gallery. She presented a dozen plaster sculptures (including *Lair, Rondeau for L., Labyrinthine Tower, Fée couturière* and *Still Life*) in addition to several pieces in latex (including *Portrait* and *Night Garden*), and an older vertical piece in wood.

This show of sculpture coincided with an exhibition of drawings and watercolors at the Rose Fried Gallery. Daniel Robbins wrote a text for the catalogue entitled *Drawings by Louise Bourgeois* as well as a major in-depth article on her work for *Art International.*

1965

In an article entitled "Le choix d'un critique" ["A Critic's Choice"], Michel Seuphor wrote that "Louise Bourgeois, in New York, has long been constructing highly straightforward yet strangely spirited totems that she calls 'Astonished Form' or 'Sleeping Figure'. . . . Her work has had a clear influence on many young American sculptors." The article reproduced three pine *Figures* from 1950.

April/May: As part of the 17th Annual Salon of Young Sculptors in Paris, Bourgeois presented *Fée couturière* in the garden of the Musée Rodin.

June–October: Bourgeois participated in a group show organized under the auspices of the International Council of the Museum of Modern Art, New York, and held at the Rodin Museum in Paris under the title "Les Etats-Unis: Sculpture du XXᵉ Siècle." She exhibited *Figure endormie II*, a 1959 bronze version of the wooden sculpture of 1950.

1966

In **September**, Bourgeois participated in the "Eccentric Abstraction" show organized by Lucy R. Lippard at the Fischbach Gallery.

Bourgeois executed *Le Regard*, a major work in canvas and latex.

She henceforth became involved in the feminist movement in the United States, actively participating in feminist art events throughout the 1970s.

1967

In "American Sculpture: The Situation in the Fifties," an article published in *Artforum*, Wayne Andersen discussed the role played by Louise Bourgeois in the 1950s art scene.

First trip to Italy, to work in marble at Pietransanta, where she would regularly return once or twice a year, usually in summer, until 1972. She produced at least thirteen major marble pieces, including *Sleep II* (1967), *Colonnata* and *Clamart* (1968) and also worked at the bronze foundries in Pietrasanta.

1968

Bourgeois produced two major hanging sculptures: *Fillette* (in latex) and *Janus fleuri* (three bronze versions) which flaunt the openly sexual nature of her œuvre. "There was a *grenier*, an attic with exposed beams. It was very large and very beautiful. My father had a passion for fine furniture. All the *sièges de bois* were hanging up there. It was very pure. No tapestries, just the wood itself. You would look up and see these armchairs hanging in

Invitation to the "Eccentric Abstraction" show, Fischbach Gallery, 1966.

1970–80

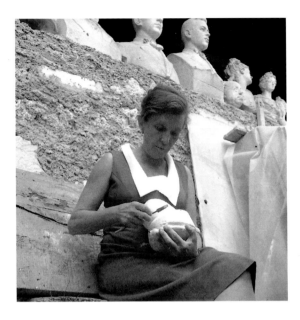

Louise Bourgeois in Italy
with *Sleep*, 1967.

very good order. The floor was bare. It was quite impressive. This is the origin of a lot of my hanging pieces."[16]

1969

May/June: Bourgeois participated in the 21st Annual Salon of Young Sculptors in Paris, showing *Sculpture* (1967–8), a bronze piece later given the title *Point of Contact*, acquired by the Metropolitan Museum of Art in New York in 1973.

In an article in *Art International*, William Rubin discussed the role played by Bourgeois in the sculpture and painting of her day, notably reproducing *Still Life, Soft Landscape I* and *Molotov Cocktail*.

Bourgeois produced *Cumul I*, a marble piece depicting clouds.

1970

Bourgeois produced *Rabbit* in plaster (a second version in bronze also exists), *La Femme-pieu* and two marble sculptures, *Femme-couteau* and *Baroque*.

1971

J.-Patrice Marandel published an article in *Art International* describing Bourgeois's activity in Italy and reproducing six marble sculptures.

She began work on *Trani Episode*.

1973

January: At the Whitney Biennial, Bourgeois showed a large marble piece called *Number Seventy-two* (later known as *The No March*), produced the previous year.

March: Death of her husband, Robert Goldwater. Bourgeois received an Artist's Grant from the National Endowment for the Arts.

During an employees' strike at the Museum of Modern Art, Bourgeois participated in a protest march carrying a banner on which she had repeatedly painted the word "No."

The Musée National d'Art Moderne in Paris purchased *Cumul I* (1969).

1974

December: Bourgeois had a solo show at the Greene Street Gallery, "Sculpture 1970–1974," featuring pieces in marble (*Eye to Eye, Colonnata, Baroque, Systems, Fountain*), bronze (the *Hanging Janus* series), and plaster (*Trani Episode*), as well as the major environment that she had just produced, *The Destruction of the Father*. The show was discussed by Carl R. Baldwin in *Art in America*.

Bourgeois continued to teach at various American colleges.

1975

Lucy R. Lippard wrote an article on Bourgeois's œuvre for *Artforum*, which reproduced illustrations of *The Destruction of the Father* (cover) and fourteen other works from the 1940s onward, including *The Blind Leading the Blind*, *Trani Episode*, *Fillette* and *Femme-couteau*.

Lynn Blumenthal and Kate Horsfield produced a videotaped interview with Bourgeois in which she discussed her family background and her education in France as well as her working methods and the inspiration behind certain works.

Bourgeois took part in a tribute to one of her former mentors, Vaclav Vytlacil, in a show of his own work and that of his students at the Montclair Art Museum.

1976

Susi Bloch published an interview with Bourgeois in *Art Journal* which stressed the work of the late 1940s and early 1950s.

Bourgeois featured significantly in the "200 Years of American Sculpture" show at the Whitney Museum of American Art.

1977

Bourgeois took part in the Atelier 17 retrospective held at the Elvehjem Art Center in Madison, Wisconsin.

Yale University awarded Bourgeois an Honorary Doctor of Fine Arts Degree.

1978

Bourgeois finally won recognition in the United States through the simultaneous presentation of two solo shows, at the Hamilton Gallery of Contemporary Art and the Xavier Fourcade Gallery in New York in **September**, followed by another show at the University Art Gallery in Berkeley in **December**.

At the Hamilton Gallery, she presented a sculpture–environment entitled *The Confrontation* and nine small pieces including two *Germinals*, *Tame Confrontation* and terracotta versions of *Hanging Janus*.

Bourgeois organized a performance around *The Confrontation*, entitled *A Banquet/A Fashion Show of Body Parts*. People stood or sat in coffin-shaped boxes while Bourgeois's friends and students, dressed in costumes designed by the artist, paraded past to a script and music evoking the world of fashion and punk.

At the Fourcade Gallery, Bourgeois exhibited a series of wood sculptures, *Structure I* to *IV*, a work in metal, *Maison fragile*, and a set of recent drawings. The Berkeley show included *Maison fragile, Lair of Five* and *Radar*.

The General Services Administration commissioned an outdoor sculpture for the Norris Cotton Federal Building in Manchester, New Hampshire—*Facets to the Sun*.

The Detroit Institute of the Arts purchased a version of *The Blind Leading the Blind*, while the Storm King Art Center in Mountainville, N.Y., bought *Number Seventy-two (The No March)*.

1979

September: A solo show at the Xavier Fourcade Gallery included thirty-three figures in wood, and a recent work called *Partial Recall*.

Eleanor Munro included Bourgeois in her book, *Originals: American Women Artists* (New York: Simon and Schuster, 1979), which featured illustrations of *The Blind Leading the Blind* and *Confrontation*.

Louise Bourgeois wearing the costume for *The Confrontation*, on the steps of her apartment on 347 West 20th Street.

Performing in *The Confrontation*, 1978.

1980–90

1980

Two solo shows in **September**, at the Max Hutchinson and Xavier Fourcade galleries, stress Bourgeois's early work and its recent rediscovery by the current artistic scene:

At the Hutchinson Gallery, "The Iconography of Louise Bourgeois" presented some thirty early paintings like *Reparation, Connecticutiana*, the four *Femmes-maisons, Fallen Woman, Red Room* and *Roof Song*, plus approximately thirty-five drawings from 1942 to 1974 and twelve engravings dating from the late 1940s. The catalogue contained thirty-one illustrations and an essay by Jerry Gorovoy.

At the Fourcade Gallery, "Louise Bourgeois Sculpture: The Middle Years 1955–1970" featured ten marble pieces including *Clamart, Eye to Eye, Colonnata, Baroque* and *Sleep II*, three bronzes (including *Torso/Self-Portrait*) and a granite version of *Trani Episode*.

Bourgeois was photographed for *Vogue* magazine dressed in the costume designed for the 1978 performance at the Hamilton Gallery. Carter Radcliff contributed an article that traced her evolution and explored the psychological motivations behind her work.

Bourgeois bought a large loft in Brooklyn, using it as both studio and storage space.

The Australian National Gallery in Canberra purchased *C.O.Y.O.T.E.*, which is a second, pink-painted version of *The Blind Leading the Blind*, (1947–9).

1981

May: The Renaissance Society of the University of Chicago hosted a solo show, "Louise Bourgeois Femme-Maison," featuring thirty-one pieces spanning the 1940s to the 1970s (including two bronze *Maisons fragiles* of 1978 and the series of engravings from *He Disappeared into Complete Silence*). The catalogue contained six illustrations and an essay by J.-Patrice Marandel, "Louise Bourgeois: From the Inside."

Kay Larson interviewed Bourgeois for one of the "Artists the Critics are Watching" features in *Artnews*.

Returning to Italy for the first time since 1972, Bourgeois worked primarily at Carrara, where she produced some twenty marble pieces largely on the themes of *Harmless Woman* and *Femme-couteau*. There she also sculpted her largest work in marble, *Femme-maison 81*.

1982

November 1982 to February 1983: The first major official retrospective of Bourgeois's work was held at the Museum of Modern Art in New York, at the initiative of Deborah Wye, associate curator in the department of engravings and illustrated books, in collaboration with Alicia Legg, curator at the department of painting and sculpture. The exhibition presented approximately one hundred works and covered Bourgeois's career from the early 1940s (the first wooden pole–figures) to the highly provocative sculptures of the 1960s, 1970s and 1980s. The show also included a selection of paintings, drawings and engravings, providing an overview of her development. The catalogue contained a foreword by William Rubin and a critical essay by Wye, as well as numerous unpublished documents and illustrations.

December: "Bourgeois Truth" was her first solo exhibition to be hosted by the Robert Miller Gallery. Robert Pincus-Witten wrote the text for the catalogue, which included illustrations of early works in wood (*Portrait of Jean-Louis, The Visitors Arrive at the Door, Spiral Women* and *C.O.Y.O.T.E.*), works in plaster from 1962 (*Labyrinthine Tower* and *Clutching*), bronzes cast in 1982, other plasters from the 1960s, recent

With Andy Warhol at the Robert Miller Gallery, 1987.

marbles (*Fallen Woman*, *Femme-maison*) and drawings (c. 1948–51).

Robert Miller henceforth became Bourgeois's official dealer, regularly exhibiting her work.

For the first time, Bourgeois published an autobiographical article, with childhood photographs (house in France, parents, and English tutor, Sadie), in the December issue of *Artforum*, entitled "A Project by Louise Bourgeois: Child Abuse."

She sculpted *Fallen Woman* in two versions, one in white marble, the other in black marble.

1983

The first film on Bourgeois, *Partial Recall*, was made by the Museum of Modern Art in New York.

The Museum of Modern Art's retrospective show traveled to the Contemporary Arts Museum in Houston, the Museum of Contemporary Art, Chicago, and the Akron Art Museum, Ohio, between **March 1983 and March 1984**.

Bourgeois produced *Femme-maison* and *The Curved House* (now at the Berne Museum, Switzerland).

1984

September/October: A show at the Robert Miller Gallery, "Louise Bourgeois, Sculpture," featured her latest work, including several *Nature Studies* (*Nature Study Velvet Eyes*, *Spiral Woman*, *Blind Man's Buff*, etc.).

Shows were held at the Weinberg Galleries in Los Angeles and San Francisco.

Louise Bourgeois working on *The Destruction of the Father*, 1974.

1985

February/March: Bourgeois's first solo show in France was hosted by the Galerie Maeght-Lelong in Paris (the show later traveled to the Galerie Maeght-Lelong in Zurich). Some fifty sculptures were exhibited, from *The Blind Leading the Blind* (1947–9) to *Nature Study* (1984). In addition to sculptures in wood from the 1940s and 1950s, there was a set of plasters and marbles from the

1960s, and bronze versions of later pieces. The catalogue, with texts by Jean Frémon and Robert Storr, featured numerous illustrations.

May/June: An exhibition entitled "Louise Bourgeois" was held at the Serpentine Gallery in London.

Bourgeois produced a bronze sculpture of a leg, entitled *Henriette*, that alluded to her sister's limp.

1986

June/July: A "Louise Bourgeois" show at the Robert Miller Gallery presented her latest sculptures— *Articulated Lair*, *The She-Fox*, and *Nature Study* (now at the Whitney Museum). Jerry Gorovoy published a brochure, *Louise Bourgeois*, to accompany the show, with an essay entitled "Louise Bourgeois and the Nature of Abstraction." In addition to the works exhibited at the Robert Miller Gallery, the brochure included illustrations of sculptures and drawings from 1947 to the 1960s.

Texas Gallery, Houston: "Louise Bourgeois: Sculptures & Drawings."

Bourgeois executed *Legs* (rubber), *Bald Eagle* (marble) and *Maison* (metal and plaster).

1987

January: A show at the Robert Miller Gallery, "Paintings from the 1940s," featured eleven paintings from 1946 to 1949.

May/June: An exhibition at the Taft Museum in Cincinnati toured US cities throughout 1988 and 1989 (Miami, Austin, St. Louis, Seattle and Syracuse). The catalogue included essays by Stuart Morgan.

1988

January: "Louise Bourgeois Drawings 1939–87" at the Robert Miller Gallery included 178 drawings and a sculpture in marble, *Serpentine*. In collaboration with the Galerie Lelong in Paris, John Cheim and Jerry Gorovoy published *Louise Bourgeois Drawings*, with an introduction by Robert Storr.

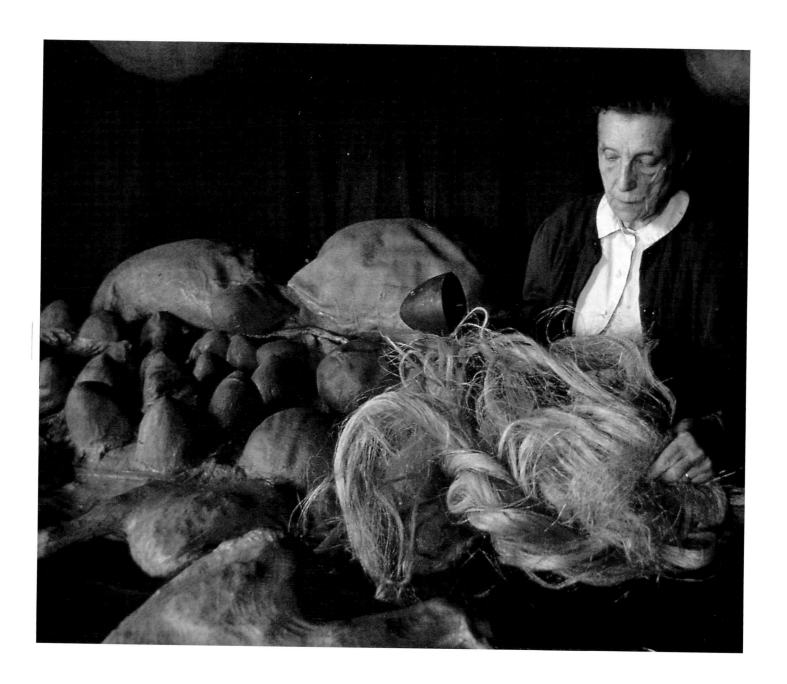

October–December: The Museum Overholland in Amsterdam hosted "Louise Bourgeois, werken op papier, works on paper." Catalogue text by Robert Storr.

Bourgeois produced a marble piece, *Sail*, and an environment, *No Exit* (exhibited at the Lyons Biennial in France, then purchased by the Museum of Modern Art, New York).

1989

Publication of numerous articles about Louise Bourgeois.

May–August: Bourgeois exhibited *Articulated Lair* (1986) in the vast "Magiciens de la terre" show organized by Jean-Hubert Martin in Paris, held jointly at the Centre Georges Pompidou and the Grande Halle de La Villette.

December: Peter Weiermar at the Frankfurter Kunstverein organized the first show of work by Bourgeois to travel throughout Europe; it went from Frankfurt to Munich, Lyons, Barcelona, Berne, and Otterlo before winding up in Lucerne in July 1991. The catalogue contained essays by Lucy R. Lippard, Robert Storr, Rosalind Krauss, and Thomas Mac Evilley.

France's "National Contemporary Art Fund" purchased five Bourgeois drawings from the 1947–51 period.

Bourgeois produced another environment, *No Escape*, and several marbles—*Untitled (with Foot)*, *Untitled (with Growth)*, and *Untitled (with Hand)*.

1990–95

1990

February/March: The Barbara Gross Gallery in Munich hosted "Louise Bourgeois Druckgraphik, Zeichnungen."

April/May: In London, Karsten Schubert Ltd. showed "Louise Bourgeois Drawings," while in **May/June** the Riverside Studios hosted an abridged version of the Frankfurt retrospective, entitled "Louise Bourgeois, Recent Work, 1984-1989." The catalogue contained an essay by Stuart Morgan.

October/November: The Karsten Greve Gallery in Cologne showed "Bronzen der 40er und 50er Jahre."

The Frankfurter Kunstverein traveling retrospective generated significant press coverage.

Bourgeois wrote an article for *Artforum*, entitled "Freud's Toys."

Bourgeois published *The Puritan* (Osiris Press), a collection of texts accompanied by thirty engravings; she also produced several sculptures—*Cœurs, Decontractée, Gathering Wool*, and *Ventouse*.

1991

February/March: The Galerie Lelong in Zurich presented Bourgeois's engraved works, including *Quarantania* (1947, printed 1990), *He Disappeared into Complete Silence* (1947) and *The Puritan* (1990).

The French Ministry of Culture awarded its Grand Prix in sculpture to Louise Bourgeois.

October/November: The "Louise Bourgeois, Recent Sculpture" show at the Robert Miller Gallery notably featured *Ventouse, Mamelles, Jambes enlacées*, and *Décontractée*.

December 1991 to January 1992: Bourgeois presented a mobile sculpture, *Twosome*, in the context of Robert Storr's "Dislocations" show at the Museum of Modern Art, New York.

Bourgeois also executed *Le Défi* (Guggenheim Museum) and *Cells I* to IV (exhibited at the Carnegie International, Pittsburgh).

1992
Bourgeois wrote an article entitled "Obsession" for *Artforum*, on the Franco-American artist Gaston Lachaise, whose work was also exhibited at the show of twentieth-century American sculpture held at the Musée Rodin in Paris in 1965.

At the instigation of publisher Peter Blum, Arthur Miller and Louise Bourgeois collaborated on a book entitled *Homely Girl, A Life*, which features a 1991 text by Miller, nineteen dry-point engravings by Bourgeois, and eight photolithographs of medical plates showing eyes.

May 12: Inauguration of a new installation, *She Lost It*, comprised a scroll of fabric five and a half meters long with a silked-screened text: "A man and a woman lived together." The piece was produced in conjunction with The Fabric Workshop in Philadelphia, in the context of The Fabric Workshop's 15th Anniversary Annual Benefit Honoring Louise Bourgeois and Anne d'Harnoncourt.

December 5: During a performance at The Fabric Workshop, Bourgeois wrapped Robert Storr in the fabric scroll, which she subsequently unrolled.

June/September: Jan Hoet, organizer of Documenta IX at Kassel, selected Bourgeois's latest environment piece for exhibition; begun in 1991, *Precious Liquids* was "a chamber full of clusters of glass and balls" (Geneviève Breerette, *Le Monde*, June 19) fashioned out of a typical New York water tank.

The work was purchased that same year by the Musée National d'Art Moderne in Paris.

October 1992 to January 1993: The Karsten Greve Gallery in Paris organized a "Louise Bourgeois" show featuring a few recent drawings and a recent sculpture series, *Needles*, including *Needle (Fuseau)* and *Poids*.

Performance produced in conjunction with the Fabric Workshop, Philadelphia, December 1992.

1993
Bourgeois continued and completed work on the *Cell* series: *Cell (Arch of Hysteria), Cell (Choisy), Cell (Class Spheres and Hands), Cell (Eyes and Mirrors)*. These works were exhibited at the Venice Biennale (the Tate Gallery in London purchased *Eyes and Mirrors*).

February–May: A show at the Karsten Greve Gallery in Cologne, entitled "Louise Bourgeois: Skulpturen und Installationen," included a spider sculpture and a set of watercolors on the spider theme.

Terra Luna Films and the Centre Georges Pompidou coproduced a film by Camille Guichard, *Louise Bourgeois*, in which the artist talks to Bernard Marcadé and Jerry Gorovoy.

June–October: Bourgeois was chosen to represent the United States at the 45th Venice Biennale—Charlotta Kotik from the Brooklyn Museum curated the installation of recent works by Bourgeois in the American Pavilion in Venice.

September/October: Bourgeois showed *Cell (You Better Grow Up)* in the Second Biennial of Contemporary Art in Lyon, France, entitled "Et tous ils changent le monde," organized by Thierry Raspail and Thierry Prat.

Bourgeois produced *Cell (Three White Marble Spheres)*.

Bourgeois received two urban commissions,

from the cities of Chicago and Choisy-le-Roi (France), respectively.

1994

Bourgeois contributed an article on Miró to *Artforum* to coincide with the Miró retrospective at the Museum of Modern Art.

Nigel Finch produced a 55-minute film on Bourgeois for Arena Films, BBC, London.

June–August: The Brooklyn Museum organized a major exhibition of work by Bourgeois from 1982 to 1993. The abundantly illustrated book published by Charlotta Kotik, *Louise Bourgeois: The Locus of Memory, 1982–1993*, contained not only Kotik's own text "The Locus of Memory," but also an article by Terrie Sultan ("Redefining the Terms of Engagement: The Art of Louise Bourgeois") and another by Christian Leigh ("The Earrings of Madame B.: Louise Bourgeois and the Reciprocal Terrain of the Uncanny"), as well as an anthology of essays by various authors. The exhibition later traveled to the Corcoran Gallery in Washington.

June 1994 to January 1995: A major exhibition of her recent work, "Skulpturen und Installationen," was held at the Kestner-Gesellschaft Gallery in Hanover; the catalogue included texts by Carsten Ahrens, Barbara Catoir, Doris von Drathen, Jerry Gorovoy, and Robert Storr, as well as statements by Bourgeois herself.

September: Bourgeois showed her latest environments at the Peter Blum Gallery in New York: *The Red Rooms (Red Room-Parents, Red Room-Child)* and an engraving, *Triptych for the Red Room*. The show corresponded with Blum's publication of *Album*, a collection of childhood photographs with comments by Bourgeois.

September–November: Bourgeois showed *The Nest* (1994) and spider drawings at the Museum van Hedendaagse Kunst in Ghent, in the context of an exhibition entitled "This is the show and the show is many things."

September–December: The Museum of Modern Art in New York hosted a retrospective show of engravings by Bourgeois; Deborah Wye and Carol Smith published a *catalogue raisonné* of *The Prints of Louise Bourgeois*.

1995

February–April: The Graphic Art Department of the Musée National d'Art Moderne in Paris mounted a show entitled "Louise Bourgeois: Pensée-Plumes." The catalogue by Marie-Laure Bernadac also contained a text by Deborah Wye.

Simultaneously, the exhibition of engravings organized by the Museum of Modern Art was shown at the Bibliothèque Nationale de France in Paris under the title, "Louise Bourgeois: estampes."

June–September: The Musée d'Art Moderne de la Ville de Paris organized a retrospective entitled "Louise Bourgeois, Exposition Rétrospective, sculptures, environnements, dessins, 1944–1994."

October–December: The Museum of Modern Art, Oxford hosted both the MOMA New York prints exhibition and an exhibition of Bourgeois's sculpture.

NOTES

1. Interview for the film *Louise Bourgeois* by Camille Guichard (Paris, 1993).
2. *Ibid.*
3. Douglas Maxwell, "Louise Bourgeois," *Modern Painters*, vol. 6, no. 2, summer 1993, p. 40.
4. Christiane Meyer-Thoss, *Louise Bourgeois, Designing for Free Fall*, (Zurich: Ammann Verlag, 1992), p. 134.
5. Guichard, *Louise Bourgeois.*
6. *Ibid.*
7. Paola Igliori, *Entrails, Heads & Tails,* (New York: Rizzoli, 1992).
8. Guichard, *Louise Bourgeois.*
9. Maxwell, p. 41.
10. Guichard, *Louise Bourgeois.*
11. *Ibid.*
12. *Ibid.*
13. *Ibid.*
14. Unpublished interview with Marie-Laure Bernadac, June 1992.
15. Guichard, *Louise Bourgeois.*
16. Meyer-Thoss, p. 185.

Louise Bourgeois in her *Cell (Arch of Hysteria)*, 1992.

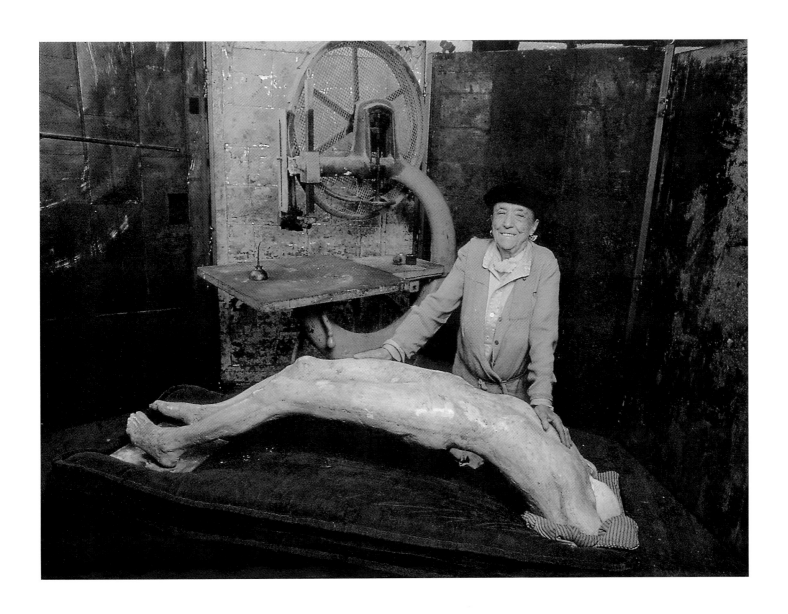

SELECTED BIBLIOGRAPHY

Writings by Louise Bourgeois

"A Project by Louise Bourgeois: Child Abuse," *Artforum*, December 1982.
"Freud"s Toys," *Artforum*, no. 5, January 1990.
"Obsession," *Artforum*, April 1992.
"Miró at 100, Native Talent," *Artforum*, January 1994.
Album, New York, Peter Blum, 1994.

Books on Louise Bourgeois

Gardner, Paul, *Louise Bourgeois*, New York, Universe Publishing, 1994.
Gorovoy, Jerry, *Louise Bourgeois and the Nature of Abstraction*, New York, Bellport Press, 1986.
Igliori, Paola, *Entrails, Heads & Tails*, New York, Rizzoli, 1992.
Kotik, Charlotta (ed.) *Louise Bourgeois: The Locus of Memory*, exhibition catalogue, New York, Brooklyn Museum, 1994.
Kuspit, Donald, *Bourgeois*, New York, E. Avedon Editions, 1988.
Meyer-Thoss, Christiane, *Louise Bourgeois: Designing for Free Fall*, Zurich, Ammann Verlag, 1992.
Storr, Robert, *Louise Bourgeois Drawings*, New York, Robert Miller/Paris, Daniel Lelong, 1988.
Wye, Deborah, *Louise Bourgeois*, exhibition catalogue, New York, Museum of Modern Art, 1982.
Wye, Deborah, and Carol Smith, *The Prints of Louise Bourgeois*, New York, Museum of Modern Art/Abrams, 1994.

Articles on Louise Bourgeois

Anderson, Wayne, "American Sculpture: the situation in the Fifties," *Artforum*, summer, 1967.

Baldwin, Carl R., "Louise Bourgeois: an iconography of abstraction," *Art in America*, vol. 63, no. 2, March–April 1975.
Bloch, Susi, "An interview with Louise Bourgeois," *Art Journal*, vol. 35, no. 4, summer 1976.
Bonami, Francesco, "Louise Bourgeois: in a strange way, things are getting better and better," *Flash Art*, no. 174, January–February 1994.
Borja-Villel, Manuel J., "Louise Bourgeois' défi," *Parkett*, no. 27, special edition "Collaboration Louise Bourgeois/Robert Gober," March 1991.

Dagen, Philippe, "La dame de verre et de fer," *Le Monde*, December 4, 1992.
—,"Louise Bourgeois hôte du pavillon américain : la sculpture au couteau," *Le Monde*, 3 June, 1993.
Dobbels, Daniel, "Doubler le silence," *Ninety*, no. 15, 1994.

Flohic, Catherine, "Louise Bourgeois, portrait," *Ninety*, no. 15, 1994.

Gardner, Paul, "The discreet charm of Louise Bourgeois," *Artnews*, vol. 79, February 1980.
—,"Louise Bourgeois," *Contemporanea*, vol. II, no. 7, October 1989.
—,"The Houses that Louise Built," *HG*, October 1992.
Goldwater, Robert, "La sculpture actuelle à New York," *Cimaise*, vol. 4, November–December 1956.

Helfenstein, Josef, "The power of intimacy," *Parkett*, no. 27, special edition "Collaboration Louise Bourgeois/Robert Gober," March 1991.

Kirili, Alain, "The Passion for Sculpture, a conversation with Louise Bourgeois," trans. Philip Bernard, *Arts Magazine*, vol. 63, no. 7, March 1989.
Krauss, Rosalind, "Portrait de l'artiste en *fillette*," exhibition catalogue, Lyons, 1989.
Kuspit, Donald, "Louise Bourgeois–Where Angels Fear to Tread," *Artforum*, March 1987.

Larson, Kay, "Louise Bourgeois: Her Re-emergence Feels like a Discovery," *Artnews*, May 1981.
—,"Dislocations," *Galeries Magazine*, no. 46, December 1991–January 1992.
Leigh, Christian, "Rooms, doors, windows: Making Entrances & Exits (when necessary). Louise Bourgeois's Theatre of the Body," *Balcon*, Madrid, nos. 8–9, 1992.
Lippard, Lucy R., "Louise Bourgeois: From the inside out," *Artforum*, vol. 13, March 1975.

Marandel, J.-Patrice, "Louise Bourgeois," *Art International*, vol. 15, December 1971.
Maxwell, Douglas, "Louise Bourgeois," *Modern Painters*, vol. 6, no. 2, summer 1993.
Morgan, Stuart, "Taking Cover: Louise Bourgeois interviewed by Stuart Morgan," *Artscribe*, no. 67, January–February 1988.
—,"The drawings of Louise Bourgeois," *Drawing*, vol. X., no. 3, September–October 1988.
—,"Les totems et les tabous de Louise Bourgeois," *Beaux-Arts*, no. 106, November 1992.

Nixon, Mignon, "Pretty as a picture: Louise Bourgeois' Fillette," *Parkett*, no. 27, special edition "Collaboration Louise Bourgeois/Robert Gober," March 1991.

Paparoni, Demetrio, "Louise Bourgeois, a conversation between Louise Bourgeois and Demetrio Paparoni," *Tema Celeste*, no. 30, May–June 1991.
Pels, Marsha, "Louise Bourgeois: A Search for Gravity," *Art International*, vol. 23, October 1979.
Pernoud, Emmanuel, "Louise Bourgeois ou la souffrance du trait," *Les Nouvelles de l'estampe*, no. 138, December 1994.
Princenthal, Nancy, "Bourgeois with a vengeance," *Sculpture*, vol. 8, no. 4, July–August, 1989.

Radcliff, Carter, "Louise Bourgeois," *Vogue*, vol. 170, no. 10, October 1980.
—,"Louise Bourgeois," *Art International*, vol. 22, November–December 1978.
Robbins, Daniel, "Sculpture by Louise Bourgeois," *Art International*, vol. 8, October 1964.
Rochette, Anne, "Louise Bourgeois at Karsten Greve", *Art in America*, May 1993.
Roskill, Mark, "Louise Bourgeois: Some Recent Drawings," *Drawing*, vol. XIV, no. 2, July–August 1992.
Rubin, William, "Some reflections prompted by the recent work of Louise Bourgeois," *Art International*, April 1969.

Seuphor, Michel, "Le choix d'un critique," *L'Œil*, no. 49, January 1965.
Silverthorne, Jeanne, "Louise Bourgeois at Robert Miller Gallery," *Artforum*, December 1984.
Sorman, Guy, "Star de l'art américain made in France: Louise Bourgeois," *Le Figaro Magazine*, 23 January, 1993.
Spector, Nancy, "Art and Objecthood," *Tema Celeste*, no. 37–8, fall 1992.
Steir, Pat, "Mortal Elements," *Artforum*, summer 1993.
Storr, Robert, "Louise Bourgeois: Gender and Possession," *Art in America*, vol. 71, no. 3, April 1983.
—,"Meanings, materials and milieu—reflections on recent work by Louise Bourgeois," *Parkett*, no. 9, June 1986.
—,"Louise Bourgeois, Works on Paper," exhibition notes, Museum Overholland, 1988.

— "Cover Story, Louise Bourgeois," *Galeries Magazine*, no. 37, June–July 1990.
— "Géométries intimes: l'œuvre et la vie de Louise Bourgeois", *Art Press*, no. 175, December 1992.

Treat, Carolyn, "Louise Bourgeois: 'Art is a Garantee for Sanity,'" *Kunst & Museum Journal*, vol. 2, no. 6, 1991.

Wye, Pamela, "Louise Bourgeois," *Arts Magazine*, January 1992.

Filmography

Blumenthal, Lynn and Horsfield, Kate, video interview with Louise Bourgeois, (Video Data Bank, School of The Art Institute of Chicago, 1975) 30 minutes.

Finch, Nigel, *Louise Bourgeois*, filmed interview (The Easton Foundation, Arena Films, BBC London, 1994) 55 minutes.

Guichard, Camille, with Bernard Marcadé and Jerry Gorovoy, *Louise Bourgeois* filmed interviews (co-production of Terra Luna Films and Centre Georges Pompidou, Paris, 1993) 52 minutes.

Partial Recall, video on Louise Bourgeois (The Easton Foundation, The Museum of Modern Art, Paris, 1983) 18 minutes.

Cornand, Brigitte, *Chère Louise*, (Canal +, 1995) 55 minutes.

Photographic Credits